Adolescents'

Online Literacies

Colin Lankshear, Michele Knobel,
and Michael Peters
General Editors

Vol. 39

PETER LANG
New York • Washington, D.C./Baltimore • Bern
Frankfurt • Berlin • Brussels • Vienna • Oxford

Adolescents' Online Literacies

Connecting Classrooms, Digital Media, and Popular Culture

EDITED BY Donna E. Alvermann

PETER LANG
New York • Washington, D.C./Baltimore • Bern
Frankfurt • Berlin • Brussels • Vienna • Oxford

Library of Congress Cataloging-in-Publication Data

Adolescents' online literacies: connecting classrooms, digital media,
and popular culture / edited by Donna E. Alvermann.
p. cm. — (New literacies and digital epistemologies; v. 39)
Includes bibliographical references and index.
1. Internet in education. 2. Internet and teenagers.
3. Internet literacy. 4. Media literacy. 5. Digital media.
6. Popular culture. I. Alvermann, Donna E.
LB1044.87.A35 371.33'44678—dc22 2009049018
ISBN 978-1-4331-0551-7
ISSN 1523-9543

Bibliographic information published by **Die Deutsche Nationalbibliothek**.
Die Deutsche Nationalbibliothek lists this publication in the "Deutsche
Nationalbibliografie"; detailed bibliographic data is available
on the Internet at http://dnb.d-nb.de/.

FSC
Mixed Sources
Product group from well-managed
forests, controlled sources and
recycled wood or fiber

Cert no. SCS-COC-002464
www.fsc.org
©1996 Forest Stewardship Council

The paper in this book meets the guidelines for permanence and durability
of the Committee on Production Guidelines for Book Longevity
of the Council of Library Resources.

© 2010 Peter Lang Publishing, Inc., New York
29 Broadway, 18th floor, New York, NY 10006
www.peterlang.com

Printed in the United States of America

TABLE OF CONTENTS

Introduction 1
DONNA E. ALVERMANN

1 Multimodal Pedagogies: Playing, Teaching and Learning
with Adolescents' Digital Literacies 5
LALITHA VASUDEVAN, TIFFANY DEJAYNES, AND STEPHANIE SCHMIER

2 Webkinz, Blogs, and Avatars: Lessons Learned from Young
Adolescents 27
JANIE COWAN

3 View My Profile(s) 51
GUY MERCHANT

4 4 Colored Girls Who Considered Suicide/When Social Networking
Was Enuf: A Black Feminist Perspective on Literacy Online 71
DAVID E. KIRKLAND

5 Textual Play, Satire, and Counter Discourses of Street Youth Zining
 Practices 91
 THERESA ROGERS AND KARI-LYNN WINTERS

6 Digital Literacies and Hip Hop Texts: The Potential for Pedagogy 109
 JAIRUS JOAQUIN

7 Digital Media Literacy: Connecting Young People's Identities,
 Creative Production and Learning about Video Games 125
 MICHAEL DEZUANNI

8 'Experts on the Field': Redefining Literacy Boundaries 145
 AMANDA GUTIERREZ AND CATHERINE BEAVIS

9 "I Think They're Being Wired Differently": Secondary Teachers'
 Cultural Models of Adolescents and Their Online Literacies 163
 KELLY CHANDLER-OLCOTT AND ELIZABETH LEWIS

10 Minding the Gaps: Teachers' Cultures, Students' Cultures 183
 ANDREW BURN, DAVID BUCKINGHAM, BECKY PARRY, AND MANDY POWELL

 Afterword 203
 KEVIN M. LEANDER

 Contributors 209

 Author Index 213

 Subject Index 219

INTRODUCTION

DONNA E. ALVERMANN

The idea for this book originated with a group of graduate students who were enrolled in a course I teach at the University of Georgia called Popular Culture and Literacy in K-12 Classrooms. Some of the students were classroom teachers (mostly at the middle and high school level); others were school media specialists and librarians who had varying degrees of teaching responsibilities at their respective schools; and still others were full-time master's and doctoral level students who were interested in some aspect of young people's engagement with digital media and popular culture. To a person, these students expressed impatience with theorizing adolescents' online literacies. As the semester progressed, they asked for readings that would make concrete connections between what the literature portrayed and what they knew to be the situation in their own classrooms, media centers, and libraries. They wanted to learn from people like themselves—educators who were finding ways to incorporate and use the digital literacies youth engage in (e.g., blogging, zining, gaming, hip hop texts, and social networking) to make classroom learning more relevant.

Adolescents' Online Literacies: Connecting Classrooms, Digital Media, and Popular Culture is a compilation of new work produced and written up by several of the same authors that the students in my graduate seminar were read-

ing. Not surprisingly, their chapters offer diverse ways of connecting adolescents' online literacies to classroom practice because I intentionally drew from a range of author-experts (classroom teachers, researchers, graduate students, school media specialists, and librarians) who reside in countries that span three continents (Australia, Europe, and North America). In this diversity lies the potential for dipping into pedagogical approaches that have implications for your own set of circumstances.

The book is also "dippable" in that you can start with any chapter and skip around without losing sight of the overall message. That said, I chose to introduce each chapter by following the order in which they are listed in the table of contents. Thus, the first chapter after this brief introduction is one by Lalitha Vasudevan, Tiffany DeJaynes, and Stephanie Schmier. In it, they vividly capture the multimodal world that youth navigate daily. These three authors take you into school settings that challenge educators to be pedagogically nimble in order to support the learning of adolescents whose literacies move across spaces of home, community, and school in rapid succession. As the authors explain, multimodality provides a framework for observing how young people use myriad digital "tools" to engage in literacies that expand what counts as communicating effectively in different contexts.

In chapter 2, Janie Cowan relies on students in her school media center to teach her how to participate in the online virtual worlds of Webkinz, Chobots, and Club Penguin. From this experience in social networking, blogging, and avatars, Cowan learns firsthand of the social and economic ethos of the Webkinz World. Viewed critically, this virtual environment offers what she terms "uncharted territory" of literacy teaching and learning possibilities in 21st century classrooms and library media centers. The next two chapters explore a range of literacies common to older adolescents' social networking that have implications for classroom teaching. Guy Merchant, in chapter 3, looks at adolescents' perceptions of their literacy practices in relation to the identity work they do while designing profile pages on several popular social networking sites. Setting this rich data set alongside teacher interviews, Merchant is able to tease out some of the tensions and contradictions, as well as possibilities, inherent in working with these new literacies in classrooms. Social networking is the backdrop for David Kirkland's chapter 4, as well, but this time the focus is on how one young Black woman's writings in MySpace reveal a story of oppression that gestures toward what he calls a therapeutic pedagogy. Using a conceptual lens that creates possibilities for implementing this pedagogy in secondary classrooms, Kirkland argues for taking Black female online narratives

seriously by using them as a "critically-grounded and academically rich literacy learning experience for all students."

The authors of the next two chapters extend the discussion by examining the literacy practices of adolescents and young adults whose access to digital media has changed the way they view themselves. For example, Theresa Rogers and Kari-Lynn Winters (chapter 5) document through various artifacts the way street youth use a monthly online zine to re-position themselves in relation to their audiences. By featuring textual play, satire, and discourse that run counter to the way mainstream media construct street people, the youth-produced zine, *Another Slice*, offers educators a glimpse into what Rogers and Winters view as alternative literacy and learning spaces that have implications for classroom practice. Then, in chapter 6, Jairus Joaquin turns the spotlight on hip hop texts and shows through his interviews with three young men how these texts inspire them during times of adversity. Reflecting on an earlier time in his life when he had used "hip hop as a social avenue to develop relationships with friends at the high school lunch table," Joaquin draws from Freire to construct a critical inquiry-based learning experience around digital hip hop texts that teachers can use as a model for designing their own lessons.

Michael Dezuanni's chapter 7 makes connections between 17 young males' everyday literacy experiences with digital media and their more formal high school curriculum. Using a poststructural analysis of data from a case study of the Video Games Immersion Unit, Dezuanni shows how classroom teachers and media specialists can involve young people in designing and producing their own games through reflective blogging and online chats. In Chapter 8, Amanda Gutierrez and Catherine Beavis delve into a curriculum unit that features a fantasy online sports game, "SuperCoach." The authors present a compelling example of how young people's online and offline worlds converge as a result of their adeptness in reading and interpreting information presented in a variety of forms, from a variety of sources.

One could hardly ask for a better ending to *Adolescents' Online Literacies: Connecting Classrooms, Digital Media, and Popular Culture* than the two chapters that follow. As Kelly Chandler-Olcott and Elizabeth Lewis point out in chapter 9, despite the centrality of online literacies to many adolescents' lives, relatively little attention has been paid to the sense that secondary teachers may, or may not, be making of this phenomenon. To address this gap in the literature, Chandler-Olcott and Lewis draw on the idea of cultural modeling to analyze data from a collective case study in which they interviewed 13 English teachers, two library media specialists, and an academic intervention special-

ist to document their perceptions of adolescents' online literacies. In the last chapter in the book, Andrew Burn, David Buckingham, Becky Parry, and Mandy Powell report findings from the first phase of a three-year, large-scale media literacy project designed to ask specific questions about a presumed generational gap between teachers' and students' awareness and use of digital media. Viewed from a perspective that takes into account both cultural capital and third-space (hybridity), the four chapter authors suggest "the gap between teachers' and students' cultures may not be quite as large, or as simple and straightforward" as previously thought.

Although I have had the privilege of reading each of the 10 chapters and the afterword by Kevin Leander several times over the past year in my role as editor, each re-reading has produced new insights and made me even more cognizant of the expertise represented here. This fact, coupled with the pleasure of working with the series editors and staff at Peter Lang Publishing, will remain with me long after the book has gone to press. So, too, will memories of the graduate students who prompted this book's origins. If I've "kept it real," I've kept my promise to them.

· 1 ·

Multimodal Pedagogies

Playing, Teaching and Learning with Adolescents' Digital Literacies

LALITHA VASUDEVAN, TIFFANY DEJAYNES, AND STEPHANIE SCHMIER

In a computer lab on the sixth floor of a federal building, four young men and one young woman spread themselves out across the machines. Three iMacs were brought in that day and set up adjacent to one another on a long folding table, and eight PCs lined the perimeter of the room. Frankie, the young woman, used one of the PCs connected to the Internet to search YouTube (youtube.com) for a video she had previously uploaded to the video-sharing site. Bruce sat down in front of an iMac, opened up iMovie, and named his file "slickone," after the moniker he had earned in his neighborhood. All of the images he wanted to use for his afternoon movie project were on his MySpace page, so he borrowed a flash drive from the facilitator of the digital media drop-in hours and accessed his online profile on a PC. After selecting six images, and with Joey's help, he transferred the images onto the iMovie clip palette. Joey and Bruce worked together to drag and drop the images onto the iMovie timeline, where images and video can be organized into a desired sequence. When Mathu,[1] the facilitator, asked if Bruce could find the "effects" tab so that he could apply them to his images, Joey, who was still sitting with Bruce, pointed to the tab and responded with laughter, "It says 'effects.'" Bruce spent the next hour applying and then removing effect after effect and made accompanying noises of exclamation and dissatisfaction at regular intervals. He left

for work before he could finish his movie, but felt confident that he had mapped out the story he wanted to tell: one of himself as a former graffiti artist who was now seeking new canvases by painting clothing, hats, and signs for friends.

The youth who used the computer lab during the digital media drop-in hours moved seamlessly between "online" and "offline" spaces, and their digital literacies reveal hybridity in their multispatial navigations. While this vignette does not offer a definitive description of a completed project or product, the interactions across youth and adult reflect the pedagogical nature of a space in which multiple modalities for expression, communication, and representation are present. In this and other digitally rich contexts in which youth are engaged in the composition of multimodal texts (Hull & James, 2007; Ranker, 2008; Ware, 2008), experimentation and exploration are encouraged and literacies are not tethered to "in-school" and "out-of-school" binaries.

The well-documented literacies of adolescents reflect the shifting terrain of young people's communicative practices and the technologies that mediate them (Alvermann, Hinchman, Moore, Phelps, & Waff, 2006; Chandler-Olcott & Mahar, 2003; Skinner & Hagood, 2008). Virtual worlds, social networking sites, microblogging services, blogs, and wikis are among the several new kinds of spaces that Web 2.0 technologies make possible. Wesch (2007), a cultural anthropologist, in his highly popular video in which he analyzes the participatory culture of Web 2.0, suggests that among the concepts we need to rethink in light of the communicative, archival, and design affordances of evolving Internet technologies are authorship, identity, aesthetics, and even love. Recent studies of adolescents' literacies resonate with Wesch's claims and illustrate a range of emerging practices across a diverse digital landscape encompassing spaces online and offline. These emerging literacies are evident in the sophisticated layering of texts, images, and sounds involved in the production of anime music videos (Ito, 2006). Digital literacy proficiency is also required to navigate and communicate within the unfamiliar semiotic contexts of video games (Gee, 2005), in which participants confront new situations, assume a range of roles and identities, and find themselves in a variety of communicative interactions. These are not merely new forms of "letteracy" (Lankshear & Knobel, 2007) and not solely concerned with the production of written texts. The challenge to educators is to be pedagogically nimble in order to most effectively support the literacy learning of adolescents who are engaged in these and many other literacies, which move across spaces of home, community, and school.

Multimodal Play

To this discussion of youths' online and digital literacies we bring the concept of multimodal play (Vasudevan, 2006), which illuminates otherwise dismissed or overlooked interactions with digital media and technologies for purposes of composing. Often, youth use humor and playfulness to navigate their daily discourses. This approach is also evident in the ways that youth approach new technologies and cultivate new literacy practices. In this chapter, we draw on research with adolescents in media saturated contexts in order to advocate a "pedagogy of play" while making connections with adolescents' digital literacies landscapes. We suggest that through multimodal play—including textual explorations, reconfigured teaching and learning relationships, and the performance of new roles and identities *with* and *through* new media technologies and media texts—educators are better able to make pedagogical connections with adolescents' evolving literacies.

The theoretical concept of multimodality provides a framework for understanding new forms of composing—not only the composing of multiple texts out of multiple modes but also the engagement of myriad digital "tools" to participate in equally varied digital geographies (Vasudevan, under review). Multimodal composing, therefore, refers to more than bringing together separate modes of expression, such as sound or image, in the production of a text. Two ideas are important to consider when applying a multimodal approach to composing. First, it is important to recognize that reading and writing have always been multimodal. As Jewitt (2005) notes, even printed texts "require the interpretation and design of visual marks, space, colour, font or style, and, increasingly image, and other modes of representation and communication" (p. 315). A multimodal approach allows educators and researchers to attend to *all* of the resources involved in composing, which are especially visible in digital composing. Second, the ability to bring a variety of modes—for example, print, image, sound—together in the same text not only changes the way a text can be conveyed but also opens up new possibilities for what kinds of meaning can be conveyed (Hull & Nelson, 2005; Jewitt & Kress, 2003). Adolescents are engaged in these types of composing across the hybrid spaces they travel on a daily basis (e.g., instant messaging with written language within a virtual world in which they must communicate using an avatar; or incorporating photographs taken with a smartphone camera to their latest blog post). Portable technologies and increased wireless connectivity enable greater variation in what is composed, where and when composing happens, and reasons for composing.

We recognize that when youth are tethered to virtual spaces, such as microblogging sites like Twitter (twitter.com) and online video services like Hulu (hulu.com), their physical location also matters. Thus, we draw on this framework of multimodal play to extend the ongoing discourse about multimodal text production by considering the makeup of the physical spaces in which teaching and learning with multiple modalities occur. Outside of schools, in many youth-focused media organizations, the availability of a wide variety of expressive modes, multiple audiences, and opportunities for collaborative as well as individual composition is mediated through a shared understanding of what we refer to here as multimodal play. While many examples of multimodal play are found to exist outside of school and in spaces that afford different social arrangements, there is growing evidence that suggests ways in which this ethos is possible within school spaces (Fisher, 2007; Hill, 2009; Wissman, 2005, 2008). As the examples in this chapter illustrate, the pedagogical stance of multimodal play can be helpful when reimagining classrooms and can be generative of meaningful literacy practices and teaching and learning relationships.

In places like Youth Radio, which is a broadcast training program for youth in the San Francisco Bay Area, as well as other projects that provide youth with largely unrestricted access to technologies, their explorations yielded unexpected and unplanned digital innovations (e.g., the music sharing service, Napster; the footage shot by children involved with the documentary, *Born into Brothels*; on the ground documentation by young soldiers of the war in Iraq) (Soep & Chavez, 2005). Soep and Chavez (2005) urge adults "to recognize that young people's media experiments are pushing the work of many adults and the institutions created 'for' youth"(p. 417) so that educators can build on these digital innovations in purposeful ways. In a youth media organization like Youth Radio, adults and youth engage in a "pedagogy of collegiality" to accomplish collective goals of youth development and media production. This "[c]ollegial pedagogy, then, characterizes situations in which young people and adults jointly frame and carry out projects in a relationship marked by interdependence, where both parties produce the work in a very hands-on sense" (2005, p. 419). This approach to pedagogy works in such a setting where a spirit of experimentation abounds, and where there is both physical and figurative room to play with roles, composing repertoires, literacies, and goals. Youth Radio and similar settings (Goodman, 2003; Hull & Katz, 2006) exist outside of the school walls. While calls for rethinking literacies pedagogies with adolescents abound (Alvermann, 2002; Burke & Hammett, 2009; Hull & Schultz, 2002; Pahl & Rowsell, 2006; Schultz, 2002), we have fewer examples of this

call to action coming to fruition inside schools.

In this chapter, we present three instances of practice from our research with youth across three unique, urban educational settings and focus on the significance of play with technologies and media in literacy teaching and learning with adolescents. Each of us assumed different positionalities in our research, which afforded us varied entry into these multimodal educational spaces. We offer three different perspectives on creating and sustaining sites of multimodal pedagogy that are informed by understandings of adolescents' emerging literacies. One case explores an eighth grade journalism and media studies class and illustrates the ways in which the teacher utilized online tools and resources in the creation of a monthly school newspaper. A second case looks at the unexpected affordances of blogging in a high school English classroom. And a third case examines the engagement of social networking and video-sharing sites in the negotiation of identities and relationships between teachers and youth in an alternative to incarceration program. We conclude our chapter with a discussion on the implications of the increasingly digitally mediated lives of youth for the educational institutions in which they participate.

Becoming New Media Journalists in an Urban Middle School

Room 208 at East Side Middle School looks very different from most of the other classrooms in this large urban public school. Thirty-five eMac computers circle the perimeter of the room surrounding a large "conference" table in the center where the 43 students enrolled in the journalism and digital media studies class meet at the beginning of sixth period each day to discuss their current projects and ask for support or feedback from the class. Though many of these students did not have an interest in journalism or expertise in digital media prior to being randomly assigned to the class by the administration, most readily took up the task put forth on the first day of school by their teacher, Mr. Cardenas, "You report. Journalists report the facts...[In] this class you will be journalists."

> Over the three years that Mr. Cardenas has taught the journalism and digital media
> studies elective,[2] he has transformed his classroom into an authentic workspace where
> he and his students explore both traditional and new media journalistic practices
> such as podcasting. During sixth period, students are journalists. They are provided with
> "press passes" that afford them freedom to move around the school to report on issues
> of interest and importance to the student body and access to a few digital still and video

cameras which they use to perform their role as journalists. This freedom comes with responsibility. Students are required to make appointments to obtain interviews from their "sources" which include faculty and administration as well as fellow students and community members. Mr. Cardenas encourages the journalism students to work hard and be creative, and reminds them often of the importance of their jobs to "dig a little deeper to find something interesting that's happening, things that will matter to [our] students." He also takes his students on a field trip to the major newspaper in the city to learn about how and where journalists work.

As the above description of his classroom depicts, Mr. Cardenas employs a pedagogy of play in his classroom informed by a view of adolescents' literacies as meaningful and complex. His students play out their role as journalists, using props such as reporters' notebooks, cameras, and press passes to write about important issues in their school ranging from the academic curriculum to the nutritional quality of the cafeteria food. In contrast to some recent attempts we have heard about of teachers bringing out-of-school online literacy practices such as social networking on MySpace into their classrooms to engage students in academic content (e.g., create a MySpace profile for your favorite English poet), Mr. Cardenas acknowledged that many of his students had gained proficiency in a range of technologies through their participation in online communities and drew upon their expertise as he introduced them to new forms of composing with which most were not already familiar.

When I (Stephanie) interviewed one student, Casey, about her experiences in the class, she shared how she appreciated the way Mr. Cardenas respected the knowledge that students brought with them into the classroom and didn't "waste time" teaching the students skills they had already learned outside of school. Casey noted "Like he [Mr. Cardenas] knew that we use cameras outside of school. He knows that you [Casey and her fellow students] know how to use them." Furthermore, Casey valued how Mr. Cardenas pushed students to learn about new ways of using familiar equipment and tools to explore topics of interest, saying "He let us do our own topics and let us play around with the camera." Another student, Sabina, described how Mr. Cardenas incorporated new online literacies into the classroom in ways that valued what the students knew and positioned them as responsible. Unlike other teachers and her parents who she felt did not trust the students at the school to use the Internet appropriately without strict supervision and instruction, she felt that Mr. Cardenas created an environment where the students could learn to use the technology responsibly and in Sabina's words, "let us learn how to fly," something that she described as essential for the youth at her school to succeed in

our increasingly digital world.

Mr. Cardenas and his students drew upon the affordances of a variety of online resources throughout the academic year as the school newspaper developed from a print-based PDF posted to the school website to a series of audio and video podcasts hosted through a free third-party online classroom resource. The podcast project required students to create a digital and downloadable audio file of one of their news stories using GarageBand software[3] (http://www.apple.com/ilife/garageband), which Mr. Cardenas had introduced through a directed whole-class lesson. Just as with all new projects that Mr. Cardenas introduced, many students played with the format of the project in order to tell their stories in creative ways.

Rosy was one such student whose podcast documented the exceptional artwork of a student at the school. Through experimentation with the software, Rosy realized that she could use both iMovie and GarageBand together to create a video podcast. In her podcast, she juxtaposed an interview she conducted with the student artist with her artwork. In so doing, Rosy created a meaningful multimodal text that showcased the artist's work in a way that would not have been possible in a solely audio format. Rosy, who aspired to be a journalist, shared that the use of technology in the journalism and digital media studies class "open[ed] the doors to what is going to be in the future…Getting us prepared for what's going to come." In an era when traditional print newspapers are quickly becoming extinct, the curriculum that Mr. Cardenas designed clearly helped Rosy consider how she can blend her proficiency with online media and passion for journalistic writing. She was able to position herself as a "shape-shifting portfolio person" (Gee, 2002), with the ability to design and redesign her work processes and texts, a skill which some have argued will be essential for success in our emerging global economy (e.g., Gee, 2002; New London Group, 1996).

Marie was another student who played with the podcast project format, leading to the creation of a digital text that uncovered and critiqued concerns over the quality of the educational experiences available to students at East Side Middle School. In her core academic classrooms where the curriculum is mandated and designed primarily to prepare students for the state standardized tests, Marie, who is an avid writer and blogger in online spaces, often takes up the position of "disengaged student," especially when the task is a traditional type of print-based school assignment with strictly mandated parameters put forth by the teacher. However, this was not the case in the journalism and media studies class, as is exemplified in the way that Marie approached the podcast pro-

ject. For the podcast, she chose one of the topics offered by Mr. Cardenas, a new teacher profile, though she had the option of coming up with a topic of her own as well. Marie wanted to interview her new English teacher, the fourth teacher that the eighth graders on her track had that year. Marie developed a list of thoughtful interview questions which included "What made you want to teach at our school?" and "Are you still in teacher school?" When I asked why she inquired about whether he was still in school, she replied, "He doesn't look like he has a lot of experience." She went on to articulate her frustration with some of the English teachers who had taught at her school previously but was impressed with the fact that this new teacher agreed to come in during lunch and be audiotaped. Marie spent her own time during lunch recording the interview, editing her podcast, writing and recording an introduction and conclusion, and adding her own touches to the piece including music. Clearly, the social space of the journalism and digital media studies class allowed Marie to take up a different subject position than in her core classes, and the multimodal affordances of the podcast project allowed her to reposition herself as a "successful and engaged" student in ways not available in her core classes. The space also allowed her to critique the circumstances in her school, and design a multimodal text, which articulated what she saw as a grave injustice: that she and her fellow classmates in this under-resourced school are not provided with the experienced teachers who can give them the quality education they deserve.

The case of Mr. Cardenas' journalism and digital media studies class exemplifies how educators can make pedagogical connections with adolescents' evolving literacies through creating an authentic and meaningful workspace in which they can explore topics and issues of importance to them and share their thoughts through the creation of multimodal online texts. Mr. Cardenas' openness and flexibility to both ideas from other educators as well as the students in the class created a different type of space than the classrooms where students spent most of their day taking core academic classes. In these spaces, strict pacing plans and standardized curriculum provided by the school district were employed, and a majority of the students in the school were positioned as "underperforming." By contrasting these dominant school spaces and routines, Mr. Cardenas afforded diverse students at East Side Middle School opportunities to tell the stories that they wanted to tell in new and different ways, allowing them to reposition themselves as successful authors and designers, as they played with literacies and identities through their roles as new media journalists.

Blogging and Other Social Media in the Classroom

In my bright, sunny classroom at a new, arts-focused small high school in Brooklyn, New York, I (Tiffany) have a small but revealing window into students' technology interests. I consciously incorporate media and various technologies into my class projects, have more technology tools available than any other classroom in the school, and invite students to participate in social networking spaces (i.e., Facebook, AIM) with me if they choose. In practice, this means that students often work on laptops from the school's computer cart during class and that I let them "get away with" more time on their sidekicks than many other teachers would, often to the dismay of my administrators. Over the course of the year, I've found that interacting with students through social media has been one of the key factors in knowing them more deeply and also building trusting relationships.

Being the "techy" teacher means that I have a broader range of media resources in my room. Most visible is the stationary Mac tower with a large flat screen monitor in the back of my classroom. As a teacher of 12th graders with college applications due and a yearbook to design, I negotiated having this nice and more or less unclaimed computer moved into my room. Because of my willingness to let students on the computer for various reasons any time of day (before and after school, during free periods, and often even during a lesson), a student is working on that computer almost all of the time. No less significant is that I have two drawers of my desk full of technology: two "unlocked" laptops that are special because they aren't blocked by Department of Education Internet filtering software and can be used to access YouTube and social networking sites. We often call these the "good" laptops, simply because of their unrestrained access to tools we need and use. Additionally, my desk drawers hold my personal SLR camera, a digital video camera purchased with an educational technology grant, a tripod, a projector, and speakers for streaming music into the classroom. Thus, the technology in the cart and desk drawers are used in this English classroom in a range of ways—from class work to college work, personal communications, and a range of visual documentation, presentation, and entertainment purposes.

Media have a real presence in our school often in terms of the arts; however, media rarely enter into content area or literacy classes in ways beyond "typing up" papers or doing loosely guided Internet research. Of the various media projects that I've brought into my classroom this year, student-created blogs

(short for web logs, journal-like personal web pages) have become the long-standing form of classroom multimodal text production that I've introduced as an educator. Student blogs fit into the classroom structure primarily as a "homework" assignment, free-writing that I read and comment on digitally and assess solely on completion. A content analysis of my students' blogs found that they focused their writing on the following issues: academic or financial stress, high school graduation, college, friendships, dating, national politics, hobbies, special events, identity, other media (i.e., games, music, films), and a few students used their blogs exclusively for creative writing—poetry and short stories.

Other technologies are brought into the classroom with implicit invitation. I often observe students with personal communication devices out on their desks—SideKicks, iTouches, BlackBerries, or the like. Students use these devices in class for a range of activities—from cell phone text messaging to instant messaging (i.e., AIM) to blogging to even typing up papers or doing research for class. My students have learned that only answering their phones in class will garner much disciplinary action, as it is distracting to others and socially inappropriate. Otherwise, small communication devices and social networking are invited into the classroom space when they aid in learning or do not get in the way of it.

As an English teacher who is a bit unconventional in her curriculum (more a writing and media teacher than a literature one), it has taken some time for students not only to trust me as an individual but also to trust my methods as a teacher. When I first asked them to start blogging many students expressed extreme dismay. "Why do we have to write so much? Can't you just give us a quiz? What's the point of all of these writing projects? Can't we learn the material another way?" Some of my students were fairly resistant to an unconventional, writing-based curriculum and my department peers weren't quite sure what to do with it either. Often these students are the ones who have been successful in more traditional literature-based classrooms. Other students, ones who struggle with print, were visibly delighted in being able to type in whatever script they like on their blogs, post photos and videos, and so on.

One particular student, A'idah, often does not want to do the assigned work for class and asks if she can blog. I don't always allow it, but her class happens to be at the end of the day and many students cut class. One afternoon A'idah asked if she could take a short story written by Junot Diaz (1997) with her to read on the train and blog during class instead. I nodded my head, handed her an "unlocked" or "good" laptop and told her I would check three entries at the end of the period. I'd learned to give her a goal and check it, because sometimes

she only pretends to blog as she sifts through Facebook pages and music videos instead.

About midway through class, I sat down next to her and watched her type. She barely looked up but began to narrate without prompting. She said, "I'm trying to describe myself from the outside in." I watched as collected adjectives poured onto the page and she checked how they lined up visually next to the photo of herself that she'd pasted into the entry. Next, I watched her edit the html code in the entry, watched her delete the ads from the song she'd posted in the entry (from imeem, a social media outlet that allows users to watch, post, and share digital content). She didn't like how the ads cluttered up her post, so she went into the html code and started editing out the ads. She moved quickly and effortlessly in editing the code; however, when she had finished the html was broken. She said, "I hate that." I muttered, "yeah, me too, because I can never figure out where I broke the html when I was deleting stuff." Nonetheless, she persevered, quickly found the missing bit of code, repaired and published the entry. I was surprised when the next thing I saw on the screen was an entry that looked different than the one we'd seen in "preview"—the words didn't roll alongside the picture just as she'd planned. When I asked her about it, she shifted to the larger question of how limiting the blog layout was. However, she exclaimed she loved blogging despite these limitations. Of course, I asked why. She started talking rapidly, rambling on. I said, "This would help me with my dissertation. Can I take notes?" She nodded, watching me begin to type up her words as fast as I could. Here's what I wrote as she talked:

> I hate writing stuff on paper because I feel like my hands can't keep up with my thoughts when I write on paper. When I get to the end of the page with my pen, I feel like I lost my thoughts.
>
> I notice that I have more good thoughts when I'm on the Internet, clicking on stuff is more efficient than writing. I can get to everything I want on the Internet. If I click on Wikipedia I can get to what I want. I have more access to things like turtles...pet section. Plus online you can find a lot of other people who think the same thing you do. Google is my favorite thing. You can research forums and just anything. It expands my thinking more than books.

[She pauses; I redirect with "Why blogging?"]

> Blogging is more exciting than a journal because people can appreciate writing more than if it's in a book. I also feel like people are more apt to read my stuff if it's on the Internet than it's in a book.

She was talking about how great it was to write quicker than on paper and I was barely keeping up transcribing her thoughts. She asked as I plugged away transcribing in real time, "You writing all this?" I nodded and kept typing. "Cool"

she said. As she talked, she unplugged her SideKick from the wall, packed up her belongings, and when she'd said about all she needed to say, she mumbled toward the door, "Yeah, I'll text you Miss DJ, we can talk more about this when I get home." As she left, I handed her the short story and told her to read it on the train.

Audience is no small thing to A'idah. Her best friend often gets a shout out on her blog, and she was pretty delighted the day a girl she had a crush on began to publicly "follow" her blog. One afternoon, after I'd commented on something I'd liked in an earlier blog entry, she asked, "So do you really read all our blogs, Ms. DJ?" I said, "yeah." Her response: "You're a good teacher, Ms. DJ." I laughed, "so you like it that I read your stuff?" "Well a lot of teachers don't actually read stuff." Writers need readers and blogs are a good shot at making that happen, if an imperfect one. A'idah told me that her favorite entry of the day was the one titled "apathy," one that I suspect she wrote for the art teacher—a mentor of hers for four years who reads her blog and keeps telling her to move beyond her newfound apathy. Instead of simply moving beyond it, A'idah uses her blog to explain how her apathy is a matter of coping with stresses for her. Thus, the blog has provided a space for A'idah to connect through writing with a few trusted readers who give her feedback on dilemmas she has experienced.

A'idah's story is not unusual. Many of my students used the space of blogging to gain an audience of trusted readers—friends, teachers, and sometimes even parents and siblings. Throughout the year, student blogs have provided me as a teacher with a sense of students' emotional states and their practical progress through many of the stresses of 12th grade—high stakes high school exit exams, difficult classes, the college application progress, and more personal, individual issues. Thus, blogs provided a way to not only get to know my students better as writers and media-savvy young people but also enabled me to be a better advisor—to follow up digitally and in person, sharing in their successes and struggles and supporting students as they developed into independent young people.

Making Our Space by Engaging MySpace and YouTube

In a classroom context where new geographies of teaching and learning were being crafted on an ongoing basis (Vasudevan, 2009), the online literacies of both youth and adults played an important role. This was evident during a brief exchange I (Lalitha) witnessed while talking with two teachers one afternoon.

Joey, a young man who was 18 years old at the time, walked into Christina's office as she, Norman, and I were discussing potential candidates for the Digital Media class I was planning. Joey, who we all agreed should certainly be one of the participants, was finished with classes for the day and had come to hang out with Christina for a few minutes before he headed off to his internship at a media design company.

The four of us squeezed into Christina's office and Joey, a born storyteller, regaled us with the latest tale of his adventures around town. He told us that while riding the subway on his way home the previous afternoon, he started talking with a young woman whose cell phone he admired aloud. It was the latest SideKick, a newer version of the phone he currently owned. Being a tech savvy teenager himself, Joey felt he had found a kindred spirit as he observed her navigate her multifunction communication device with ease. Not wanting to lose touch, Joey and the young woman "swapped URLs" so that they could access and be linked to each other's MySpace profiles. The three of us listening to the story laughed out of curiosity, and Joey clarified that "they"—presumably, youth of his generation—are more inclined to share online profile information than phone numbers. He identified a shifting communicative lexicon that is readily emerging in the social practices of youth.

Far from being dismissive, however, Norman and Christina were engaged in the story and probed Joey further. They asked him about his online profile, made note of his URL, and agreed to "friend" him so that his profile could be linked to each of their profiles as well. These teachers, like many of the other teachers, counselors, and other staff members at Alternative to Incarceration Program (ATIP), also used the social networking site and actively communicated with others via their online profiles. Some of them were linked to participants via the "friending" function of the site. As Christina once noted, MySpace messaging was sometimes the quickest and most consistent way of contacting the participants when they couldn't be reached otherwise. I created an online profile for myself as a way to maintain contact with some of the youth, particularly after they graduated from the program, and found Christina's observation to ring true. Sometimes cell phones and home phones were shut off for periods of time, but the youth could always find a way to access their MySpace pages.

At the ATIP where Christina and Norman taught, and where Joey was a participant, educational classes were organized to support participants' preparation for the General Equivalency Diploma (GED) test. ATIP provided a range of services for youth who had been arrested and mandated to attend their pro-

gram by a judge, in consultation with a court representative who worked with the program. Only a small percentage of the mostly young men who attended the program already had their high school diplomas or equivalency certificates. Many had dropped out of high school prior to their arrest and most had a history of interrupted school experiences. However, many displayed a range of digital competencies including, but not limited to, participation in online social networking spaces. Amid a steady stream of photocopied math and grammar worksheets—that, on first glance, seem out of place in a context that places primacy on a holistic approach to education—are consistent pedagogical practices that draw on youths' digital literacies.

One afternoon, following the administration of a GED predictor that eligible participants take to assess their readiness for the GED exam a few weeks later, Norman was conducting a mini-lesson about basic economic principles. He asked the class of eight young men seated in the classroom what they knew about investing. There was a long pause, and then one young man asked for clarification: "You mean, like, how white people invest their money?" Norman, who was of South Asian descent and who had recently cut his long dreadlocks, looked at the young man wearing an over-sized plain white tee-shirt with curiosity. He probed for a longer response. The young man continued, "Cuz, people in the hood—they *wear* their investments." A smile began to creep across Norman's face and, seeing the computer lab unoccupied, Norman shifted the physical location of that afternoon's class across the hall. He asked Martin, the young man who made the observation about racial differences and investment strategies, to find evidence for his claim. A couple of the other participants sitting near Martin laughed when he initially logged into his profile. The humor was due in part to the cacophony between Martin's "tough-guy" pose seen in his profile photo and the good-natured persona he often displayed at ATIP. In response to Norman's invitation, Martin clicked on several of his friends' profiles, repeating "see?" after each one. As he brought up several images of youth adorned with large pieces of jewelry or pointing to customized accessories, Norman wrote terms on the whiteboard on the wall adjacent to Martin in a manner reflective of free association. He wrote "consumption" next to "supply/demand" and then underlined both with a double line and underneath wrote, "personal economics." During the next 45 minutes of class, everyone in class opened up their own MySpace profile and began identifying images that reflected some of the economic terms that Norman had highlighted. The room was filled with a steady stream of laughter as the young men looked over each other's shoulders, and as they waved

Norman over to share their visual artifacts.

The teachers at ATIP recognize the importance of the visual media for the youth who filter through their classrooms every day. They are equally aware that these youth are inhabiting and participating in a variety of digital spaces that are multimodal and online in some way. Similar to Martin's navigation of MySpace to support his economic argument, ATIP participants routinely brought up video clips they had either viewed or uploaded to YouTube, the video-sharing site. Like Frankie, the young woman who used her YouTube video to simultaneously communicate a narrative about her sexuality and her identity as a multimedia artist, other participants named and shared videos they found terrifying, funny, realistic, and unbelievable.

Along with Norman and Christina, Tony was another teacher at ATIP whose pedagogy was responsive to the cultural funds of knowledge that youth brought with them into the classroom (Moje et al., 2004; Moll, 1992). One of the classes Tony taught was Next Steps, a college preparation seminar designed to meet the needs of ATIP participants who either had obtained their high school diploma or who had taken the complete GED test. During one of the cycles of Next Steps that I documented, the writings of James Baldwin served as the main texts for the seminar. Tony, who had been teaching at ATIP for four years at the time, had begun to explore the visual realm in his teaching and was increasingly aware of the participants' familiarity with digital technologies and YouTube in particular. He began to incorporate this resource into his teaching as a way of illuminating the words and messages of a prolific author like Baldwin. By using a familiar resource like this video-sharing site, whose access is blocked in many public schools, Tony aimed to disrupt any dichotomizing that might have occurred between a revered author and current popular texts. In doing so, he was not merely using "out of school" literacies and texts to bridge "in school" objectives, but rather strived to construct a hybrid space constructed of shared understandings—amongst Next Steps participants and teachers—toward the realization of collective goals.

On one particular afternoon, this hybrid space lived in the context of Tony's office where he had access to his computer and loudspeakers. Rather than continue a discussion on the way Baldwin moved and held his cigarette during interviews, Tony shifted the location of class so that he could share a video of the author in different contexts. What ensued was a visual journey of representations of Blackness across various media clips found on YouTube. Table 1[4] offers an overview of this journey:

Table 1. YouTube Exploration of Representations of Blackness

Topic of Video Clip	Description' and Context
James Baldwin	James Baldwin being interviewed by Kenneth Clark about race in America—his own personal experiences, and his thoughts on the nation. A long list of related clips includes several different people talking about Baldwin. http://www.youtube.com/watch?v=Rt-WgwFEUNQ
Reflection on Baldwin and *Little Black Sambo*, by Margaret	A woman reflects on having James Baldwin as a houseguest, and her embarrassment at having her young daughter share her copy of *Little Black Sambo* with Baldwin. http://www.youtube.com/watch?v=47qAZWkwOaw
Little Black Sambo	An animated illustration of the children's book of the same name, noted in the previous clip. http://www.youtube.com/watch?v=qSfGvptL_TY
Tom & Jerry	A popular children's cartoon featuring a wily mouse, an easily duped cat, and a Black housekeeper (Mammy Two Shoes) who is always depicted from the shoulders down.
Jeffersons	George, the patriarch of a middle class Black family, living on the Upper East Side of Manhattan with his wife, Louise, and son, Lionel. They were prosperous enough to hire a housekeeper, Florence.
Good Times	A sitcom from the 1970s that portrayed a Black family, headed by Florida and James Evans, living in a housing project in Chicago, Illinois.
All in the Family	The show about Archie & Edith Bunker, a seemingly mismatched couple, living in a working-class neighborhood in Queens, New York. Archie's prejudice toward anything outside of his world view was the driving force of the show, which was the genesis of both *The Jeffersons* (a direct spin-off) and *Good Times* (a spin-off of *Maude*, a direct spin-off of *All in the Family*).
Cosby Show	A show about an affluent Black family living in Brooklyn, New York, made up of two professional parents—Heathcliff (Cliff) and Clair Huxtable—and their five children.
Sanford & Son	Another 1970s sitcom about Fred Sanford, an antiques and junk dealer, and his son Lamont.
Martin	A 1990s sitcom that focuses on the life of Martin Payne, a disc jockey and later television host, and his friends. Much of the comedy comes from Martin Lawrence's own stand-up comedy act.
Paul Mooney	An American comedian whose comedic material often addresses race in America, and which has been the object of critique and adulation.
Cedric the Entertainer roasting Secretary of State Condoleezza Rice	A clip of the White House Correspondents' Association annual dinner (2005) during which Cedric the Entertainer pokes fun at Secretary Rice by suggesting that she has two distinct personalities: her public persona and a second, which he demonstrates using racialized and gendered gesticulations. http://www.youtube.com/watch?v=T-bDO92S1jU

It was clear from Tony's enthusiasm and the ways he punctuated the video clips with commentary that this was a person and a subject for which he had great passion. Tony thought of himself as an artist and writer and used multimedia texts to elicit these and other identities from the young men who were enrolled in his classes. Tony's objective in this class session, and with his emphasis on Baldwin's work throughout Next Steps, was to illustrate the power of language for the youth seated around him. Not only did he share the writing of a beloved author with young men who had not been exposed to this work before, he also provided another way into *reading* Baldwin: by seeing and hearing the author,

and interacting with other media texts, which Tony felt reflected the lasting impact of this pioneering African American author.

Afterwards, Tony reflected on his decision to move the class to his office with a characteristic smile and look of amusement on his face. He was surprised that "it worked," referring specifically to the conversational rhythm and observational insights about the representations of African Americans across various media that emerged in between the collective viewing of clips. The young men in the class took a cue from Tony's engagement with and spontaneous analysis of the texts and began to share their own intertextual connections: comparing reruns of the *Cosby Show* with current representations of Black families; recalling the cartoons they had watched as kids when the clip of *Black Sambo* appeared on the screen; musing about the ways in which President Obama had been characterized in the news as, alternatively, "not Black enough" or "too Black." Many of the video clips that the group watched were not familiar to most other than Tony, but each was evocative of multiple connections and engendered further inquiry that was nurtured during the next several weeks of the Next Steps seminar.

Although YouTube was a familiar resource for the young men in Next Steps, the setting and purpose of this class session suggested new uses for this popular video-sharing site. This pedagogical move, reminiscent of recommendations for educators to effectively leverage the funds of knowledge about popular culture that adolescents bring into the classroom (Alvermann, Moon, & Hagood, 1999; Morrell, 2004; Staples, 2008), was consistent with Tony's objective to connect with the youth with whom he interacted every day. Even in his role as a teacher, he sought to be a "student of students" (Staples, 2005). Like Norman and Christina, Tony embraced spontaneity and play in his pedagogy. Multimodal play is a pedagogical stance that holds real possibilities for the youth at ATIP to be reengaged in their educational trajectories. This is an approach that is culturally responsive, digitally intuitive, and grounded in a commitment to teaching and learning *with* youth.

Creating Classrooms of and for Multimodal Play

We conclude this chapter by widening the lens once more to consider the vast landscape of the increasingly digitally mediated lives and literacies of youth. In their three-year study of the online habits of teens, Ito and colleagues (2008) found that youth regularly navigate various new media and technologies includ-

ing social networking sites, online games, video-sharing sites, mobile phones, MP3 players, and the like. While these artifacts of digital culture saturate the daily lives of youth, Ito and her colleagues assert that when youth engage in these practices and spaces, they are developing a range of social, intellectual, cultural, and technical knowledge that should not be dismissed. Thus, they argue, adults who impact the lives of youth—including educators, caregivers, and policymakers—must take seriously the ways in which "new media forms have altered how youth socialize and learn" (2008, p. 2). Their findings echo the arguments we have made in this chapter about the impact of youths' digital cultures and practices for literacy teaching and learning across contexts. As youth are engaged in the processes and practices of exploring, making, and remaking their identities across a wide array of representational modalities and spaces, both online and offline, the role of the educator becomes more complicated and, we would argue, ripe with possibilities.

In this chapter, we offered a brief look at three different classroom contexts in which we explored adolescents' online and digital literacies from a variety of perspectives. At the center of each example is the profound act of teachers and students *knowing* each other through multimodal play in order to teach and learn together. We invite readers of this chapter to consider the implications of these instances of practice for other settings, such as non-urban classrooms, school libraries, and after-school programs. We wonder how institutional spaces such as these might more effectively engage the digital knowledge and practices in which young people are *already* proficient. When educators are more aware of adolescents' digital literacies and composing repertoires, they can more effectively marry instructional goals that children and youth need to meet in order to successfully navigate formalized education with pedagogical agility that affords adolescents multiple ways to construct and represent knowledge. Thus, as our work and that of others (e.g., boyd, 2008; Soep & Chavez, 2005) suggests, educational institutions must become spaces that can more readily accommodate and encourage literacy experimentation, exploration, and discovery.

Notes

1. Mathangi (Mathu) Subramanian worked with Lalitha as a research assistant on the project Education In-Between: A *Study of Youths' Lives, Learning, and Imagined Futures within and across the Justice System.*
2. The class was referred to as an elective by school administrators though students were predominantly assigned to the class based on scheduling needs.
3. GarageBand is a software program available on Macintosh computers that allows users to

author various types of audio recordings by composing, recording, and mixing music.
4. This table originally appeared in Vasudevan, L. (2009). Performing new geographies of literacy teaching and learning. *English Education*, 41(4), 356–374.
5. Some clips were only played for a few seconds and thus not all of the clip URLs were documented accurately. Here, I briefly note the context for each clip that was viewed, drawing from field notes of the ongoing, intermittent discussion. I intentionally do not offer an extensive analysis of these clips but rather present this table to provide additional background for the Next Steps class.
6. A children's book that originally depicted a caricature of a South Indian child given the name "Sambo." In the 1930s, newer versions of the book gained popularity in the United States but were widely criticized for depicting racially insensitive stereotypes.

References

Alvermann, D. (2002). Effective literacy instruction for adolescents. *Journal of Literacy Research*, 34(2), 189–208.

Alvermann, D., Hinchman, K., Moore, D. W., Phelps, S., & Waff, D. (2006). *Reconceptualizing the literacies in adolescents' lives* (2nd ed.). Mahwah, NJ: Lawrence Erlbaum.

Alvermann, D., Moon, J. S., & Hagood, M. C. (1999). *Popular culture in the classroom: Teaching and researching critical media literacy*. Chicago, IL: International Reading Association.

boyd, d. (2008). Why youth (heart) social network sites: The role of networked publics in teenage social life. In D. Buckingham (Ed.), *Youth, identity, and digital media* (pp. 119–142). Cambridge, MA: MIT Press.

Burke, A., & Hammett, R. F. (2009). *Assessing new literacies: Perspectives from the classroom*. New York: Peter Lang.

Chandler-Olcott, K., & Mahar, D. (2003). Adolescents' "Anime"-inspired "Fanfictions": An exploration of multiliteracies. *Journal of Adolescent and Adult Literacy*, 46(7), 556–566.

Diaz, J. (1997). *Drown*. New York: Riverhead Trade.

Fisher, M. T. (2007). Writing in rhythm : Spoken word poetry in urban classrooms. New York: Teachers College Press.

Gee, J. P. (2002). Millennials and Bobos, *Blue's Clues* and *Sesame Street*: A story for our times. In D. E. Alvermann (Ed.), *Adolescents and literacies in a digital world* (pp. 51–67). New York: Peter Lang. .

Gee, J. P. (2005). Learning by design: Good video games as learning machines. *E-Learning*, 2(1), 5–16.

Goodman, S. (2003). *Teaching youth media: A critical guide to literacy, video production, & social change*. New York: Teachers College Press.

Hill, M. L. (2009). *Beats, rhymes and classroom life: Hip-hop, pedagogy, and the politics of identity*. New York: Teachers College Press.

Hull, G., & James, M. A. (2007). Geographies of hope: A study of urban landscapes and a university-community collaborative. In P. O'Neil (Ed.), *Blurring boundaries: Developing writers, researchers, and teachers: A tribute to William L. Smith* (pp. 250–289). Cresskill, NJ: Hampton Press.

Hull, G., & Katz, M. (2006). Crafting an agentive self: Case studies of digital storytelling. *Research in the Teaching of English*, 41(1), 43–81.

Hull, G., & Nelson, M. E. (2005). Locating the semiotic power of multimodality. *Written Communication, 22*(2), 224–261.

Hull, G., & Schultz, K. (2002). *School's out!: Bridging out-of-school literacies with classroom practice.* New York: Teachers College Press.

Ito, M. (2006). Japanese media mixes and amateur cultural exchange. In D. Buckingham & R. Willett (Eds.), *Digital generations: Children, young people, and new media* (pp. 49–66). London: Routledge.

Ito, M., Horst, H., Bittanti, M., et al. (2008). *Living and learning with new media: Summary of findings from the digital youth project.* The John D. and Catherine T. MacArthur Foundation Reports on Digital Media and Learning.

Jewitt, C. (2005). Multimodality, "reading," and "writing" for the 21st century. *Discourse: Studies in the cultural politics of education, 26*(3), 315–331.

Jewitt, C., & Kress, G. R. (2003). *Multimodal literacy.* New York: Peter Lang.

Lankshear, C. & Knobel, M. (2007). Researching new literacies: Web 2.0 practices and insider perspectives. *E-Learning, 4*(3), 224–240.

Moje, E. B., Ciechanowski, K. M., Kramer, K., et al. (2004). Working toward third space in content area literacy: An examination of everyday funds of knowledge and discourse. *Reading Research Quarterly, 39*(1), 38–70.

Moll, L. C. (1992). Funds of knowledge for teaching: Using a qualitative approach to connect homes and classrooms. *Theory into Practice, 31*(1), 132–141.

Morrell, E. (2004). *Linking literacy and popular culture: Finding connections for lifelong learning.* Norwood, MA: Christopher-Gordon Publishers.

New London Group. (1996). A pedagogy of multiliteracies: Designing social futures. *Harvard Educational Review, 66*(1), 60–92.

Pahl, K., & Rowsell, J. (2006). *Travel notes from the new literacy studies: Instances of practice.* Buffalo, NY: Multilingual Matters.

Ranker, J. (2008). Composing across multiple media: A case study of digital video production in a fifth grade classroom. *Written Communication, 25*(2), 196–234.

Schultz, K. (2002). Looking across space and time: Reconceptualizing literacy learning in and out of school. *Research in the Teaching of English, 36*(3), 356–390.

Skinner, E., & Hagood, M. C. (2008). Developing literate identities with English language learners through digital storytelling. *The Reading Matrix 8*(2), 12–38.

Soep, E., & Chavez, V. (2005). Youth Radio and the pedagogy of collegiality. *Harvard Educational Review, 75*(4), 409–434.

Staples, J. (2005). *Reading the world and the word after school: African American urban adolescents' reading experiences and literacy practices in relationship to media texts.* Unpublished doctoral dissertation, University of Pennsylvania.

Staples, J. M. (2008). "Hustle & Flow": A critical student and teacher-generated framework for re-authoring a representation of Black masculinity. *Educational Action Research, 16*(3), 377–390.

Vasudevan, L. (Under review). Education remixed: Digital geographies of youth.

Vasudevan, L. (2006). Pedagogies and pleasures: How multimodal play helps us reimagine and represent adolescents' literacies. Paper presented at the American Educational Research Association, San Jose, CA.

Vasudevan, L. (2009). Performing new geographies of teaching and learning. *English Education*. *41*(4), 356–374.

Ware, P. D. (2008). In and after school: Teaching language learners using multimedia literacy. *Pedagogies: An International Journal, 3*(1), 37–51.

Wesch, M. (2007). Web 2.0...The machine is us/ing us. Retrieved April 20, 2009, from http://www.youtube.com/watch?v=6gmP4nkOEOE

Wissman, K. (2008). "This is what I see": (Re)envisioning photography as a social practice. In M. L. Hill & L. Vasudevan (Eds.), *Media, learning, and sites of possibility* (pp. 13–45). New York: Peter Lang.

Wissman, K. (2005). "Can't let it all go unsaid": Sistahs reading, writing, and photographing their lives. *Penn GSE Perspectives on Urban Education, 2*. Retrieved July 11, 2008, from http://www.urbanedjournal.org/archive/Issue3/notes/notes0006.html

· 2 ·

Webkinz, Blogs, and Avatars

Lessons Learned from Young Adolescents

JANIE COWAN

"The work of literacy instruction is as much about listening and learning as it is about telling and teaching"
—KIRKLAND, 2007

The computer lab is pulsing and buzzing with palpable energy; the Webkinz Club is officially in session, and I am rotating around the room like an orbiting planet. Normally lethargic, exhausted kids from a full day of school sit in front of computer screens during this voluntary after-school club with rapt attention, bouncing in their seats and calling to friends across the room without moving their eyes from the screen. There is so much going on that I cannot keep up with it all; I cannot bear to take my eyes from them long enough to jot notes on the empty pad in my hands. My earlier suspicions regarding today's activities are once again confirmed—I am definitely *not* the center of attention this afternoon. Nonetheless, the kids seem pleasantly conscious of my presence and interested in engaging me in conversation as they deftly navigate Webkinz World (http://www.webkinz.com/). Unlike any other computer-focused after-school club I have ever "taught," this one is distinctly different; the members are not only "into" the activity—they are literally *in* it as they move their Webkinz avatars about the site. Club time passes quickly, and the call to log off is met with cries of dismay. As members reluctantly leave

the lab, plans to continue spill into the hallway: "I'll be on tonight at 8:00—meet me in the tournament area...or just call me in the green zone and you can come to my room....These students' plans will not involve cars, telephones, or even getting dressed: they are planning a virtual visit. Standing in the doorway of the media center, I am left to wonder...what has just transpired here? What made this afternoon technology experience so different from others we have enjoyed? What did I miss? And most importantly, why doesn't the *school day* feel this energetic?

Young adolescents such as these are active members of a participatory culture (Jenkins, 2006). Out-of-school literacies have expanded to include online activities such as instant messaging, blogging, gaming, website design, social networking, and participation in virtual spaces; students of all ages text message, transmit digital photographs, capture video, and download music. Virtual worlds, once largely the domain of older teens and adults, are now increasingly popular with young adolescents, and the online industry has responded to these young consumers with virtual sites geared to a younger teen and preteen audience such as Webkinz World (Ganz), Chobots (Vayersoft), and Club Penguin (Disney). As online activities rapidly occupy time once spent with books, educators are called to turn their attention to these engaging digital spaces. Students display multiple literacies and ways of knowing as they navigate hyptertextual environments requiring skills other than those traditionally associated with school sanctioned literacies, enjoying a sense of personal agency often denied them during the school day. Although digital literacies have been researched with older adolescents, these literacies remain relatively unstudied in the young adolescent age group. Virtual worlds also remain largely unstudied among young adolescents, yet such research may offer rich opportunities to gain insight into how students use multiple literacies as they interact digitally in virtual spaces.

Multiple Literacies and the "Digital Divide"

I approach this study from the research perspective of a school library media specialist. Often asked by classroom teachers and technology specialists to collaboratively develop and teach curricular lessons linked to state performance standards, I seek to design experiences for our students that engage them. However, we often seem to fall just short of these goals with our young adolescent students; the 11- and 12-year-old set is just not easily impressed. I have long suspected that their out-of-school literate lives look very different from the lit-

eracy and learning experiences we attempt to pass off as "cool" in school, and these savvy digital natives (Prensky, 2001) are getting restless. The seemingly unsurpassable "digital divide" (Honan, 2008) between home and school has been the topic of research over the past few years, with notable contributions to the field. Although the term *digital divide* typically refers to issues of technology access and availability, it is also an apt description for the frequent disparity between home and school literacies. Schools, however, bear some responsibility to bridge the home-school literacies gap. Luke and Luke (1995) suggest that schools should become the "crux" where both students *and* teachers develop practices for exploring these multiple literacies, warning that failing to do so puts schools at risk of transmitting "simulated competencies to nonexistent subjects" (p. 378). Alvermann and Hagood (2000) call for school communities to engage in a joint effort to blur the binaries of in-school and out-of-school literacies and narrow the digital divide. The need for *authentic* experiences in schools that offer students opportunities to "be" in real-world situations as much as possible is increasingly important in the face of a rapidly changing global world.

In this chapter, I seek to fill a gap in the literature as I explore the observations, responses, interactions, and literacy engagement of 20 young adolescents (ages 11 and 12) during an eight-week after-school club. Navigating the virtual spaces of Webkinz World (http://www.webkinz.com/) and Chobots (http://www.chobots.com/) with my young participants, I seek to address the following research questions: How do young adolescents use traditional literacies such as reading and writing in virtual spaces? What other literacies do they employ in their virtual engagement? How do young adolescents exercise personal agency within these spaces? How do they engage with others in virtual spaces? And finally, how do young adolescents perceive the possible underlying ideologies of virtual spaces?

Conceptual Framework

I conceptually frame this study within the tradition of sociocultural and critical theory. Drawing upon the work of Gee (2004) in the field of literacy education and cultural studies, I view student engagement in virtual spaces as a socially and culturally situated literacy practice. In the course of such literacy practice, participants display multiple literacies as they both transact and interact within the multimodal text of virtual worlds. Within a framework of critical theory, I consider website construction and participant experience from a

somewhat Marxist perspective as I examine issues of power, authority, and ideological perception.

Critical theory offers a useful lens through which to view both participant responses and the virtual spaces themselves. Critical theorists such as Apple (1979) and Williams (1977) recognize the important role of underlying and often imperceptible ideology in communicating values, meanings, and beliefs through text. As both researcher and participant, I attempted to remain attentive to the possibility of ideology at work as we explored these virtual worlds, noting the extent to which participants were able to exercise agency in opposition to the assumed modes of conduct within the virtual space. I was also interested in seeing how my young adolescents may "read" or perceive any unspoken "rules of participation" within their experiences of virtual spaces. Through a combined lens of critical literacy and critical media literacy, I seek to address possible power relationships involved in the design and experience of these spaces from multiple perspectives, with particular focus on audience or participant perceptions.

Virtual Worlds—"Bending Culture"

A fair amount of research has focused on the use of Internet websites in sanctioned educational contexts. Less attention, however, has been given to popular websites that young people use for "unofficial purposes"—those termed "unsanctioned" by the school community (Stone, 2006, p. 53). Virtual worlds seem to push the definition of non-traditional websites a step further. Participants in virtual spaces essentially "write" the fluidly enacted script in real time as movements, interactions, and responses become "text." Unlike other print- or image-based interactive websites, virtual worlds allow participants to choose how they will "physically," visually, *and* verbally engage others in a non-gaming environment via an *avatar*, or self-selected representation of themselves. Drawing upon the work of Lankshear and Knobel (2002) in the field of New Literacy Studies, the increasing presence of video gaming, instant and text messaging, blogging, website activity, and online social networks in the lives of young people both in and out-of-school underscores the need to expand the limited, traditional definition of text as print to include digital elements such as video, pictures, sounds, hyperlinks, and moving figures. Work within the New Literacy Studies demonstrates the additional need to expand our idea of *literacy* to include the skills necessary to successfully navigate digital spaces. Street (1984) suggests that there is no one "singular phenomenon" that is literacy, but

there are as "many literacies as there are social practices" (p. 1).

Recent research indicates kids are flocking to virtual worlds in record numbers. Studies from the University of California-Irvine, the University of Southern California, and Iowa State University reveal 34 percent of American children and teens using the Internet visited a virtual world at least once a month in 2008 (Hendrick, 2009). Eager to exercise personal agency often denied them at home and school, young adolescents use virtual worlds to enact new and fluid identities as they earn, spend, create, sell, work, play, interact, and travel. The shift in interactive social technology from the "single track" communication style of phones, email, and text messaging to complete virtual enactment via a self-selected "avatar" chosen to personify the participant implies what Kelly (2008) refers to as a "cultural bend." No longer revolving around the spoken word or image directed at intended recipients, communicative participation now involves "being there" in real time, with many others—known and unknown. Eager to communicate with others in the most immediate ways available, members of today's participatory culture (Jenkins, 2006) are turning to virtual Internet websites in record numbers.

Student Perspective

Despite evidence that a large percentage of young American adolescents engage in online activities out of school (Lenhart, Madden, Macgill, & Smith, 2007), they are infrequently asked to weigh in on matters of digital literacy. Alvermann (2008) suggests that the process of theorizing adolescent online participation is incomplete without the inclusion of student voice and opinion. Students continue to become literate in new technologies outside school walls, regardless of education's acknowledgment of these literacies. In a study entirely focused upon young adolescent student response to education and technology issues, Spires, Lee, and Turner (2008) found that middle grade students *want* to bring their out-of-school literacies into school to increase academic engagement. According to Spires and his associates, students clearly call for greater participation in their own education in "real-world" contexts, constructing interactive, media-oriented ideas about technology uses for schools. Student participants expressed the desire for technology experiences in school that will prepare them for future jobs, noting a discrepancy between home and school digital opportunities. Interestingly, students also expressed understanding of the necessity of Internet security, citing potential predators and inappropriate content as areas of concern affecting school web access.

The Webkinz Club Journey

The journey to The Webkinz Club began with a series of interesting posts to my recently developed webpage blog. Launched a year ago, the media center blog continues to capture the responses of our school community to various things I simply wonder about, such as reading preferences, opinions of movies spawned from books, or out-of-school digital activities (Cowan, 2008). A question about website preferences garnered more responses including exclamation points and smiley faces than all of the other questions combined. Posts about websites featuring virtual worlds such as Webkinz World (http://www.webkinz.com), Chobots (http://www.chobots.com/), and Club Penguin (http://www.clubpenguin.com/) popped up regularly, with Webkinz topping them all. Curious to know more about these possibly entry-level virtual worlds for young adolescents, I decided to go directly to the source for more information. Capitalizing on the ready resource of diverse, restless, and willing 11- and 12-year-olds in our after-school program, I sought to invite some young experts to the media center computer lab for a little exploration outside of the regular school day.

"This Has to Stop NOW": District Permissions and "Unsanctioned" Web Spaces

It is advisable to begin any endeavor involving schools and students with the proper permissions in place; I therefore approached both local and district level administration and technology coordinators with the idea of forming a voluntary group of students to explore virtual online spaces during after-school hours. Following the assurance that proper parental permission would be secured and that regular instructional activities of the school day would remain intact, I was granted permission to invite young adolescents to participate. However, both local and district administrators expressed concern that the students would be "properly monitored" during these sessions, indicating some hesitancy and reluctance to turn the students loose in virtual worlds potentially unattended. Once again, I assured these officials that while I could not possibly control each mouse click in the computer lab, I would certainly remain attentive to what transpired during our time together—the students' activities and responses would be the very focal point of the club. Additionally reassured by secured parental permission, district personnel granted what was to become a charter for "The Webkinz Club."

Research regarding student online behavior demonstrates an occasional dif-

ference between the beliefs of school district leaders and the reported experiences of students and parents. School districts, rightfully concerned about student safety and their own liability, are often reluctant to incorporate social networking sites into the school environment, despite evidence from parents and students that participation in these sites has not actually generated problem behaviors (Grunwald Associates, 2007). This concern became evident as I sought technical access to virtual sites on campus. Despite initial district level conversations, I later discovered that access was blocked to *all* of these virtual sites on the school server via a filtering system. Through properly channeled follow-up requests, I eventually obtained access for Webkinz World and Chobots and limited access for Club Penguin. Ultimately, bringing all these virtual sites to full access and performance would require more technical time and attention than the school system could afford to give for a "nonschool-related activity," as per conversation with county personnel. Interestingly, I later received a direct personal phone call from a district level technology coordinator informing me that "this had to stop *now*." I could no longer solicit help from school or county level technology specialists for these virtual sites, as the system was "not in a position to support" such activities, and could not be "held responsible" for access to unsanctioned virtual sites at school.

Responses such as these seem to indicate a privileging or sanctioning of some sites as appropriate for school use and some as inappropriate. As the definition of "literacy" continues to expand, perhaps school systems will feel more comfortable allowing previously banned sites into the schools. As Stone (2006) aptly states, "little attention is paid to developing young people's critical readings of websites"(p. 53); critical analysis is not possible if sites are not available for discussion and review. However, there may be an even more compelling reason to allow the exploration of virtual sites in schools: they may very well be the next logical step in creating educational experiences that transcend the limitations of even our current digital capabilities. More discussion of these possibilities will follow as I later consider the implications of virtual world sites for education.

My Young Digital Teachers

Information was collected from students aged 11 and 12 during a series of eight after-school club sessions. Having procured the appropriate parental and student consent, a core group of 10 male and 10 female students (a favorable coincidence) eagerly joined me in a weekly club focusing on the online virtual worlds of Webkinz, Chobots, and Club Penguin (included in the invitation

despite limited school access, as I wanted to gather *comparative* information from the students regarding their outside engagement with this site). I was also pleased to see ethnic and socioeconomic diversity in the sample group, despite the school's predominantly white student composition (see Tables 1 and 2). It is interesting to note that no parents expressed concern regarding either their children's potential misconduct within these virtual spaces or my ability to adequately monitor their activities—a concern expressed by district personnel prior to the study.

As both researcher and club participant, I circulated around the room jotting down observations and student comments, interacting with students, asking both spontaneous and planned questions as they played in these sites, and taking instructions from students as I played in these sites myself. Students also responded to a set of questions posted on my webpage concerning the number of Webkinz toys they owned, the amount of time they spent per week on virtual sites, and other general questions about the sites and their participation. However, the largest portion of data was gathered during the sessions themselves as I sat among them or gathered them around to give *me* mini "lessons."

The data collected from these sessions were analyzed using thematic content analysis. Often described as a research technique for making valid and replicable inferences from texts, thematic content analysis offers a useful way of assessing trends in the observational and written data gathered from participants and drawing preliminary conclusions. All field notes, observations, and interviews were coded; the data were then grouped into themes and categories for analysis and discussion. Due to the qualitative focus of the study, quantitative information such as the number of Webkinz owned or the amount of time spent on virtual sites was simply charted or tallied for comparison.

To add another perspective to the study, several parents were also interviewed outside of regular club time to gain additional information on young adolescent participation in these virtual worlds. Transcribed interviews and field notes from these conversations were also analyzed qualitatively using thematic content analysis.

"My First Virtual World"

Described as "my first virtual world" by 12-year-old participant Julie, Webkinz World seems to be an entry point for many young adolescents to the virtual landscape often viewed with trepidation by parents. Although not professing to be a true replication of society, Webkinz World does offer many components of daily life for young members. Within the "walls" of Webkinz World, partic-

ipants navigate from place to place via a virtual representation of their pur-
chased Webkinz pet, which functions as an *avatar*. Webkinz members may
design a room for their pet, maintain responsibility for its care, read the daily
"Newz," watch "TV shows," play online games or take educational quizzes to
earn cash (KinzCash), purchase items and services, work at a "job," take a vaca-
tion to various destinations, host parties, invite others to visit their "rooms,"
make and share short movies, compete against other Webkinz members in tour-
naments, and use virtual cell phones to chat with friends.

Launched in 2005, Webkinz World continues to gain popularity with the
upper elementary and early teen crowd; CEO Howard Ganz stopped publicly
commenting on Webkinz profit after 2006, when sales had topped the 1 mil-
lion mark. High usage statistics for virtual sites such as Webkinz (2.8 million
unique visitors in 2006–2007) indicate that these sites successfully "meld"
online and offline worlds (Tedeschi, 2007). Beyond simple product synergy (a
marketing term for the simultaneous release of branded merchandise), Ganz
Corporation's Webkinz site demonstrates a possible societal tendency to incor-
porate online activities into "real" life; for Webkinz owners, a stuffed pet may
be enjoyed both physically *and* virtually. This blended duality of experience is
nothing new to the adult set: adults using virtual worlds regularly "meet" oth-
ers online and extend these relationships in person, business is transacted
online and "realized" face to face, and companies such as Monster.com facili-
tate offline employment activity. Given this new "ethos" or mindset that con-
tinues to blur the boundaries of online and offline activity in daily life
(Lankshear & Knobel, 2006), it is not surprising to see virtual worlds gain
increasing participation; living life is becoming a seamless enactment of
online/offline behavior. It is also no surprise to see young adolescents function-
ing naturally in this "seamless" environment, as indicated by the conversations
of Webkinz Club participants cited in the opening section of this chapter.

Let the [Virtual] Games Begin

The students and I quickly fell into this sort of "seamless" environment on our
first day of The Webkinz Club. Following an initial group meeting to generate
a few ground rules—no "dissing" (insulting) others, patience with computers
(!), no calling across the room (which they soon found too difficult to follow),
and sharing Ms. Cowan's time with others—we were ready to enter Webkinz
World. I found it interesting that club members brought their "real" Webkinz
with them to the club, placing them strategically on tops of computers, in their
laps, on their heads or shoulders, and beside their keyboards. Boys and girls alike

eagerly logged into Webkinz World, and I spent most of that first day learning the basics as I circled the room. Subsequent group conversations during club sessions, as well as individual interviews with participants, yielded information regarding the extent to which these young adolescents are immersed in the world of Webkinz.

Based upon interview data, I assembled the responses of 10 regularly attending male and female club members regarding their extent of ownership and participation in Webkinz World (see Tables 1 and 2 for individual participant responses). Female participants appear to spend around three hours a week in Webkinz World, owning anywhere from one to fifty-two of the Ganz plush pets. Male club members seemed to generally own fewer Webkinz and spend less time on the website, reporting an average of one to two hours per week playing with one to thirty-seven pets. Both groups occasionally cited Club Penguin as "more fun" because it imposed fewer restrictions regarding movement, interaction, and chat among participants. Two female participants mentioned a recent preference for other social networks such as Facebook (http://facebook.com/), enjoying the exchange of pictures and "real-time talking." "In Webkinz, you can't use your own words," Chloe says. "It feels a little phony." It is interesting to note that although interview questions focused primarily on activity in Webkinz World, participants continued to compare this site to Club Penguin (see comments in Tables 1 and 2).

Parental Involvement in Webkinz World

Parents, it would seem, have a strong interest in their children's participation in Webkinz World. According to Marcia Turner (2008), author of *The Complete Idiot's Guide to Webkinz*, Webkinz World offers "a wealth of online activities…many of which are at least partially educational," designed to "strengthen keyboard skills," "work on spelling and word formations," and "improve memory skills" (p. 3). Turner's book, clearly targeted at parents, covers the ins and outs of navigating Webkinz World, offering written and illustrated instructions for every game and task. Citing the purchase of a Webkinz as an "accomplishment" of which one should be "proud" (a somewhat disturbing, middle/upper class sort of view, through my critical lens), Webkinz World is touted as a place "where all the fun is." However, in talking with the kids, I discovered that *none* of them own this book, nor do their parents. Interestingly, all but two participants report their parents "not even knowing if I am registered or not." However, two participants had parents who played in the site

themselves (calling the student's earlier comments about parental knowledge into question), and one of these parents actually had her own Webkinz account. The Webkinz website itself features an extensive parent section with information regarding password safety, laundering instructions, user agreements, and suggestions for "limiting your child's computer time." Aside from the limitations placed upon users by the site creators, such as a selection list of words and phrases to use in "chat," parents may further restrict a child's ability to chat with self-created text. However, even the full chat permissions allow only words in the Webkinz "dictionary," excluding such words as "boyfriend." Student participants were surprisingly accepting of this; I later learned that many of them use other social networking sites such as Facebook (http://www.facebook.com) for unrestricted conversation. Interestingly, the unrestricted chat capability of Chobots attracted many club members outside of school; one student was actually banned from the site for engaging in language deemed inappropriate by site moderators. However, another student reported personal discomfort (and parental restriction) after an incident of language toward her from another avatar. (I noted this apparent interest in Chobots for possible subsequent exploration.)

During the course of the study, I was able to talk with a few parents of Webkinz Club participants. Citing the "educational value" of Webkinz World, these parents applauded games on the site that teach typing skills and the emphasis on responsibility inherent in caring for pets and purchasing necessities. Parents also favored the "economy" of Webkinz World, feeling that it forced kids in a "real" situation to earn money, spend money, and make discriminating financial decisions. Parents interviewed also seem to feel that Webkinz is a "safe" place for their children to interact with others due to the permissions requirement for unscripted chat, as well as the site monitoring feature for unapproved language. Adults also noted the "warm, friendly, happy" feel of Webkinz World—an almost "Disneyesque" environment with few truly negative consequences (see Figure 1 on p. 46). Although pets can "run away" if unattended, no Webkinz pet can ever actually "die"; interestingly, only failure to purchase subsequent pets can separate a child from access to his/her pet.

Parents do involve themselves heavily in the world of Webkinz via their wallets—the average Webkinz Club participant (from a predominantly upper middle class school population) owned over 20 Webkinz plush animals retailing at around $15 each, with some owning as many as 80. A few parents also purchase magazines, trading cards, and other Webkinz-related products that can be registered in Webkinz World for KinzCash, the local currency.

Pay to Play: Access and Social Justice

Since you must purchase a Webkinz toy with a coded pet tag to register in Webkinz World, it appears that this virtual world is a "pay to play" environment. I noted this distinctly as our lively club met one afternoon, joined by a young lady new to the school. The room grew uncomfortably silent for a moment when 11-year-old Eliyah turned to me from her computer screen and said quite poignantly, "*I* want to adopt a pet, too." Other students paused, turning from their screens to look both at her *and* at me for a response; the kids knew that she would need the numbers from a new Webkinz tag to play. Having just received the gift of a Webkinz penguin from another student that had not yet been registered, I was delighted to share so our new friend could join in. Yet, that moment served to bring the question of access to the surface in our group. I revisited this topic the following week during a brief pre-session club meeting (Eliyah was absent that day), asking members how they felt about the "pay to play" idea. One particularly thoughtful member reflected upon her raised consciousness since our last session: "I feel bad complaining about expiration dates when others do not even have a pet at all." I left the club that day wondering if group participation in a virtual space might also have real-world implications for larger issues of social justice.

The Social and Economic Ethos of Webkinz World

Webkinz World appears to be essentially cast in the glow of middle and upper class life. Although members may interact through visits, chats, and group games, there appear to be limited meaningful opportunities to function in Webkinz World beyond personal acquisition. The most popular choice with our club members by far was participation in one of the large arrays of individual and group games or tournaments. Interestingly, site members may also choose to take an educational quiz (a strong preference of parent participants) or to visit the Employment Office for a job assignment. My young club teachers strongly discouraged this route, as it was "a waste of time, and did not pay enough." Choosing to visit the office anyway, I found a Webkinz Job Board listing various employment opportunities such as "hamburger cook," "fence painting," "mail sorter" [for KinzPost], or "flooring assistant." Given the generally blue collar nature of available jobs, I can see why members chose other routes to earn money: I wondered aloud why there were no positions available for teachers, physicians, or attorneys. "We don't need any of those in Webkinz

World, I guess…" replied Steven. Although this sort of answer does not surprise me coming from a young adolescent, it does spur some thinking regarding the potential of virtual sites to teach real-world economics: what would happen if kids could navigate a real societal simulation, complete with job responsibility, accountability to the law, or taxation?

Upon logging in to Webkinz World, members are greeted with an updated *KinzVille Times* newsletter (see Figure 2 on p. 47) enticing participants to purchase Webkinz-related products with *real* money—a shift from the virtual purchasing power used within the rest of Webkinz World. This page also offers advice on the newest virtual (and free) games and activities within the site, the status of owned pets (mine was a bit hungry and unloved this day), and winning scores for recent group tournament games. A gallery of "My Stuff" displays across the bottom of the screen a silent inventory of my Webkinz World acquisitions. Clicking "Things to Do" offers a menu of activity choices, such as visiting one of 75 various "rooms" in the clubhouse. Within these rooms, Webkinz avatars interact and chat with one another or leave the room to compete in games together. My gray cat avatar enjoyed a visit with a little black dog, chatting about favorite activities in Webkinz World (see Figure 3 on p. 47).

Authority: The Unseen Moderator

According to the Bulletinz link on the Webkinz site, Ganz employs an array of "technical wizards, creative writers, awesome artists, and terrific support people" to administer Webkinz World. Although these site moderators are relatively invisible to the end user, members in Webkinz World do experience the effects of their control as they navigate within the website and seek to personalize their avatar and its environment. This authority is clearly evident in the Webkinz Studio, a purchasable item (with KinzCash) in Webkinz World's virtual store, the W Shop. For 1,000 KinzCash, members may set up a movie production studio in their own Webkinz room to create and produce a short video. Although participants are required to select sets, props, actors, and scenes from a bank of choices, they may type in authentic dialogue for their characters (within the scope of acceptable Webkinz language) and edit up to 15 scenes for overall effect. Pending dialogue approval from the above-mentioned Ganz support team, member-created videos are archived and available for view by the larger Webkinz community. However, these unique, elaborate, and very individualized productions are immediately co-opted by Ganz, as stated in the site user agreement: "Upon submission, all creative suggestions, ideas, notes, art-

work, drawings, stories, room designs, concepts…submitted by you to Ganz shall be deemed to be…the property of Ganz" (http://www.webkinz.com /us_en/).

I asked the Webkinz Club how they felt about this appropriation of their creative property one Tuesday afternoon as they taught me to make a movie. "It isn't fair," said 11-year-old Susan. "We do all the work, and they get all the credit." "Yeah," chimed in Steven. "I bought the Webkinz…they got their money. Why can't I use the website however I want?" Some students confided that they share their information with others regardless of Webkinz' alleged "authority": "No one can stop me from showing everyone else what I do anyway," said 12-year-old John. "So what if my name isn't on it." Interestingly, my young digital teachers were not deterred by this and other impositions in Webkinz World; they had quickly determined what they term "the deal" with Webkinz World, and actively, persistently worked to circumvent site limitations to their advantage. The desire to create and share strongly overrode any site restrictions and "rules." This focused determination and savvy problem solving were something to behold; my inner researcher pondered how this might be tapped for school-day activities.

Agency: The Power of Choice

The issue of personal agency within Webkinz World quickly rose to the surface in our conversations and play, especially in the area of avatar movement and conversation. "I can't do anything but jump and walk around," says Connor. "And I can't ever say anything *real*." However, the young man did enjoy hosting a "party" in Webkinz World, inviting all of his virtual friends to his football-themed room and serving food items from his personal refrigerator to guests. Although he complained about the unpredictability of the site (it often froze, or a room "closed"), Connor seemed to feel satisfied with the experience of watching his buddies roam around his own private virtual space. I wondered how these kids would have interacted at this party had they been able to live chat and move about with less restriction and decided to raise the question at one of our sessions. Responses were enthusiastic: "We would have played my air hockey game!"…"We needed to talk about what we wanted to do"…."We would try to spy on my sister!" Although these and other club participants acknowledged the many restrictive features of Webkinz World, they still reported spending anywhere from 30 minutes to several hours per week on the site (see Tables 1 [p. 45] and 2 [p. 46]).

Blogging to Extend Conversation

Around our third session together, I began to notice a concern among participants that others were "left out" of our club. Aaron posed an idea one afternoon during a pre-session group chat: "Hey, Ms. Cowan—I have a bunch of friends that own a lot of Webkinz and play all the time…we should ask them stuff too." After an animated discussion of their respective friends' activities in virtual spaces, as well as our inability to accommodate all of them in our after-school club, the kids decided to launch a new blog from the media center webpage to invite outside participation. Blogging, a practice already enjoyed by our school population as a means of weighing in on various topics (Cowan, 2008), seemed a viable, immediate, and popular way for the club to share knowledge, invite participation, and gain further perspectives about Webkinz and other virtual worlds. Questions crafted by club members for this blog included topics both general and specific: *How many Webkinz do you have? What are your favorite games? How often do you visit Webkinz World? What would you change about Webkinz World? Which games earn the most KinzCash? Will your parents let you chat? Have you gone on vacation* [in Webkinz World]? Although many responses to the blog included stories of Webkinz World or lists of favorite Ganz pets, posts frequently included comparative tales of participation in other popular virtual world sites such as Club Penguin and Chobots. According to the blogging community, these sites offered more freedom and opportunities for virtual participation than Webkinz World. Club members reviewed and responded to these posts, acknowledging that these other sites were indeed less restrictive to participants. Following group discussion and consensus, The Webkinz Club decided to attempt to access the intermittently available Chobots site for group exploration at school. Our next Tuesday afternoon session proved to be especially energizing, as we hit upon a window of availability in Chobots, with "groundbreaking" results.

"Slipping the Surly Bonds of Earth": Gardening in Chobots

It is 3:30 P.M. on a Tuesday afternoon: "Hey, Aaron, come over here and hand me that shovel. We need to turn the dirt over before it rains….Josh and Aaron are growing peanuts on an 8'x10' patch of "soil" in one of the many cities in Chobots. The Webkinz Club is once again in session and enjoying the good fortune of accessibility. "No, Josh, we need to start over there," Aaron replies. "Hey, here comes Ben—hey Ben! Is that your Chobot? Are you 'Rob02?'"Aaron calls over his shoulder to another student in the computer lab (so much for our

initial rules). Ben's avatar, Rob02, joins his friends on the screen, and the three of them negotiate the garden plot. "I want to come!" shouts Lena. "You have to be in the right city..." "Hey, how much fertilizer are we supposed to apply to this soil?" "Click on the seed catalog and read the directions—bring it over here..." (Student's avatar moves across the screen and hands a virtual catalog to someone else's avatar.) "I'll minimize this [screen] and google 'peanuts' to see if I can find out..."And so the conversations continue as the group communally completes the garden preparation. The kids were gardening in cyberspace; they had essentially "slipped the surly bonds of Earth" (Magee, 1941)—the physical limitations of time and place—to cultivate a virtual garden. I am invited to join them, and soon "librarylady" shows up to lend a hand. Aaron (usually a shy young man) assumes leadership of the garden, assigning Josh the task of "finding out stuff" about peanut gardening before the next club meeting. We all pledge to "be there" tonight to confer about subsequent garden work, as the club does not reconvene *in person* for another week.

Our club session stayed with me that evening, and I did show up in the virtual garden as promised. My students were there as well, though many flitted away after a time to visit other Chobots "cities." It occurred to me as I watched these young people move freely about the virtual space, choose their activities and level of participation, receive assistance from and collaborate with others, and consult with multiple sources of information that virtual worlds may offer education more than we realize. During our eight-week club, the kids and I had explored some important aspects of online participation in virtual worlds together, and several ideas have emerged as a result of our playful collaboration.

Epistemologies and Stratification at Work

There seems to be an undeniably collaborative and communal mentality associated with virtual world participation. I observed teaching and learning as often simultaneous and fluid, occurring *at the point of need*. Roles frequently shifted, as students (and teacher) perceived during the school-day environment to be one "sort of person" constructed themselves to be a "different sort of person" in the discourse of our virtual worlds. Stronger students both academically and behaviorally occasionally assumed the role of follower, and less assertive students stepped out to leadership. School-day assessments of "ability" seemed to blur as well, with those labeled to be of "lower" ability and performance demonstrating an impressive use of applied vocabulary, inference, synthesis, and analysis. Normally sullen or quiet youth spoke to others across the room (a

breach of protocol that later became acceptable) in an engaged, helpful, animated, and positive manner. Young adolescents were observed drawing upon multiple literacies (Thomas, 2007)—both traditional, school-based literacies ("seeds germinate before they sprout") and non-traditional, unsanctioned literacies ("avatars move using left-right and up-down arrow keys, Ms. Cowan")—to problem-solve new, authentic situations. This inherent leveling of academic and social strata made it possible for us to come together in a virtual space to gain new skills and knowledge. Those adept in the navigation of virtual worlds may indeed possess the greatest future cultural capital—that of adaptation and hybridity.

Site Construction and Ideology

From a critical perspective, Webkinz World appears to be essentially based upon an ideology of production and consumption; young adolescents are positioned as consumers within this virtual space, "earning" and "spending" virtual money to purchase items for themselves or their Webkinz avatar pets. Governed by an unseen body of site moderators within the parent company (Ganz), Webkinz World grants participants limited agency regarding movement and conversation; creative items produced by participants (such as videos) are publicly distributed via the site, yet Webkinz (Ganz) retains ownership of all content. Unlike other virtual spaces such as Chobots and Club Penguin, entry into Webkinz World depends *entirely* upon the outside purchase of a stuffed Webkinz toy containing a necessary admission code. Although site participants enjoy the many entertaining features of Webkinz World, it is undeniably evident that this virtual space ultimately exists to encourage Ganz purchases.

Parents, however, did not appear to share this ideological perspective of the website. Based upon field notes and interview data, parents in the study seem favorably supportive of their children's participation in the economy of Webkinz World, citing its "educational value" and "real-world" opportunities to earn, buy and sell. Appealing to the "safe, friendly" environment of Webkinz World, parents termed involvement in Webkinz World a "wholesome" activity.

Student participants, on the other hand, demonstrated a surprising level of general consciousness regarding the consumer-oriented ideology of Webkinz World. Interview transcripts and observational data reveal participant comments concerning pay-to-play access, site ownership of user-created media, and limited personal agency within the web space regarding movement, conversation, and room construction. Several participants indicated resistance to site

authority, voicing an intention to "do what I want" by attempting to circum-vent site restrictions. Others responded with conscious compliance despite a critical reading of the site; these students claim to "know the deal" with Webkinz World (regarding the ownership of media and restricted chat), yet choose to "play anyway, because it is fun." Within a critical media literacy framework, these students appeared to critically assess both site navigation rules *and* their own participant (audience) stance in relationship to those rules.

Traditional Literacies and Possibilities for Education

It is evident to me that virtual worlds in no way replace or supersede tradition-al literacy activities. The Webkinz Club kids made it quite obvious that they regularly employ these literacies in their navigation of Webkinz World; students reported "reading the directions" to follow a recipe purchased for a new appli-ance, writing a script for a movie, creating a storyboard on paper to develop the story line, visually assembling items, and using computation and estimation skills to determine KinzCash expenditures and earnings. However, virtual worlds may offer an uncharted territory of additional possibilities for classrooms. Education is somewhat behind the times in this regard; most school-mediated technology platforms do not comfortably support virtual sites, largely due to the necessity to filter content for school use. The use of social networks is gener-ally discouraged and viewed with skepticism in school environments for many reasons, and educators are often understandably reluctant to open themselves up to the liability of these sites. Sanchez (2009), a frequent user of Second Life, cautions that without the benefit of experience, we simply cannot determine what constitutes best practice. Social virtual worlds have not been used by enough educators to assume "that we have already seen the best" of what these worlds have to offer the educational community (p. 28). The call to future exploration is clear, and our kids can lead the way.

How could we begin to conceptualize the educational use of virtual worlds for young adolescents? Consider the following possible scenarios: a biology class collaboratively performs dissection with a class from England; an industrial arts class designs, assembles, and test-drives a prototype automobile; a drama class performs a play in a Roman amphitheater; a high school football team refines plays in the offseason; an economics class manages the finances of a virtual urban city; a physically challenged student competes in team sports. These and

countless other possibilities exist within the developing framework of virtual worlds. Although innovative teachers continue to create engaging, technology-rich lessons for students daily, what more might we do without the limitations of time, space, and expense? Virtual worlds offer endless possibilities to fully engage young adolescents, seamlessly blurring the boundaries and binaries of "here and now." Authentic experiences and opportunities await us in the field of virtual technology, and our students stand ready to participate and co-create. Will we as educators successfully "slip the surly bonds of Earth" to meet them in virtual spaces?

Table 1. Male Participants—Webkinz Ownership and Participation

Name[a]	Ethnicity	Webkinz Owned	Weekly Time in Webkinz World	Additional Comments[b]
John	White	37	3–4 hours	"I am *obsessed* with the Wheel of Wow."
Steven	White	25	0 hours	"I forgot my password."
Jerome	African American	1	1 hour	"My brother and I have to share."
Phillip	African American	2	30 minutes	"We are never home."
Aaron	White	11	1 ½ hours	
Josh	African American	10	30 minutes	"I play on Club Penguin three times as long."
Ben	White	6	1 ½ hours	"I spend a *lot* more time on Club Penguin."
Quin Li	Chinese	14	4	
Andre	White	22	0 hours	"I *love* to go on, but our computer is broken."
Connor	Indian	3	3–4 hours	"I play a lot!"

[a]Pseudonym. [b]Comments that appear to support or enhance data in Columns 3 and 4 of the above table.

Table 2. Female Participants—Webkinz Ownership and Participation

Name[a]	Ethnicity	Webkinz Owned	Weekly Time in Webkinz World	Additional Comments[b]
Sherry	White	52	3 hours	"I like to buy stuff for my room."
Lin Mao	Chinese	5	3–4 hours	"I like to play games."
Margita	Latina	1	4 hours	"I only have one! *One!*"
Chloe	White	29	3 hours	"I like to invite friends to my room."
Ashley	White	23	2 hours	
Felicia	African American	32	2–3 hours	"I bought them all myself."
Susan	White	31	30 minutes	"I just never have time."
Julie	White	19	3–6 hours	"My first virtual world."
Elijah	African American	1	0	"*I* want to adopt a pet, too."
Lena	Latina	48	3–4 hours	"I spend more time on Club Penguin."

[a]Pseudonym. [b]Comments that appear to support or enhance data in Columns 3 and 4 of the above table.

Figure 1. Webkinz World home page.

Figure 2. *KinzVille Times* page displaying status of author's avatar on lower portion of screen.

Figure 3. Virtual encounter between author's gray cat and another avatar in a clubhouse room.

References

Alvermann, D. (2008). Why bother theorizing adolescents' online literacies for classroom practice and research? *Journal of Adolescent & Adult Literacy, 52(1)*, 8–19.

Alvermann, D., & Hagood, M. (2000). Critical media literacy: Research, theory, and practice in "new times." *Journal of Educational Research, 93(3)*,193–205.

Apple, M. W. (1979). *Ideology and curriculum*. New York: Routledge & Kegan Paul.

Cowan, J. (2008). Diary of a blog: Listening to kids in an elementary school library. *Teacher Librarian, 35(5)*, 20–26.

Gee, J. (2004). *Situated language and learning: A critique of traditional schooling*. London: Routledge.

Grunwald Associates LLC. (2007). National School Boards Association. *Creating and connecting: Research and guidelines on online social and educational networking*. Retrieved October 10, 2007, from http://www.grunwald.com

Hendrick, B. (2009, January 6). Elf: Good works for both worlds. *The Atlanta Journal-Constitution*, p. E1.

Honan, E. (2008). Barriers to teachers using digital texts in literacy classrooms. *Literacy, 42(1)*, 1–8.

Jenkins, H. (2006). *Fans, bloggers, and gamers: Exploring participatory culture*. New York: New York University Press.

Kelly, K. (2008). *Becoming screen literate*. Retrieved January 31, 2008, from http://www.nytimes.com/2008/11/23/magazine/23wwln-future-t.html

Kirkland, D. (2007). *Digital underground: Urban youth, new technologies, and composition*. Paper presented at the 20th Annual Penn State Conference on Rhetoric and Composition, College Station, PA.

Lankshear, C., & Knobel, M. (2002). Do we have your attention? New literacies, digital technologies, and the education of adolescents. In D. E. Alvermann (Ed.), *Adolescents and literacies in a digital world* (pp. 19–39). New York: Peter Lang.

Lankshear, C. & Knobel, M. (2006). Digital literacies: Policy, pedagogy and research considerations for education. *Nordic Journal of Digital Literacy, 1(1)*, 12–24.

Lenhart, A., Madden, M., Macgill, A. R., & Smith, A. (2007). Teens and social media. *Pew Internet & American Life Project*. Washington, DC: Pew Charitable Trusts. Retrieved January 3, 2008, from http://www.pewinternet.org/PPF/r/230/report_display.asp

Luke, C., & Luke, A. (1995). Just naming? Educational discourses and the politics of identity. In W. T. Pink & G. W. Noblit (Eds.), *Continuity and contradiction: The futures of the sociology of education* (pp. 357–380). Cresskill, NJ: Hampton.

Magee, J. (1941). High flight. Retrieved February 14, 2008, from http://www.skygod.com/quotes/highflight.html

Prensky, M. (2001). Digital natives, digital immigrants. *On the Horizon, 9(5)*. Lincoln, NE: NCB University Press.

Sanchez, J. (2009). Implementing Second Life: Ideas, challenges, and innovations. *Library technology reports: Expert guides to library systems and services, 45(2)*.

Spires, H., Lee, J., & Turner, K. (2008). Having our say: Middle grade student perspectives on school, technologies, and academic engagement. *Journal of Research on Technology in Education, 40(4)*, 497–515.

Stone, J. (2006). Popular websites in adolescents' out-of-school lives: Critical lessons on literacy. In M. Knobel & C. Lankshear (Eds.), *A new literacies sampler* (pp. 49–65). New York: Peter Lang.

Street, B. (1984). *Literacy in theory and practice*. Cambridge: Cambridge University Press.

Tedeschi, B. (2007). Fuzzy critters with high prices offer lessons in new concepts. Retrieved February 16, 2009, from http://www.nytimes.com/2007/03/26/technology/26ecom.html?_r= 1&scp=10&sq=johnson,%20krisanne&st=cse

Thomas, A. (2007). *Youth online: Identity and literacy in the digital age*. New York: Peter Lang.

Turner, M., & Turner, G. (2008). *The complete idiot's guide to Webkinz*. New York: Alpha Books.

Williams, R. (1977). *Marxism and literature*. New York: Oxford University Press.

· 3 ·

View My Profile(s)

GUY MERCHANT

Social software has rapidly begun to transform popular perceptions of the Internet. Although the early adopters are not always young, online social networking is now firmly embedded in youth culture. Yet less than 10 years ago the idea that children and young people might use digital communication to sustain and extend their friendships was startlingly new. In an early study of teenagers' uses of chatrooms it almost seemed to me that I was documenting an exotic behaviour that was hidden from public view (Merchant, 2001). Now not only the names of the most popular social networking sites— MySpace, Facebook and Bebo—but also the practices associated with them are very much a part of public discourse in the major world economies as well as in developing ones. In this chapter I look at how the literacies associated with social software present a new set of challenges for educators, illustrating this with data from my own research with teachers and the students they work with.

The changes in popular engagement with digitally mediated communication that this involves have been widespread and transnational whilst at the same time being unevenly distributed and locally interpreted. Differences between the ways in which social networking sites are used and populated reflect differences between societies as well as within them. For all the talk

about the role of new technology in widening social participation (Davies & Merchant, 2009) digital divides persist, although perhaps not in the rather narrow ways originally suggested by Tapscott (1996). Whilst the use of social networking sites spans many traditional social groupings such as race, gender, social class, occupation and age group, there is plenty of evidence of the barriers to participation as well as carefully articulated resistance or refusal. Despite a number of widespread survey studies, the patterns and effects of digital exclusion have yet to be charted or theorised (Selwyn & Facer, 2007). At the same time the reach of SNSs has become such that 'doing friendship' online has rapidly become normalised.

Between moral panic about the negative effect of these new practices on our cultural life, on our social interactions, and even on our cognitive functioning, and the idealisation of a utopian networked society in which everything is 'better' because it is digitally enhanced, lie the everyday practices of a large segment of society. In general terms these digital practices have become so commonplace and so familiar that they frequently escape our serious attention. In addition to this, everyday literacy practices in SNSs are often depicted as being trivial or banal, and as such unlike the real world of corporate uses of ICT (Carrington, 2008). Nonetheless, SNSs are providing an arena for the development of new skills and understandings as well as new kinds of sociability, and they have succeeded in doing this in areas in which many training programmes have failed. Furthermore, many of the digital practices associated with Web 2.0, including social networking, are now being incorporated into mainstream institutional uses of new technology—and this is particularly the case in education, as learning platforms or virtual learning environments begin to include such features as blogs, wikis and RSS feeds (Davies & Merchant, 2009). What is being learnt informally through social networking may well become as important in educational activity as it is in the world of work.

Experts and literacy educators have seized upon the Web 2.0 phenomenon as a way of challenging the status quo and proposing a fundamental re-appraisal of education (Gee, 2004; Lankshear & Knobel, 2006). Regardless of where we stand on this debate, surveys on both sides of the Atlantic testify to the widespread appeal of online social networking (Livingstone, Bober & Helsper, 2005; Lenhart et al., 2007). In these new social environments children and young people are involved in a process of making and remaking identities, taking complex decisions on how and what to present to their friends and the wider community.

In this chapter, I draw on data from ongoing research into the use of SNSs,

focusing directly on adolescents' perceptions of the literacy and identity work they do on the profile pages of popular social networking sites. Setting this alongside teacher interviews I explore the possibilities as well as some of the tensions and contradictions that lie at the heart of working with these new literacies in classrooms. This work is framed by my own belief that it is important that educators understand and engage with the digital literacies in general (Merchant, 2007a) and SNSs in particular, and I argue this for a number of reasons. Firstly, because SNSs invoke new literacy practices that are significant in the everyday lives of children and young people; secondly, because they provide important contexts in which identities are constructed and produced through digital practices; and thirdly, because they offer opportunities to explore complex issues around commercialisation, the ownership of content and copyright. In the first part of this chapter I begin with a brief definition of SNSs before expanding on these three propositions.

Mapping the Territory—
Social Networking Sites

Social networking could be regarded as a way of describing the patterning of everyday practices of social interaction—particularly those that take place outside of the normally intimate relationship structures of family life. Traditionally, this social networking has been driven by face-to-face interaction (see Wellman, 2002). In this way we could talk about the social networks of friendship groups, co-workers or those that form within the social institutions of a whole variety of groups, organisations and clubs that serve our varied needs and affiliations. Social institutions and the informal or casual encounters that occur in and between them provide contexts for the maintenance and development of friendship and acquaintance. Just as Goffman (1983) describes the rise of the two-couple dinner party as a middle class social network ritual, so we might extend this notion of network rituals to include hanging out on street corners and in shopping malls, or the various encounters that are the social lifeblood of the night-time economy. Social network rituals are an essential yet constantly changing feature of youth culture.

If this rather sketchy picture captures an understanding of what we might call 'traditional' face-to-face social networking, then it could be suggested that advances in the technologies of communication have tended to act as accompaniments and sometimes supplements to these patterns of interaction. So, for example, postal systems and telephone networks have, for most of their histo-

ry, allowed us to sustain and thicken existing social network ties. From this point of view online social networking could be seen as an extension of this phenomenon. However, such an argument is not to be read as an attempt to gloss over some important distinguishing features of SNSs or their significance as new digital literacy practices; in fact that is one of the main concerns of this chapter.

The term *online social networking* is probably best used as a way of capturing, in a rather general way, the use of web-based communication to build or maintain such things as friendship or interest groups, extended family ties, and professional, political or religious affiliations. As popular perceptions of the Internet shift from seeing it as a platform for delivering content and information to viewing it as a space for interaction and entertainment (Merchant, 2006) so the use of a wide range of new literacies has come to the fore. This has led to the rise of what Brandt has called self-sponsored writing: a writing that belongs to the writer rather than an institution (Brandt, 2001). In other words, children and young people are increasingly involved in a new literacy practice that is self-initiated and largely independent of formal education.

Literacy educators, it has been argued, urgently need to assess the significance of new communication technologies and the ways of producing, distributing and responding to others in this new textual universe (Lankshear & Knobel, 2006). The web environments, software tools, and media that help to produce this textual universe are extremely varied and include well-established practices such as email groups, listservs and bulletin boards, as well as more recent developments such as MMOGs and 3D virtual worlds. These and related practices could be seen as constituting online social networking as a popular and broad-based activity.

An important subset of online social networking is made up of those environments that are specifically designed to support and develop friendship, and whose overt purpose is to provide a context and appropriate tools for doing this. I use the term *social networking sites* (SNSs for short) to describe these environments—Bebo, MySpace, Facebook and Twitter being the most popular examples at the moment (see Figure 1 for more). Whilst I part company with boyd and Ellison (2008, p. 211) on the distinction between 'networking,' which they argue implies active 'relationship initiation,' and 'network,' which for them suggests relationship maintenance, I find their definition of SNSs extremely helpful. boyd and Ellison (2008) anchor their definition to three core characteristics:

- Individual users or members construct a public or semi-public profile on the site

- Users/members create and list connections with others (friends, follow-ers or buddies)
- Users/members traverse the site through their own and others' friendlists

Although it could be argued that these characteristics are shared with other environments which may not focus on friendship quite so explicitly (Blogger and similar applications come to mind), the emphasis on presence, connection and community is certainly germane to an understanding of these SNSs.

Figure 1. A map of social software showing some popular sites that promote social networking (left) and SNSs (right)

To conclude this preliminary attempt to map the territory, it is important to acknowledge a certain blurring of boundaries between wider online social net-working and the smaller area of specific SNSs as defined above (see Figure 1 for an illustration of this). This blurring is most evident in web-based services that have supported the growth of a community, or communities of interest—or what Gee (2004) refers to as an affinity space. Here I am thinking of such phenomena as the Flickr photo-sharing community, music exchange in Last.fm, and those other online spaces which benefit substantially from having their own 'in house' social networking tools. Because these sites depend on social network-ing around a specific activity, usefully described by Engestrom (2007) as a

'social object,' they provide a template for educational activity. As I argue elsewhere (Merchant, 2007b), it takes relatively little imagination to picture how the social object might be reconstituted as a learning object. In fact some applications in VLEs already hold this promise, suggesting that learners' experiences of social networking could easily transfer into educational environments, as social networks shade into learning networks.

The attraction of social networking and its relevance to recent developments in education are highlighted by the FutureLab document 'Social Software and Learning.' Here the authors (Owen et al., 2006) suggest that:

> ...social software is enabling people to do things with internet technology that they clearly want to do themselves—and as they discover more things they want to do the software develops. Social software is therefore satisfying a need that maps closely onto educational needs and current agendas. Social software is about personal services on the web, and consequently it is about personalisation. It is inherently social and the gains of using social software are gains that come from collaboration. (p. 28)

In what follows I focus on SNSs as an arena for new literacy practices, as online spaces for producing identity and friendship, and as a particular kind of textual performance.

Social Networking Sites as an Arena for New Literacies

The communicative practices that are sometimes rather loosely referred to as Web 2.0 or social networking constitute rapidly developing forms of digital literacy (Davies & Merchant, 2009; Lankshear & Knobel, 2006) and these are central to our current concerns. Leaving aside for now the controversies about terminology and definition (see Merchant, 2007a for an exploration of these), the fact that SNSs involve youth in new ways of producing, distributing and responding to text seems to be at once highly significant and unavoidable. The interviews we[1] conducted with teenagers show that, whilst these young people might not consider themselves as experts, they freely refer to new practices such as 'changing skins,' 'writing on walls,' 'messaging,' 'apps' and 'tagging photographs,' in describing their everyday literacy activity. To say, as one of our interviewees did, 'you can just write on their wall really quickly—it's a convenient thing,' is to acknowledge a particular kind of expertise and interactivity as well as to hint at its normalisation in the daily lives of young people. So in these and other ways, SNSs depend upon a form of interactive written discourse that is enriched by the multimodal affordances of the social networking software, as members share and comment on observations, music and images. Through their immersion in these communicative environments, many young

people are now aware of the potential to extend and enrich their social interactions, to maintain a connection with different groups such as 'people from choir' and 'relatives that live in America' and so on.

Teenagers are also sensitive to the ways in which spaces like Facebook can be used to navigate the complex worlds of friendship and intimacy. Below, one interviewee describes how online and offline worlds interweave as SNSs are used to soften inhibitions and to provide a starting point for more difficult interactions:

> I think you can make closer friends with people because by talking to them—maybe on Facebook, maybe on the chat thing—you might then have more confidence to talk to them in school or out—I think that can help where you do sort of get close to people—and then it is easier to talk to people

But of course, the role of SNSs in overcoming reticence or shyness in face-to-face communication sits alongside the work that these teenagers do in friendship maintenance—those online activities that are frequently referred to as 'catching up.' Although some commentators have been rather dismissive about the banal or frivolous activity that this involves, I would argue that the playfully social (to borrow a phrase from Graham, 2008) plays a very important part in these new textual worlds, and has, in fact, always been significant in human relationships. This is well illustrated when one of our interviewees describes how she might maintain a 'connection' with her friend.

> ...with your really close friends—like with us—we just leave sort of stupid comments—like if we haven't seen each other in a couple of days because now we are at a different school—it's just we will be like 'love you'...

Beyond these concerns with maintaining and developing friendships, there is often a suspicion amongst teenagers of the more random or unsolicited SNS encounters. Consistent with boyd and Ellison (2008), their emphasis appears to be on making existing social networks visible, rather than meeting new people. Nonetheless the teenagers that we have been working with are acutely aware of the wider web audience and even some of the media stories that have drawn attention to the blurring of personal and professional boundaries. Caution may be exercised in deciding what to make public because 'you hear those things about how like universities and employers look at it...'

In sum, to use a well-worn and perhaps rather traditional categorisation, these observations suggest that children and young people that use SNSs are attuned to the dimensions of audience, form and purpose in their online production and consumption of texts. Teachers concerned with literacy, commu-

nication studies, English or media studies, take note! But somehow, education-al responses to the changing nature of literacy in curriculum design and con-tent as well as pedagogy have to date been rather patchy (Dowdall, 2009). On the whole it would be fair to say that the most interesting work has been done by enthusiasts (see Davies & Merchant, 2009, for examples) rather than through funded initiatives or by state and government mandate. Partly as a result of this there is a disconnect between the experiences of young people and some teachers' understandings of how digital literacy practices might be used in the classroom. So for example, one teacher we interviewed saw the new lit-eracies in terms of a generational divide as she reflected on her experience as a parent:

> you suddenly realise what your son's writing....it's a separate language that is on there

And then she goes on to describe this as:

> a breakdown of children's ability to be able to write correctly

These are particularly candid comments, and we have little empirical evi-dence to date on how widespread such attitudes are amongst teachers. But from the data we have collected, it seems that teachers do have quite varied respons-es to the new literacy practices of their students. Indeed some are very keen to include students' experiences where they can and even go so far as attributing resistance to those they perceive to be the 'more traditional teachers.' However, as Burnett's (2009) work with pre-service teachers illustrates, there is a com-plex relationship between teachers' experience and confidence in using digi-tal literacies and the practices that they promote in the classroom. It is not a simple matter of age, experience or confidence.

In some instances it appears that curriculum guidance can give permission and encouragement to incorporate work on SNSs in school settings. As one teacher commented:

> In my GCSE Media course, they must use new technologies—so things like podcast-ing is their coursework...like wikis and blog pages.

She described how looking at SNSs had had a positive influence because it allowed students to engage with media texts they were familiar with. Reflecting and writing on that work enabled students to understand the diversity of tex-tual forms that they used in their daily life. In other cases, teachers were encouraging students to use their social networks to informally support school study and revision work and even sometimes creatively recruiting young peo-ple's literacies to serve more conventional purposes, as the following describes:

I say write up your notes and I used to say do it in shorthand but now I say do it in [that] language and it won't take you long, and they write it down in this form that I can't understand. I shorten words but not to the extent that they do!

But a more sophisticated response to teenage engagement with SNSs would need to reach beyond note taking and one-off study. If learning is a specialised form of social interaction or engagement, then the literacy practices of online social networking may well provide a template for new kinds of pedagogy.

Youth and Online Identity Performance

Online social networking has rapidly become a mainstream youth activity. In the UK, a recent survey by the Office of Communications (OfCom, 2008) found that almost half (49%) of 8–17–year–olds had a profile on a SNS. Similar evidence is available elsewhere (Lenhart et al., 2007), and this suggests that although the fortunes of particular sites and providers may change, this sort of activity is likely to remain or grow. So although whole sectors of a population may migrate from MySpace to Bebo, from Bebo to Facebook and so on, as and when a particular site attracts attention, the role of SNSs in social life persists. This has led commentators like Beer (2008) to suggest that an analytical emphasis on new kinds of sociability and friendship may be more useful than the online/offline distinction that is often made. From this point of view, creating and maintaining an online presence can be seen as important identity work.

On SNSs members create profile pages, post pictures of themselves, display their friendships and allegiances, and indicate their tastes and preferences for different cultural products. They position themselves in these and other ways in the eyes of their friends—their actual and imagined readers. It is perhaps not surprising, then, to find that academic study in this area often makes reference to the theatrical metaphor elaborated in the early work of Goffman (1959), as users quite literally perform identity in successive modifications of the multi-modal pages of their online texts. These performances constitute a fluid and negotiated identity which, as Dowdall (2009) notes, is tethered to others in complex ways.

In the everyday social networks of young people it seems to be increasingly compelling to have some sort of presence on an SNS. Although Willet's (2009) work does identify a category of 'refuseniks' (young people who have made a principled decision not to engage), students in this category are clearly a minority. In my own work there is evidence of what might be described as gentle peer pressure, captured by the comment: 'loads of people were on it and

they were sort of—just—you should use it!' Empirical work has yet to grapple with issues of levels of engagement. So although we have an emerging picture of the popularity of SNSs it is harder to separate out occasional, persistent or even reluctant engagement.

Amongst young people who are regularly involved, there are some interesting indications of how conceptions of taste are enacted on profile pages (see for example, Liu, 2008). Liu (2008) describes online social networking in terms of a 'textual performance of the self,' arguing that:

> The virtual materials of this performance are cultural signs—a user's self-described favourite books, music, movies, television, interests, and so forth—composed together into a *taste statement* that is 'performed' through the profile. By utilizing the medium of social network sites for taste performance, users can display their status and distinction to an audience comprised of friends, potential love interests, and the Web public. (p. 253)

In my own interview data, there is clear evidence that cultural products are significant in teen networks. Not only do they talk about picking up information from profile pages as an interesting activity, they are also keen to learn about the favourite books and films of others. The idea of a 'community of readers' is clearly within reach, as the following statement suggests:

> you can […] start discussions about it as well, so if you see someone's favourite book is like Catcher in the Rye and you can go oh I like that.

This raises an important question for educators. Should this kind of activity be regarded as part of the non-formal social learning that we hope takes place outside of classroom environments or would we be better advised to take this into account when designing more formal learning experiences? This question is addressed in some detail in the final section of this chapter.

The relationship between literacy and identity has emerged as a key theme in recent scholarly writing. Literacy researchers and educators—particularly those adopting a socio-cultural perspective—are increasingly interested in the ways in which literacy is a key site for identity work. Literacy practices, they have argued, provide an arena for constructing and performing identities, and youth identity production in SNSs is a pertinent example of this. Exploring the ethics and aesthetics of textual performance on profile pages presents another important challenge for educators, since it provides an opportunity to explore taste and preference in consumption as well as issues of self-presentation and what is appropriate in online behaviour. In my own work, teenagers talk about attention-seeking behaviour and friends *wanting to look their best*; but never-

theless within this social group there is a tacit understanding of what is accept-able. So images that show friends, humorous situations and social occasions are normal, but 'posing,' or anything overtly sexual, attracts criticism from the peer group. Here the boundaries can be subtle or ill-defined. For example, one of our interviewees was clear about what she disliked:

> Well, like pouting! But I never do because you look ridiculous, mine [photographs] are normally amusing ones, or ones that I will look at and be like oh I really enjoyed that time…

It is quite likely that there are not only broad gender differences here but also differences within and between social networks. Nonetheless, the views of these girls concur with Willet's (2009) study of 14–16–year-olds in which sexually suggestive poses were seen as unacceptable. Again these are issues for educators to grapple with here, some of which fall under the category of safety online, which is explored in the next section.

Unpackaging the Text

Taking a greater interest in SNSs as a textual form is one way in which we might begin to understand what fires young people's enthusiasm and the ways in which they might prefer to learn. At the same time it is important to appreciate that teenagers who use SNSs constructively will be engaged in valuable learning processes through uploading, sharing and commenting on their own and others' content and ideas. These may be starting points in helping us to evaluate the role of SNSs in educational contexts, opening up the potential to learn *through* this kind of activity. At the same time, though, SNS pages provide an opportunity for the sort of critical and analytical reading that is central to media studies and critical literacy (Buckingham, 2003). Some key themes here are the commercial interests of providers and advertisers, the ownership of content, and the issues of self-presentation and representation that were touched upon in the previous section.

A common blind spot in the work of those who extol the benefits of Web 2.0 and user-generated content is the simple but perhaps transparent fact that sites are owned, designed and structured for different kinds of content production, distribution and interaction. A critical media studies approach to SNSs highlights these issues, encouraging young people to be more discerning consumers and producers of digital culture. An awareness of activities such as covert advertising and the corporate harvesting of market data need not necessarily work against the interest and engagement that is evident in youth par-

ticipation in SNSs. However, the emphasis in this sort of approach is on learning *about* new media rather than learning *through* new media. Working in the media studies tradition, Buckingham (2003) offers a conceptual framework that can help us in planning this sort of approach in the classroom. The framework separates out four themes: production, representation, language and audience, and these provide a basis for the outline in Figure 2. These concepts can be applied to the classroom study of 'SNSs-as-texts,' allowing us to structure learning activities that critically examine social networking as a media phenomenon.

PRODUCTION
Technologies that are used to generate and distribute material
Commercial interests (advertising, market intelligence, and sponsorship)
Persuasion and influence – the activity of individuals and interest groups
Media links (relationships between providers and other platforms)
REPRESENTATION
Authenticity and authority in claims to truth
Viewpoints that are adopted or omitted
Judgements about accuracy, truth, opinion and misinformation
LANGUAGE
Design – visual and verbal rhetorics
Site structure, affordances and constraints
Levels of formality and assumptions about users/members
Kinds of interactivity, feedback and control or moderation
AUDIENCE
User exposure to visible and invisible commercial interest
Opportunities for data harvesting
The varied purposes that sites are used for
Differences in enjoyment and interpretation of sites – the individual response

Figure 2. Conceptual Framework for Critical Study of SNSs (adapted from Buckingham, 2003)

An area that this framework does not succeed in fully capturing is related to some of the issues of identity and self-presentation that were raised in the previous section. With the rise in the popularity of SNSs, there have been a number of high profile cases which have called into question the safety of youth engagement with new media and what counts as appropriate behaviour in online environments. Whether this takes the form of supposed online suicide pacts, or exposure to sexual predators, the darker side of life online is part of the discourse that surrounds social networking. I argue that although there are

some significant issues about security, privacy and online safety, these are bet-ter pursued by education than by crude attempts at control and surveillance (see Davies & Merchant, 2009 for a fuller discussion). As Bryant (2007) suggests, it is often the case that teenagers:

> ...are more knowledgeable than the people telling them what they can and cannot do.(16)

And this point was elaborated on by one of the teachers in my own study who argued that:

> because they know far more about it, they know how to get round our firewalls, they know if things are blocked how to get in there how to access it, and they speak this language on the message wall that I don't understand. It is a whole new language, so it is interesting that they would be the ones to teach us about E-safety.

Who Is Taking SNSs Seriously?

Given the growing significance of SNSs in students' lives it is important to look at the influences that frame educational responses to the new literacies involved. Some of the difficulties that educators may face in drawing on these student experiences in the context of formal learning may be beyond their con-trol, constrained as they are by curriculum and assessment regimes as well as institutional policies—but there are also some other areas of difficulty. Firstly, there is the perceived danger of unfiltered and open access to online interac-tion, fuelled as it is by moral panic over Internet safety. Secondly, there is the suspicion, still felt in some quarters, of anything that smacks of popular culture in which young people are often more expert than teachers. Thirdly, there is lack of knowledge or familiarity—to some extent, online social networking is still seen as the province of the young and a foreign country to some teachers. Finally, there are relatively few models of good practice to draw upon. Yet when we think that the popularity of SNSs stems from the way they provide a con-text for friendship and affinity around shared interest, and see how they are spaces in which self-directed learning *can* take place, they begin to seem more attractive. They clearly provide opportunities for geographically and temporal-ly dispersed groups and individuals to communicate, exchange information and develop ideas, and from this perspective, we may be able to glimpse some new ways of structuring learning communities.

 It is easy to underestimate the fundamental shift in teachers' working prac-tices that social software invites. However, those who have responded to the

challenge are often enthusiastic. A quick look at the ways in which creative teachers have explored the educational potential of Twitter is a case in point. Examples are as varied as Steve Rayburn's approach to teaching Dante (University Laboratory High School, 2009); Will Richard's Twitter Latin test (bigtweet.com, 2009); and Many Voices, the collaborative story initiated by an elementary school teacher in Maryland (twitter.com, 2008). A more polished approach is offered by TwHistory which in one project presents sequenced messages from key players in the American Civil War. Figure 3 is a screenshot of some of these Twitter messages (tweets). On their information page the designers explain that:

> Twitter is being used for many things. Here at TwHistory we feel the service can be a novel way to tell the stories of our past. We pick historical figures, especially those that kept detailed journals or histories, and tweet the experiences they went through. (TwHistory.com, 2009)

Figure 3. President Lincoln tweets from the Battle of Gettysburg (http://www.twhistory.com/)

Here we get the sense of a carefully planned initiative that takes full cognizance of the particular affordances of time-based message posting in a social

networking service.

Other examples of educational uses of SNSs are poorly documented but include the use of music and video-sharing sites to host students' digital media projects. By providing a wider audience for these sorts of products, students may well attract a broader range of critical comment as well, of course, as exposing themselves to unfiltered reactions. Sensitive teachers can alert their classes to this possibility, perhaps using this as an opportunity to guide students in becoming more critical online readers and more responsible in their peer-to-peer interactions. A strong advantage of this sort of Internet publication is that learners can view their work at home and often decide to share it with family members. Educational uses of Facebook confer similar advantages and disadvantages. Teachers can use Facebook in the classroom by creating a group for their class. The whole class will then be able to interact with each other and post new information on the wall. The potential to add hyperlinks, pictures and videos makes this an attractive option.

More than anything, teachers will need to consider and experiment with different ways of using and adapting SNSs, and they will need support and encouragement to do so. From my own work, it seems that some are beginning to see what this could be. In the words of one of our teachers:

> I think that if you can get students interested and engaged through media, you may have to back track to get what you want, you may have to dip into their world and then reel them back into yours so [...] you [...] embraced the text culture—I think yeah I am going to have to think like that a little bit because dipping into their world gets what you want out of them.

Why Educators Should Know about Social Networking

This initial exploration of how young people and their teachers are using SNSs provides a number of areas of interest for educators which are broadly suggestive of three kinds of activity in educational settings. The first of these is to *learn about* SNSs and their role in learners' lives—doing this is an essential ingredient in the work of understanding the worlds that our students inhabit and in recognising the knowledge, skills and dispositions that are involved as social and cultural capital. Although many schools currently bar access to SNSs, a recent study by the National School Boards Association (2007) revealed that 60% of the 9–17–year-olds they surveyed used these online spaces to discuss educational topics. This underlines the imperative to recognise and validate the learning that takes place in SNSs (Owen et al., 2006) and

to realise that the purely social sits alongside more informal learning.

The second kind of activity is to *learn from* social networking in order to appreciate the kinds of social interaction and informal learning SNSs can support, and as a result to reflect upon and refresh our own pedagogies and designs for learning, whether or not these involve new technologies. Some of the examples included above show some early attempts to use SNSs—but more thought could be given to the development of applications that will support educational activity.

The third and final area of activity is to *learn with* SNSs, and by this I mean to focus in a critical way on the literacy practices that are developing in and around social networking, as well as the identities that are produced and performed through the various acts of multimodal and collaborative textual composition. This last area of activity is, as we have seen, entirely consistent with the well-established approaches and analytical frameworks associated with critical literacy and media studies.

Despite claims that the social web is a rich space for informal learning, to date there has been little serious attention paid to the form or nature of that learning. Researchers such as boyd (2007), Carrington (2008), Merchant (2007b) and Davies (2006) have all *described* the learning that takes place, but no model has been developed yet to theorise this learning. At the same time, however, there is growing evidence of innovative educators using Web 2.0 and social networking applications in the classroom (Lankshear & Knobel, 2006)—but it must be said that these are small gains in a political and educational environment that often sees ICT as a solution to all its problems—from providing for employment and skills shortages to 'curing' pupil disaffection and underachievement.

The focus of this chapter has been on the use of popular SNSs, and I have attempted to underline some of the key characteristics of their use and how these may relate to education. In the introduction I emphasised the broad appeal of online social networking in a world in which one's position on the 'social graph' (Fitzpatrick, 2007)—the global mapping of everybody and how they're related—seems to count for a lot. Whilst I have drawn attention to the realities of occasional, persistent or even reluctant engagement, as well as the presence of those who refuse to participate, there may well be a further role for education in ensuring that those students, who for one reason or another do not have access to SNSs are not disadvantaged as a result. The right not to participate should, I believe, be upheld, but the opportunity to learn and develop through social networks should not be withheld.

Notes

1. The study referred to here was conducted by the author and research associate Claire Wostenholme and funded by Sheffield Hallam University.

References

Beer, D. (2008). Social network(ing) sites...revisiting the story so far: A response to danah boyd & Nicole Ellison. *Journal of Computer-Mediated Communication 13*, 516–529.

bigtweet.com (2009). 'Latin test via Twitter' 29 April 2009. Retrieved 1 May 2009, from http://bigtweet.com/c/b/twitter/willrich45/wFquw

boyd, d. (2007). Why youth (heart) social networking sites: The role of networked publics in teenage social life. In D. Buckingham (Ed.), *Youth, identity, and digital media* (pp. 119–142). (MacArthur Foundation Series on Digital Learning). Cambridge, MA: MIT Press.

boyd, d.m. & Ellison, N.B. (2008). Social network sites: Definition, history and scholarship. *Journal of Computer-Mediated Communication 13*, 210–320.

Buckingham, D. (2003). *Media education: Literacy, learning and contemporary culture*. Cambridge: Polity.

Burnett, C. (2009). Personal digital literacies versus classroom literacies: Investigating pre-service teachers' digital lives in and beyond the classroom. In V. Carrington & M. Robinson (Eds.), *Digital literacies: Social learning and classroom practices* (pp. 115–129). London: Sage.

Brandt, D. (2001). *Literacy in American lives*. New York: Cambridge University Press.

Bryant, L. (2007). 'Emerging trends in social software for education. *Emerging Technologies for Learning*, Vol. 2.' Retrieved 15 March 2009, from http://emergingtechnologies. becta.org.uk/index.php?section=etr&rid=14172

Carrington, V. (2008). 'I'm Dylan and I'm not going to say my last name': Some thoughts on childhood, text and new technologies. *British Educational Research Journal 34*(2), 151–166.

Davies, J. (2006). Escaping to the borderlands: An exploration of the internet as a cultural space for teenaged Wiccan girls. In K. Pahl and J. Rowsell (Eds.), *Travel notes from the New Literacy Studies: Instances of practice* (pp. 57–71). Clevedon: Multilingual Matters.

Davies, J. & Merchant, G. (2009). *Web 2.0 for schools: Learning and social participation*. New York: Peter Lang.

Dowdall, C. (2009). Impressions, improvisations and compositions: Reframing children's text production in social networking sites. *Literacy 43*(2), 91–99.

Engestrom, J. (2007). 'Microblogging: Tiny social objects. On the future of participatory media.' Retrieved 31 May 2008, from http://www.slideshare.net/jyri/microblogging-tiny-social-objects-on-the-future-of-participatory-media

Fitzpatrick, B. (2007). 'Thoughts on the social graph.' Retrieved 20 April 2009, from http://www.http://bradfitz.com/social-graph-problem

Gee, J. P. (2004). *Situated language and learning: A critique of traditional schooling*. London: Routledge.

Goffman, E. (1959). *The presentation of self in everyday life*. London: Penguin.

Goffman, E. (1983). The interaction order. *American Sociological Review 48*, 1–17.

Graham, L. (2008). Teachers are digikids too: The digital histories and digital lives of young teachers in English primary schools. *Literacy 42*(1), 10–18.

Lankshear, C., & Knobel, M. (2006). *New Literacies: Everyday practices and classroom learning* (2nd ed.). Maidenhead: Open University Press.

Lenhart, A., Madden, M., Macgill, A. & Smith, A. (2007). *Teens and social media.* Washington, DC: Pew Internet and American Life Project.

Liu, H. (2008). Social network profiles as taste performances. *Journal of Computer-Mediated Communication 13*, 252–275.

Livingstone, S., Bober, M. & Helsper, E. (2005). *Internet literacy among children and young people: Findings from the UK Children Go Online Project.* London: London School of Economics.

Merchant, G. (2001). Teenagers in cyberspace: Language use and language change in internet chatrooms. *Journal of Research in Reading 24*(3), 293–306.

Merchant, G. (2006). Identity, social networks and online communication. *Journal of E-Learning 3*(2), 235–244.

Merchant, G. (2007a). Writing the future in the digital age. *Literacy 41*(3), 118–128.

Merchant, G. (2007b). Mind the gap(s): Discourses and discontinuity in digital literacies. *Journal of E-Learning 4*(3), 241–255.

Monahan, J. (2007). 'Missed opportunity.' In *The Guardian Newspaper* 9 January 2007. Available at http://www.guardian.co.uk/education/2007/jan/09/elearning.technology4 last accessed on 20 April 2009.

National School Boards Association (2007). *Creating and connecting: Research and guidelines on social—and—educational networking.* Available at http://www.nsba.org/SecondaryMenu /TLN/CreatingandConnecting.aspx last accessed on 29 April 2009.

OfCom (2008). *Social networking: A quantitative and qualitative research report into attitudes, behaviour and use.* Available at www.ofcom.org.uk/advice/media_literacy/medlitpub/medl-itpubrss/socialnetworking/report.pdf last accessed on 29 April 2009.

Owen, M., Grant, L., Sayers, S. & Facer, K. (2006). *Social software and learning.* Bristol: Futurelab. Available at http://www.futurelab.org.uk/resources/publications-reports-articles/opening-education-reports last accessed on 26 April 2009.

Selwyn, N. & Facer, K. (2007). *Beyond the digital divide: Rethinking digital inclusion for the 21st century.* Bristol: Futurelab. Available at http://www.futurelab.org.uk/resources/publications-reports-articles/opening-education-reports last accessed on 22 April 2009.

Tapscott, D. (1996). *Growing up digital: The rise of the Net generation.* New York: McGraw-Hill.

Twhistory.com (2009). 'Home Page' 10 February 2009. Available at http://www.twhistory.com/ last accessed on 30 April 2009.

Twitter.com (2008). 'Many voices.' Available at http://twitter.com/manyvoices last accessed on 22 April 2009.

University Laboratory High School (2009). 'Anonymous fame: Steve Rayburn's "Twitter in Hell" project gets national attention.' University of Illinois. Available at http://www.uni.uiuc.edu/og/news/2009/04/anonymous-fame-steve-rayburns-twitter last accessed on 26 April 2009.

Wellman, B. (2002). Little boxes, globalization, and networked individualism. In M. Tanabe, P. Besselaar & T. Ishida (Eds.), *Digital cities II: Computational and sociological approaches* (pp. 10–25). Berlin: Springer.

Willet, R. (2009). 'It feels like you've grown up a bit': Bebo and teenage identity' paper presented at the ESRC Seminar Series: *The educational and social impact of new technologies on young people in Britain*. Available at http://www.education.ox.ac.uk/esrcseries/uploaded /Seminar%204%20Report.pdf (pp. 28–34).

4 Colored Girls Who Considered Suicide/When Social Networking Was Enuf

A Black Feminist Perspective on Literacy Online

DAVID E. KIRKLAND

"...bein alive & bein a woman & bein colored is a metaphysical/dilemma."
—NTOZAKE SHANGE

The storied lives of Black females saturate the spaces they occupy. As literacy artifacts, these stories, these well-written lives, tell us many things about what and why young Black women write. They also teach us about ourselves—about who and what we are and can be. It comes as no surprise, then, that these stories, which have stretched across the quiet distances of a too often overlooked femininity, are moving fast forward toward the new histories being written and rewritten by Black women online through new technologies.

My first encounter with such stories, which I call Black female literacy artifacts, came offline during my childhood. Growing up, I spent a lot of time with my mother. She was a street-wise woman, a daughter of inner-city Detroit, a victim of its unfulfilled possibilities. It was in that beaten-up city—home of chronic poverty, plight, and my own passions—that my mother came to cultivate stories of a young woman surviving yet starving.

"It ain't never been easy to be a woman," she would lament. "But we women have a power, and that power is our curse." She would continue commentary like this for hours on end, attempting to reconcile the shame she felt from selling her body.

"Yeah, I sold my pussy," she would rudely blurt out usually under the influence of some mind-numbing substance. "But I didn't sell my soul." It was not unusual for her to share such details with me. She would often openly render her secrets when intoxicated like the time she reached into her oversized black bag that seemed to have everything in it from random snacks for eating to useful tools for fixing things. I had never known my mother to be a writer, but from the depths of this black bag emerged a little, well-used notebook, protected only by a worn cover and joined by a thin spiral wire that was bent out of perfection. With a combination of deep agony and relief, she cuddled that notebook between her clinched fingers before opening its timid pages. Smeared in random but purposeful directions were a series of thoughts, numbers, and hard to read markings that resembled both poetry and prose. There were also doodles of cantankerous scenes, images of naked women and slobbering men, notes on her suicidal thoughts, and prayers to God for forgiveness. In that well-used notebook in her purse, my mother had constructed a multimodal, handwritten world that, although it made little sense to me then, has helped me to understand the powerful and humanizing event of literacy in the lives of some young Black women.

"I remember the first time." She paused. Silence. "I came home that night and wrote it all down." She turned to a creased and torn page in her accusing notebook—its crinkled edges jagged and used. She began to read:

"Tonight I did it," she continued, rehearsing the common wisdom of the street: "I had to do what I had to do." As she read, the air between us thinned. My mother's eyes swelled with moisture as she continued with her story. "My babies can't eat air. And it didn't last that long anyway. But I am still ashamed of myself, but I can feed my kids and I didn't have to rob no banks. I don't know if I will do it again, but I will do anything to feed my kids, or I'll die."

Touched and troubled by her, then, seven-year-old note and its genuflection to death as a human option, my quiet eyes clinched to beat back the tears that were amidst due to her confession. She turned to me, pain still afflicting her voice. "I gotta support y'all some way. Money don't grow on trees," she would explain before ending with that, now, all too common refrain. "It ain't never been easy to be a woman."

Many years later, I sit with my mother's notebook gripped in my curious hands, seeking to understand literacy in her life, hoping that the secrets of her literacy will reveal the secrets of literacy in the lives of the young girls I am studying at Brooklyn Community Gardens (BCG)[1]—a community center in New York City. In contemplating my mother's words, her stories, I am remind-

ed of what Ntozake Shange (1997) once wrote: "...bein alive & bein a woman & bein colored is a metaphysical/dilemma." I know that Shange couldn't have read my mother's notebook because it was composed long after Shange had penned her choreopoem. For her part, my mother never read Shange's poetry or saw her plays, an observation of which I am sure because she didn't seem much into reading or viewing plays back then.

Whatever the case, Shange's statement, in its modest clarity, helped me to understand not only what but also why my mother wrote. The statement hints at a theme that transfixes itself onto the stories of many Black women, even my mother's—a metaphysical dilemma which utterly shapes her life. She writes to understand this dilemma, which unfortunately she shares with other women. She writes to overcome it, to reconstruct and rewrite herself beyond it. Understanding this, I wondered: How does this particular purpose for practicing literacy, the purpose of rewriting selves, look in today's online social universe? What types of practices and products do young Black women yield in their digital rewritings? Moreover, what do their digital products—the particular Black female literacy artifacts that render the stories of Black women visible online—reveal about the nature of Black female iDentities, struggles, and strengths? For the remainder of this chapter, I seek to answer these questions.

An Organic Pheminism: Viewing Black Female Digital Texts through New (Male) Eyes

To answer the questions I posed earlier, I use what I call an organic pheminist (/feminist/) framework, which is a feminism taught to us—each of us—through the particular stories/lives of the females we encounter and know. It is organic in that it is not the rigid product of academic debate or the pointless perspectives of prideful pontification. My use of the "ph" spelling in pheminism as opposed to the traditional "f" is meant to set off this particular meaning, a meaning that distinguishes organic pheminism from traditional uses of feminism. In doing so, I seek to locate my register, pheminism, within African American linguistic conventions (e.g., the use of "ph" to spell phat [as opposed to fat] in hip hop linguistics to create a deliberate homophone which serves a greater rhetorical effect). This particular play on language, or semantic inversion as Smitherman (1999) refers to it, offers interlocutors a way to appropriate codes not belonging to them (and codes of power imposed on them), and makes codes their own. In this way, I am attempting to (re)define a feminism that is sensitive to the female experience, but one that can also be picked up by non-

females. I am also attempting to articulate a hip, contemporary, and organic per-spective on the greater Black female narrative that is not beholden to the stric-tures of the academy or of academic definitions. Phemenism—an organic form of feminism—merely is. Its principles and tenets exist in the real stories of our grandmothers and mothers, sisters and wives, daughters and cousins, and even our friends. It is what we, individuals—male or female (it doesn't matter)—learn about women and femininity from (other) females who surround and grow within and out of us.

Viewing the digital world through this framework—a conceptual lens that both erases the borders between race and gender oppression and highlights the need for a humanist vision of the written female and for female writings—creates new possibilities for empowering a new knowledge respectful of the female iDentities (digital identities) constructed in digital (con)texts. The life of one young lady in particular, Maya, as told on her MySpace page, exists in this vein. Maya's story (see later in this chapter), composed in poetry and performance, reveals the complicated truths of being Black and female in an oppressive world that gets extended to online contexts. Her metaphysical dilemma shares the same indignities that stroked Shange's hands to sing, that wrenched my mother's to write. It was revealed in her online stories—a syner-gy of past and present captured in the bold testimony of texts, which in Maya's case was extended online.

My Positionality

In order to write about young women like Maya, I found myself writing about a metaphysical dilemma that, as a male, I have had relatively little true con-tact with. However, through my mother, I have somewhat come to know this dilemma—if only as a caring onlooker. And just as writing about my mother could never be done in simple terms, writing about the online literacy lives of Black females and their metaphysical experiences could not be simply done.

To tell their stories, I have chosen to incorporate my own story by leading with my mother's story. Like the stories of the young ladies I studied in Brooklyn, I found in my mother's story, in her writings, a literacy artifact never easy to examine, in part, due to its sheer complexity and raw emotion. Such artifacts have cracks in them and ruptures that my masculine mind, by itself, could not quite understand, a fragility that my hardened hands alone were not fit to han-dle. I was confronted with tough questions: How could a woman sell her body? How could she pursue death in the face of life? Such questions in the writing of her story took new shape in my head, particularly when reading the online

writings of the young Black women I studied: How could a person, a woman, not do anything, everything—including selling her body—in order to survive, in order to raise her children?

Some will undoubtedly question, with squalid accusation, why I am using my mother's story instead of another literary source. I began this piece by using my mother's story for two reasons: First, I learned of the metaphysical dilemma of being a Black female through my mother's writings. In order to best represent this dilemma, I felt that I myself had to be honest and include her in this work. Second, as you might have guessed by now, I am not a Black woman. In order to add some legitimacy to this work—of which I am not sure how much I can lend it—I feel that it is important to illustrate, through my story, where I exist in this story. This existence for me includes my mother, her metaphysical dilemma, and what it has taught me about understanding Black female narratives.

Still, other critics among us would say that my mother had other options—that she did not have to sell her body and contribute pages to divulging shameless secrets. I would say that they, like me, have never been a woman, and certainly not a Black woman. This is not to apologize for the success of patriarchy in leaving Black women with such measurable options. It is to render patriarchy void and, in a sentence, place myself squarely within this work: Momma, I understand.

Black Feminism: A Theoretical Framework for a Male Researcher

Reading Black feminist thinkers such as Patricia Hill Collins has informed my organic pheminist perspective. While we learn a lot through living, things that are lived are not always as they appear, particularly when lines of race and color are breached and performed to balance life's inequities. For Collins (1993), Black women's stories are testimonies to their emerging power as agents of knowledge. By viewing the young women I studied, including my own mother, as "self-defined," "self-reliant" individuals, I am seeking to speak to the importance that self-sanctioned knowledge plays in empowering oppressed people. One distinguishing feature of this perspective is "its insistence that both the changed consciousness of individuals and the social transformation of political and economic institutions constitute essential ingredients for social change. New knowledge is important for both dimensions of change" (Collins, 1990, p. 221).

Given this, I have sought to follow what James Baldwin has instructed, to search deeply within answers for the questions they conceal. From a Black fem-

inist perspective, real conditions prompt very real questions (Collins, 1999, 2000; Fox-Genovese, 1988; Guy-Sheftall, 1995; James & Sharpley-Whiting, 2000). What do the stories of Black women say about our physical and digital realities? As a literacy researcher, I must ask: What does it say about the changing and expanding role of literacy in lives increasingly lived online? What does it say about teaching and learning literacy, about young women and men poised to participate in a multicultural global society with complex physical and virtual borders (Kirkland, 2008, 2009)? The answer to my essential question about my mother, then, was not a simple matter of right and wrong. That is, my mother is not a bad person. She is, in her own right, a phenomenal woman. This answer suggests a much deeper question: Why did the world not afford this phenomenal woman—and many like her—other choices?

Regardless of the offerings of what seems to me to be a stingy world, Black feminist thinkers promote (and sometimes chastise) the idea of resilient (or strong) Black women (hooks, 2000; James & Sharpley-Whiting, 2000; McDowell, 1985). Such women are capable of redefining realities, as in the case of Ida B. Wells who, with her pen, changed how we would know the story behind the treatment of Blacks in the post-Civil War South. Such women are also capable of rewriting history as to reveal the unique female story that quietly endures, though absent in the careless chronicles of men. We see this in the annals of writers such as Maya Angelou, Alice Walker, and Toni Morrison, whose transcendent zeal for storytelling has produced works that themselves have reshaped history. But ultimately, the resilience of the Black woman is captured in her effort to redeem or rewrite a self in the stew of her sexuality and sisterhood, in the powerful midst of meddling men and their malign manners (Foster, 1996; Fox-Genovese, 1988; Hartman, 1997).

This observation is not to bash the world and its shortcomings. Should you, dear reader, be interested in that sort of work, I can refer you to several sources. However, in this work, I want to use what I have learned from Black women and from observing and reading about them to explore the narratives of Black females and illustrate how new digital ones are being written and embedded within rich traditions of counter-storytelling (Carby, 1987; Doriana, 1991; Foster, 1996; Fox-Genovese, 1988). I also hope to show how online social communities like MySpace and Blogspot have helped young Black females extend this tradition.

Sharing Stories: A Note on Method

I blend two traditions—ethnography (cultural analysis) and literary criticism

(text analysis)—to analyze the emergent patterns in two (not including my mother's) Black female narratives. Including these narratives, I explore or incorporate into my analysis four data sources: (1) my mother's notebook; (2) the archived works of Black women such as Shange; (3) fieldnotes and transcripts of the conversations and testimonies of my research participants (both male and female) from BCG; and (4) the online stories of two Black females—a rap posted on YouTube and two poems written by Maya.

Through my analysis of these sources, I hope to argue that Black female digital narratives chart the expansion and intensification of Black female lives, stories of Black women that have bumped up against a myriad of new and old social realities. I maintain that these stories should be given much attention, read in literacy classrooms so that students—both male and female—can understand the conditions of women today in order to transform those conditions for a better tomorrow. I hold that such a process presents a *therapeutic pedagogy*—where pedagogy is designed to promote healing, social awareness, and righteous understanding. My process of interpretation is, thus, grounded in an organic pheminism, as organic pheminism teaches us to learn from the everyday lived stories of our sisters. It is also guided by a "grounded theory" approach (Strauss & Corbin, 1990), which seeks to contribute to existing theories and develop new understandings of particular phenomena, in this case literacy in online social communities and Black female iDentities. My goal for this chapter is to help readers better understand how young Black women practice literacy and tell their stories online.

Revisiting My Mother's Notebook: The Sexual Politics of Literacy Online

The final lines in my mother's notebook are incomplete. They read: "If I have to do it again, I cannot...." The pages end. Her written words are muted. Yet, her story continues with me along with a set of longing questions hard to refuse. What is it to a boy who wishes for his mother but cannot find her? He is not a boy at all, but a motherless child. Some kind of reverse bastard. But even his description tells her story. In an organic sense, I carry her story with me everywhere I go, even into the field where I am observing and talking to youth about reading and writing online.

It was in the field where I met one particular young lady. She reminded me of my mother. I wondered if she was what my mother must have been like when she was younger. The young lady looks at me, glad for an audience. I looked

back at her, drawn by her familiar presence. I asked what she was doing online:

"I'm chattin," she said, popping a piece of gum against her spry tongue.
"Chattin with who?" I responded.
"This boy who like me."

I peeked over her shoulder to grab a look at this boy who "like her." She was clicking through an album of pictures on his Facebook page. There was a gleam in her eyes. She thought the boy was cute. There was also a gleam in mine—more like a startled glare; this was no boy. The young man pictured looked older than me.

Though I was concerned by the virtual voyeurism that I was witnessing, the interaction with the young female participant was instructive. I learned through the interaction about the kind of back-and-forth play that was practiced online, a random game of peeping, where looking at someone's pictures was a way of "reading" that person. This observation was at least true for my young female participant. I began to wonder: if she was looking at a boy online, then certainly some boy was looking at her too. And if the boys are looking at the girls…I began to worry!

Not long after my interaction with the young lady, I had the opportunity to join a group of boys who were on their MySpace pages. Upon joining them, I asked what they were doing:

"Looking at this girl," one of the guys answered.

"Can I look too?" I asked, hoping to get a sense of what exactly they were looking at. Before they could really answer, I positioned my curious head closer to the computer screen. There she was. A young lady with her lips poked out, holding up deuces with one hand while her other hand rested firmly on her raised hip. I looked back at the young men, now intensely watching them and listening to their interaction. Perhaps, it was normal for young men to "look" at girls; however, the way they looked at her was odd. The young men's sensation with flesh was to me no less loathsome than the cruel and dehumanizing appetites of those who devoured the sight of captives during chattel slave auctions, reducing men and women to morsels of meat. The young men were looking at images of young ladies, rating them as if they were mutton.

"Man, she a 8," one of them called out.
"Naw, she a 10," said another.

I paused, noticing the stitch of untutored masculinity in the room, which in years would become full grown adult perversion. For the story that these young

men were writing about young Black women, played in the Jezebel set (Hartman, 1997), where Black female bodies have long been put on display for masculine show. Such bodies were and continue to be auctioned off by prying eyes and, in this case, limited even more by an ungainly ratings system that results from stunted maturity.

Ironically, the boys pointed me to a Black female narrative. They were listening to a rap song they found on YouTube (http://www.youtube.com/watch ?v=PC0p3lZ3KAU). The young men probably did not view the rap as I did, as a Black female narrative. Nevertheless, this particular literacy artifact told the story of a young Black female, Shaunte Andrea Jones, whose tragic story is a powerful reminder that the perversions that grow out of youthful peeping do not always grow old. When left unchecked, they sometimes grow worse.

The rap, which can be found on YouTube, ironically warned against the dangers of online social contexts such as MySpace. In the rap, Shaunte Andrea Jones is lured into the world of MySpace by its stark social appeal and the possibility of gaining friends along with male attention. On MySpace, Shaunte dabbles in the delight of boys, posting suggestive images of herself, and reveling in the attention she would get. But the story moves along tragically, as some Black female narratives do (Fox-Genovese, 1988). Not all the attention that Shaunte gained was innocent. A certain man much older than Shaunte—a pedophile and would-be murderer—happens upon her page. He introduces himself to her, communicates regularly with her, and gains her affection. The two meet offline. It would be the last meeting Shaunte would ever have. He rapes and kills her.

This true story, elemental of the metaphysical dilemma that writers such as Shange observe in their stories of Black womanhood, is yet another example in a sequence of stories about Black women. It shares in the tragedy of my own mother, who bartered her body to men for money. It is the story—taken to the extreme—of my young female participant, who used her online time to peek at older men. It is the story of the pictured young lady holding up deuces whom the boys I sat near rated. Such stories, especially when taken together, are awful and real—a reflection of our worst fears. They also remind us of Shange's metaphysical dilemma—the struggle of being Black and female. Moreover, while the online stories of young Black women experience the same tragic pulls as their offline kin, the Black female narratives of Web 2.0 seem a bit more depressing, if only because, in that world, young women like Shaunte Andrea Jones find another place to be objectified, abused, and made targets of men. The difference, then, between the online and offline worlds of Black

females can be seen in little boys rummaging through pictures—a sordid kind of visual literacy where value is misplaced in an informal rubric that rates and objectifies females. The difference can also be read in the stories of young women like Shaunte, which reveal the invisible presence of men who stalk cyberspace for young female victims. Of course, these exposed habits of men are not new. They have been long with us, learned through a culture that fetishizes sex through the procession of billboards that line our streets and the orgy of magazines that teases at our eyes in grocery stores. There is also the television—an old technological domain where patriarchy is passed on. And of course there are the many other forms of pimp media that trade on female images for profit.

And yet, what feels unique to me about the online narratives of Black females today is a sort of new metaphysical dilemma—the dilemma of being alive, Black, and female in a virtual world with no prefixed borders. It is in this porous and vacuous space (Kirkland, 2009) that I have come to know Shaunte Andrea Jones, the unpleasant boys who introduced me to her, my curious young female participant, and a host of people like them. To my modest mind, they tell (or at least come together around) stories of new Black femininity, its new dilemmas, and the digital literacy artifacts surrounding its iDentities. It is through such artifacts that I begin to see my mother's story anew. I see that she is unlike her sisters who survived the chains of chattel slavery; my mother would never relinquish herself to an auction block. However, in a time that has replaced chains with clicks, I somehow feel that—unlike my mother—young Black females of today find themselves lodged along an auction row anyhow, lost within a kind of peevish, murky Ebay (auctioned new millennial style) with their electronic feet fettered to a stable podium of timeless oppressions.

Digital Rewritings of Black Female Narratives: Metaphysical Transcendence

Black women are not simply victims of the digital age (or of any other age for that matter). While some online Black female narratives, tugged by histories of sexual politics, gravitate toward oppression, others transcend victimization and seek to rewrite history. With the growing sensation in literacy studies to glamorize the so-called digital literacies, we have yet to begin to seriously study such stories or explore the many and complicated truths that they tell. Importantly, we are yet to examine the ways in which young Black females are tirelessly reading and writing off the page, deciphering and scripting digital selves in the expanding contexts of cyberspace (Lenhart & Madden, 2007). For

many Black females, this digital construction of meaning, both in making sense of themselves and of their surrounding worlds, defies the complication of histories of oppression and exploitation, of times where being Black and female lent itself to unprecedented abuse (James & Sharpley-Whiting, 2000).

In such narratives, Black women inherit strength to struggle. They spill words into open digital spaces to carry them through the silent tempests of patriarchy. They use electronic instruments such as blogs to navigate the troubled seas of this manufactured cyber channel. But more specifically, in online social communities, many young Black women, like Maya whose poetry you will read below, forge identities, fully immersing, even baptizing themselves in such digital waters. In the stew of their stories, they cook up powerfully new flavors. They visit one another to share in each other's secrets, forming strong social relationships and friendship bonds. These relationships are illuminated through the brilliance of image and word. Their images and words tell a story not only of struggle but also of triumph; they narrate the new literate journey through which young Black women increasingly chart their lives.

Of course, the digital literacy boom is not confined to Black females. According to the Pew Internet and American Life Project, more than half of what it calls "online teens," or teens who use the Internet, are older girls, between ages 15 and 17. These young ladies also use social networks and have created online profiles (Lenhart & Madden, 2007). "For girls," the report continues, "social networking sites are places to reinforce pre-existing friendships," while boys use the Internet and visit social networking sites to flirt and make new friends (p. 1). Their description of teen purposes for online social networking raises important issues some of which I've already alluded to, such as the gendering of participation in online social communities and the sexual politics associated with "reading" and "writing" online.

Findings, such as boys flirting, also suggest that traditional gender roles and power relations have indeed spilled onto teen purposes for online participating. However, what is less clear is how such purposes shape not only teen online social participation but also other things such as their language use and literacy practices and how youth see themselves and are seen by others. Still such questions about language, literacy, and iDentity intensify when race and gender are introduced, particularly for Black females, whose experience with literacy has been documented as "pervasive and emotionally charged," "both historically and institutionally" different than females of other races (Sutherland, 2005, p. 400).

Therefore, the dilemma of being Black and female is stitched in the seams

of Black female literacy practice. Based on findings from her study of Black females and literacy, Sutherland reveals this dilemma as complicated, highlighted by the relative lack of power for Black females to represent themselves to themselves and others as complex human beings, "and thereby to contest the bombardment of negative, degrading stereotypes" (p. 392). Indeed, some Black women are sucked into the vacuum of the digital status quo, especially when it comes to online participating. This fact is made clear in the stories of Shaunte Andrea Jones and the young female participant I discussed in the previous section. However, not all Black females succumb to patriarchy or the disempowering pull of never-ending victimhood. Throughout the vast expanse of digital space, there are Black female narratives that express the relative degree of autonomy that young Black females share in telling their own stories. Regardless of the actual content of Black female literacy artifacts, the act of literacy itself—especially when it insists on self-definition—validates Black females' power as human subjects (Collins, 1993, p. 43).

Such a thought exists in the concept of *human agency*, where literacy when practiced to shape realities is grounded in socially transformative interactions (Bakhtin, 1981). In this view, studying the thematic threads of Black female stories from a transformative point of view can provide context and impetus for understanding Black female online literacy lives. Further, one must view Black female online literacies and the stories that arise from them as contingent on the particular available affordances of the digital environment—the *representational* resources of language and symbols as well as the *situational* resources of people, purposes, contexts of use, and technologies (Bakhtin, 1986; Brisk, Burgos, & Hamerla, 2004; Mandler, 1988; Matute-Bianchi, 1991). Because certain uses of technology have the potential to amplify both the representational and the situational resources (O'Brien & Scharber, 2008), the artifacts of Black female online literacies provide an ideal product for examining the digital Black female narrative.

Take the case of Maya, whose blogspot page is abounding with examples of *self-encouraging love*, a literacy practice used by Black females to negotiate ascribed iDentities (Sutherland, 2005). Maya's blogspot page reveals the human agency that is tied to this Black female literate act. That is, her blogspot writings bend the Black female metaphysical dilemma into quite another kind of narrative experience. I call this new kind of narrative experience *metaphysical transcendence* because it possesses an agentive dimension, which allows Black women to fashion stories less from a posture of shared tragedies than from a

place of lived triumphs. The following poem, written by Maya and posted on her blog, is an example of this:

note to self:

you are not alone and

i

love

you.

always,

yourself

Maya's poem beckons to the unity of dialogism, where self speaks to and responds to self (Bakhtin, 1981, 1993; Dyson, 2003). It is through this dialogue that Maya's poem gains meaning—at the intersection between internally per-suasive and authoritative voices that speak within/to her (Bakhtin, 1986). Her being, her iDentity, is further revealed in the content of her poem's mes-sage, which is a declaration of love and, paradoxically, a reminder/letter to a lonely self that she is "not alone." In this "note to self," the thematics of the Black female narrative embraces its other tone—one of resilience and strength. Maya refuses to be a victim, and if it must be this way, she has the power, a rel-ative degree of autonomy, to love herself and transcend her present condition. In this way, Maya rewrites the story of tragedy commonly associated with nar-ratives of Black women (Foster, 1996; Higginbotham, 1992; hooks, 1981) into a story of triumph, in which young Black women like Maya are uniquely loved (cf. Fisher, 2007; Kirkland, 2009; West, 2008).

While there is power in her rewriting, the true power of the poem is in its placement on Maya's blogspot page. By publishing the poem electronically, she has simultaneously claimed a space for herself in the digital universe, and her (re)telling of story in this particular domain subverts the tragic pulls of Black female narratives as peddled by patriarchy. This is done imaginatively in the visible presentation of her words, which fall neatly down the descending line of a scrolling page. Maya's words also sweep across the screen, doing a digital dance of sorts, which is no less impressive as they move in step with the heart-felt tones of determination and a transcendent clarity. For Maya, "There are many [stories] of women online that degrade us. I'm interested in using the Internet to empower us."

Perhaps no less empowering is another one of Maya's poems, published on Maya's MySpace page. Its title: "a seedhead dandelion born in brooklyn."

There is a woman whose spirit is paper thin on this phone
the plum of her lips is hugged dry, chapped
death is inching at her god and the "i cant do this anymore"slinger in the air like an
awkward silence gathered humid thick
she is a novel beauty struggle story living where life is an absent-minded gift
a miracle is fucking wild in her blood,
torturous insane magic murmuring in her needle plucked veins
and she should die the way life dealt with her
like this, like some victim.

Where the hell are these angels
conjuring these mornings she lives to see,
who are these cosmic forces pinching at her skin?

Her heart is yelling at me a deep shade of blueberry blows
and i feel the confusion stretching in her shoulders
window broken self-esteem,
can hear the deriving tear yawning on her cheek
her hands are gutter, drain spouts
I wish I knew how to hold a home this broken, together.

This woman is where I curb my face, the only coiling power person
that can bend my shape, so backward, so straight.
I am sudden struck affected at the soft sheer peel of her words
and it will always be so, no matter her lift or draft.

This woman on the phone is my mystery flaw, my compliment beauty mark.
I know the tender "I will do whatever it takes for you" love of her being,
still staring into the brown of my no good father's shaped eyes.

A woman that owns her heartbreak and raises its child,
Is an all too strong spine of a life
I wish there were words I could offer this woman
beautifully disastrous as her love
in these splitting fragile moments,
each billow of her pain hovering in my chest like a celestial ohm.

Of the many poems that Maya has written, this particular poem struck me as unique and quite powerful. Maya balances things in it that are Black and female—a metaphysical dilemma and its metaphysical transcendence. She doesn't appear interested in denying the struggles of Black women. Rather, in the bleak and oft-unspoken reality of quiet words, she embraces them: "I am sudden struck affected at the soft sheer peel of her words/and it will always be

so, no matter her lift or draft." Still, "she is a novel beauty struggle story living where life is an absent-minded gift/a miracle is fucking wild in her blood." The issue of miracle, the miraculous resilience of the captive and captivating female soul, through Maya's words, gets found in the tenure of "a novel beauty." Though the metaphysical dilemma exists, there is a transcendence—a hope within her "in these splitting fragile moments," despite "each billow of her pain hovering in my chest like a celestial ohm."

There are wishes in Maya's Black female story—her poem—and also dreams, which are themselves transitory, a celestial offering of solidarity and refuge from an ill-forsaken metaphysical dilemma. And common to the wishes and the dreams is a spirited message which rests between the lines of sad sounds. Such was also the case in Maya's first poem and its appeal to human agency—a self-encouraging love that competes with an utterly disastrous benevolent form of the same ("I know the tender 'I will do whatever it takes for you' love of her being"). It is not that Maya does not see (or render well) the metaphysical dilemma of being Black and female. In fact, she does it too well, using a "torturous insane magic murmuring in her needle plucked veins/and she should die the way life dealt with her/like this, like some victim." It is in her refusal to take the victim's stance that Maya begins to transcend this dilemma, as she traces the woman's tragedy to audacious places of hope to find an element of meaning and mockery in her words that denies it. Maya will not be just "like some victim," and the written woman she reveals in her poem—though faced with Shange's metaphysical dilemma—will be no victim either. She will—they will together—metaphysically transcend it.

Even narratives like the one told in the poem, ones capable of metaphysical transcendence, do not exist in a neutral female-friendly space because online social communities are contested sites, layered in the same complexities that constitute the physical and historical geographies in which they are embedded. We hear this in Maya's poem, a recentering of sorts, which has been given life in our expanding online social universe—and, there, it is given volume and voice. Its transcendent meaning is in rejecting the objectifying forces that seek to hijack Black female iDentities by polluting online social spaces with misogynistic impulses that get fully featured in wall posts, inboxes, message boards, and picture play. While the semiotic and symbolic relations of this new Black feminine iDentity—which the boys have little power to trade on for pleasure—gains a voice of its own, a new set of stories emerges more powerfully than the old. They speak to broader concerns as to what it means to be a woman, a reader, and a writer in the 21st century.

Reading Black Women Online: Toward a Therapeutic Pedagogy

As I set my printed pages of Maya's poetry on a pile next to my mother's note-book, I begin to think about what literacy artifacts found in the online worlds of Black women mean. Of course, I think in relation to what I know and have come to know about women based on my relationships with them, my observ-ing and learning from them about their lives and ways of thinking. Indeed, I could never think like a female nor write her story from the same place that she does. But this organic lens that she lends me moves me to see the digital worlds of Black women anew. From this vantage point, I begin to question: What do these worlds, these new transit boundaries, mean in relation to Black female iDentity, to Black female literacy, and to the overall changing story of Black female histories? Importantly, I ask: What do they mean to the boys who I found rating images of Black females online, to girls like Maya, Shaunte, and my Black female participant who, like the boys, vacillated in and out of a voyeuristic virtual realm. What do they mean to stories past, to my mother, whose own lived narrative gets balanced in my hands as not to be lost in the litter of time? For me the answers to these questions all point to a new centu-ry literacy classroom, where online narratives of Black females can be shaped, shared, and studied in order to promote healing, social awareness, and a right-eous understanding of Black femininity.

In essence, the answers to my questions deal with the emergence of a ther-apeutic pedagogy that deals in the organic stuff of the Internet—those tensions alive in our everyday social interactions and personal narratives that grow out of the real conditions of real people. Therapy in its most basic sense seeks to heal, but it first seeks to reveal so that we as joint participants in this thing called life, being more aware of its most harmful and dangerous tendencies, can reinvent it.

A therapeutic pedagogy follows a similar process as Freire's (1995) "problem-posing" approach to education. It first seeks to empower the individ-ual to knowledge of self and other, and our surroundings by introducing the sub-stances of those things from where they are best found. Indeed, Black females are writing and rewriting the substance of themselves in digital dialect in the formless fibers of cyberspace. They do so in meaningful ways that require us to visit them so that we can know them and act upon what threatens to hurt them. At times, this visit may look different for females than for males, for Blacks than for Whites. That is because individuals may require unique treatments based on their own social make-up. The boys who rated the girls online, while capa-ble of appreciating a conscious rap song about patriarchy gone wild on the

Internet, were not in place to visit images of Black females where they could truly know them without posing a threat to them. By contrast, Maya, whose interactions online were literally virtual therapy, was in a place to help others heal through her own words and meditations.

Imagine the boys who rated the girls online and my voyeuristic female participant studying Maya's poetry for its deep meaning, tracing for themselves the metaphysical dilemma of being Black and female and the metaphysical transcendence of her resilience. Imagine them in the classroom listening on YouTube to the story of Shaunte Andrea Jones, rapped in the oral technology of rhythm and verse. What might they learn about being Black and female; what might they learn about themselves that might heal them—that might help heal other Black females? They too could claim a digital space to tell their stories, for the telling of stories is itself therapy.

Youth are already charting the digital dimension and sometimes without tracing its links to politics or the past. This is disheartening because the ways Black females experience digital spaces and script their stories there suggest that we do more with them. These spaces are not stable or static but changing like the stories of Black women that dwell within them. Therefore, it is important for educators to act in ways that allow us to know Black women today. In cyber space, these women are unlike my mother. They are, more and more, becoming writers of their own stories. Obtaining the evidence of this and studying this evidence, for me alone, has been transformative. I believe that, if taken to scale in classrooms, such a study of digital texts will make for more informed, more loving, and more sensitive youth.

At its most fundamental level, the significance of such an approach to the Internet and its online social worlds is simple. It is tied to taking Black females seriously and respectfully by seriously studying their ways with digital words. Moreover, it sets out to reverse a pattern of history so deeply ingrained that adolescent Black female digital literacy practices come across as performances that deviate from the social norm. But, the online writings of Black women cover a range of traditional topics that are as normal as birth and life: from love to abandonment and from rape to abortion. By analyzing these topics, any study of Black female online narratives will provide a critically grounded and academically-rich literacy learning experience for all students. Such an experience can in turn lead to new literacy policies, practices, and pedagogies capable of connecting young women and men to discussions of esteem, power, place, performance, and purpose. Importantly, such an experience can offer reprieve to our young women walking the delicate tightrope of being Black and female in

a new digital world—a liberatory place *"...for colored girls who have considered/suicide/but are movin to the ends of their own/rainbows."*

Note

1. All names of people and places in this chapter are pseudonyms.

References

Bakhtin, M. M. (1981). *The dialogic imagination: Four essays* (M. Holquist & C. Emerson, Trans.). Austin, TX: University of Texas Press.

Bakhtin, M. M. (1986). *Speech genres and other late essays*. Austin, TX: University of Texas Press.

Bakhtin, M. M. (1993). *Toward a philosophy of the act.* (V. Liapunov, Trans.). Austin, TX: University of Texas Press.

Brisk, M., Burgos, A., & Hamerla, S. (2004). *Situational context of education: A window into the world of bilingual learners*. Mahwah, NJ: Lawrence Erlbaum.

Carby, H. C. (1987). *Reconstructing womanhood: The emergence of the Afro-American woman novelist.* New York: Oxford University Press.

Collins, P. H. (1990). *Black feminist thought: Knowledge, consciousness, and the politics of empowerment.* Boston: Unwin Hyman.

Collins, P. H. (1993). Toward a new vision: Race, class and gender as categories of analysis and connection. *Race, Sex & Class, 1*(1), 25–45.

Collins, P. H. (1999). Reflections on the outsider within. *Journal of Career Development, 26*(1), 85–88.

Collins, P. H. (2000). *Black feminist thought: Knowledge, consciousness, and the politics of empowerment* (2nd ed.). New York: Routledge.

Doriana, B. M. (1991). Black womanhood in nineteenth-century America: Subversion and self-construction in two women's autobiographies. *American Quarterly, 43*(2), 199–222.

Dyson, A. H. (2003). *The brothers and sisters learn to write: Popular literacies in childhood and school cultures.* New York: Teachers College Press.

Fisher, M. T. (2007). *Writing in rhythm: Spoken word poetry in urban classrooms.* New York: Teachers College Press.

Foster, M. (Ed.). (1996). *Unrelated kin: Race and gender in women's personal narratives.* New York: Routledge.

Fox-Genovese, E.. (1988). My statue, my self: Autobiographical writings of Afro-American women. In S. Benstock (Ed.), *The private self: Theory and practice of women's autobiographical writings* (pp. 63–89). Chapel Hill, NC: University of North Carolina Press.

Freire, P. (1995). *Pedagogy of the oppressed.* New York: Continuum.

Guy-Sheftall, B. (Ed.). (1995). *Words of fire: An anthology of African-American feminist thought.* New York: New Press.

Hartman, S. V. (1997). Seduction and the ruses of power. In S. V. Hartman (Ed.), *Scenes of subjection: Terror, slavery, and self-making in the nineteenth century America* (pp. 79–112). New York: Oxford University Press.

Higginbotham, E. B. (1992). African-American women's history and the metalanguage of race. *Signs, 17*(2), 251–274.

hooks, b. (1981). *Ain't I a woman: Black women and feminism.* Boston: South End Press.

hooks, b. (2000). *Feminist theory: From margin to center.* Cambridge, MA: South End Press.

James, J., & Sharpley-Whiting (Eds.). (2000). *The black feminist reader.* Malden, MA: Blackwell.

Kirkland, D. E. (2008). Shaping the digital pen: Media literacy, youth culture, and MySpace. *Youth Media Reporter, 2*(1), 146–164.

Kirkland, D. E. (2009). Standpoints: Researching and teaching English in the digital dimension. *Research in the Teaching of English, 44*(1), 8–22.

Lenhart, A., & Madden, M. (2007). Social networking websites and teens: An overview. Retrieved November 6, 2008, from http://www.pewinternet.org/PPF/r/198/report_display.asp

Mandler, J. (1988). How to build a baby: On the development of an accessible representational system. *Cognitive Development, 3,* 113–136.

Matute-Bianchi, M. E. (1991). Situational ethnicity and patterns of school performance among immigrant and non-immigrant Mexican descent students. In M. A. Gibson & J. U. Ogbu (Eds.), *Minority status and schooling: A comparative study of immigrant and involuntary minorities* (pp. 205–247). New York: Garland Publishing.

McDowell, D. E. (1985). New directions for Black feminist criticism. In E. Showalter (Ed.), *The new feminist criticism: Essays on women, literature, and theory.* New York: Pantheon.

O'Brien, D., & Scharber, C. (2008). Digital literacies go to school: Potholes and possibilities. *Journal of Adolescent & Adult Literacy, 52*(1), 66–68.

Shange, N. (1997). *For colored girls who considered suicide/When the rainbow is enuf.* New York: Scribner.

Smitherman, G. (1999). *Talkin that talk: African American language and culture.* New York: Routledge.

Strauss, A. L., & Corbin, J. (1990). *Basics of qualitative research: Grounded theory procedures and techniques.* Newbury Park, CA: Sage.

Sutherland, L. M. (2005). Black adolescent girls' use of literacy practices to negotiate boundaries of ascribed identity. *Journal of Literacy Research, 37*(3), 365–406.

West, K. C. (2008). Weblogs and literary response: Socially situated identities and hybrid social languages in English class blogs. *Journal of Adolescent & Adult Literacy, 51*(7), 588–598.

· 5 ·

Textual Play, Satire, and Counter Discourses of Street Youth Zining Practices

Theresa Rogers and Kari-Lynn Winters

The term homeless implies something missing. I call it "homefree."
—Marcin, from *Another Slice* interview

Marcin, one of the street youth we met during the course of a year working on a zine project, voices an opinion above that was prevalent among the group. Many of the youth energetically embrace the street culture, at least temporarily, and have much to say to the rest of the world about homelessness. The zine they created, *Another Slice*, represents this energy and voice. With sophisticated uses of textual play and satire, the zine counters the discourses commonly circulating about homeless people (Hermer & Mosher, 2004).

The work the youth produced in the zine also speaks to the differences in the kinds of literacy practices adolescents are engaged with across more and less formal learning contexts, such as inside and outside of schools (Alvermann, 2001; Hull & Schultz, 2001; McCarthey & Moje, 2001). This chapter extends such observations into the world of some of our most marginalized youth by looking closely at the literacy practices of adolescents and young adults living on the margins of society as examples of powerful cultural productions.

As researchers in the areas of literacy and media have observed, citizens on the margins of society often engage in "tactical" (DeCerteau, 1984) uses of public spaces—creatively borrowing and recombining rules and products for

their own ends (Boler, 2008; Knobel & Lankshear, 2002). Tactical media, in particular, are often localized inventions of practices that contest dominant values and discourses, as opposed to "strategic" media that uphold or perpetuate them. The literacy forms and practices of the street youth in the context of zine production reflect these tactics, carrying implications for educators interested in critical and new literacy practices among youth across the fluid boundaries of school/out-of-school contexts in online and offline spaces.

This chapter is based on a project in which we spent over a year working with street-entrenched youth, ages 16–24, who produced a zine entitled *Another Slice*, which, in their words, provides an outlet to share "art, thoughts and feelings with their peers as well as others" (from the inside cover). The project is, in turn, part of a larger study, the YouthCLAIM project, that supports and investigates the critical literacies and arts-integrated media practices among youth in communities and schools (Rogers et al., 2009). The zine project took place at a youth services center (herein called "the Center") that provides a safe space and various resources for homeless or street-entrenched youth in Vancouver, Canada.

When we began working at this site, the youth were creating a handmade and photocopied do-it-yourself (DIY) paper zine; more recently they shifted to posting the zine on a website—a transition that included an initial resistance and an eventual embracing of the idea of an online presence. In this and other work on youth literacies (Rogers & Schofield, 2005; Rogers et al., in press) we have taken a "spatial" perspective that allows us to conceptualize these practices as "traveling" across social/cultural spaces, rather than occurring in fixed geographical places (Lefebvre, 1974; Soja, 1989). In witnessing the way this zine traveled between offline and online spaces, we concur with Leander and Kim's (2003) argument that these locations are better conceptualized as closely intertwined rather than separate social spaces. What is of particular interest here is the nature of the literacy forms and practices street youth engaged in within and across these zine spaces.

Some Background on Zines and Street Zines

Zines have a long and complex history in North America. Fan magazines started in the 1930s are often seen as prototypes. Since then zines have been appropriated by a variety of "affinity groups" (Gee, 2004) such as political activists in the 1960s, punk rock musicians in the 1970s, feminist and girl power groups in the 1990s. More recently there has been a proliferation of countless groups

posting online zines (Rottmund, 2009; Knobel & Lankshear, 2002). Zines provide a space for these affinity groups to voluntarily come together to share information and participate in appropriating and transforming cultural materials to tell their own stories and build their own communities (Jenkins, 2006).

Street zines have a unique history and trajectory. The first street newspaper in North America may have been *Hobo News* from the 1910s and 1920s in New York City; there are now an estimated 50–70 street or homeless newspapers and zines in North America and Europe (Dodge, 1999). Street newspapers and zines often include poverty-related political issues and free expression with the intent of providing a platform for homeless people to regain independence and maintain self-respect. They include investigative journalism for social action, information for the homeless, poetry and other literary writing, letters, photos, and essays. They often invoke traditional media discourses on the homeless and use sarcasm, and the intended audiences are local (Dodge, 1999; Torck, 2001).

Zines have been taken seriously in popular youth culture (Knobel & Lankshear, 2002) and media studies (Buckingham & Sefton-Green, 1994; Black & Steinkuehler, 2009), and to a lesser extent in literacy studies (Guzzetti & Gamboa, 2004). From all these perspectives, it is argued that zines provide a rich perspective on the cultural production of youth in alternative communities. Because street youth often have tenuous and mobile subjectivities and affiliations, *Another Slice* serves as a particularly unique space, though engagements with it are often fragile and incomplete, not unlike the literacy practices of marginalized youth in school contexts (Rogers & Schofield, 2005; Schofield & Rogers, 2004). Nonetheless these engagements provide a powerful example of the sophisticated cultural productions of youth in a community context.

Another Slice: A Zine by and for Street Youth

Another Slice has its roots in both street newspapers and zine formats. Until recently it was either given away or sold on the street by the youth for extra income. An earlier version of the zine (simply called *Slice*) started in the 1980s but ran into a series of censorship issues, and it was no longer supported by the safe house in which it was located. While the Center, funded by the provincial government, is reluctant to censor any contributions by the youth, it also draws the line at what it calls "isms"—racism, sexism, etc.—or anything bordering on hate speech, which is a violation of the Canadian Charter of Rights.

Another Slice was begun in the late 1990s by one of the original *Slice* contributors who is now working at the Center, with the stated purpose of provid-

ing youth with "a venue for self-expression and freedom of thought" and dedication "to all young people coping with survival on the streets" (from the inside page). It is published several times a year, more recently every month, sometimes in themed issues (Halloween, tattoos, issue for social workers, etc.).

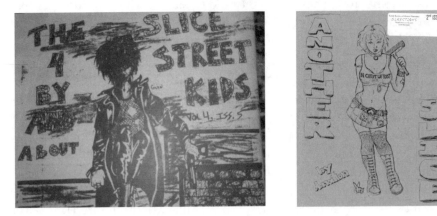

Figure 1. Sample covers from *Slice* and *Another Slice*

Another Slice includes a range of genres and forms—poetry, art, photography, announcements, sayings, essays, interviews, etc (alone or combined) to express interests, to present issues such as drug use, homelessness, power and identity, and to share information about services and surviving on the street.

We were participant observers in the zine group that met one evening a week during a 10-month period, providing various kinds of informal teaching, technical and material support for writing, photography and production. In the beginning, we observed for several weeks a group that was producing and publishing the zine, creating a board game about homelessness and other activities. Later we were more fully engaged in supporting the zine production, which included photographs, artwork, word games, ads, and hybrid literary and expository writings. In these works they were depicting their lives, sharing their interests, or arguing philosophically or politically about issues important to them, including drug use, trust, issues of power and identity, outreach services for homeless youth, and surviving on the street.

Street culture is itself complex and multifaceted. At any given meeting, there may be self-identified tweakers (drug users or former users), trainhoppers (youth who travel on the trains), twinkies (those newer to the streets), youth from multigenerational families of "vagabonds," artists, poets, activists, and so on. Some had the equivalent of a secondary school education and others did

not. Some were still on the streets and others were temporarily housed or couchsurfing. That is, rather than a homogenous street youth culture, the group was made up of individuals and subgroups, each constructing differing and particular kinds of identity positions or subjectivities based on their local situations, interests/beliefs, projects, and goals. Sometimes these differences caused tensions in the group, and at other times they worked together more harmoniously.

Homelessness itself was seen less as a fixed identity marker among the youth than as a temporary situation and affiliation. As one youth wrote: "It's nice when you can remind yourself that you're only living your life like this temporarily as a cautionary tale for your future self." Though many found it to be dangerous and difficult to live on the streets, they often expressed positive aspects of street life and culture—such as freedom, nonconformity, and a sense of community. As Marcin, who was quoted at the opening of this chapter, explained in an interview conducted for a themed issue for a social worker audience:

> The thing is a lot of people on the street who choose to be on the street and constantly they're being bombarded with statements that they are doing something wrong—that they need help or need to change. 'You're a victim of circumstance.' Well no I'm not. The term homeless implies something missing. I call it 'homefree.'…I'm street man. I'm old school. I don't choose this forever. I don't know what the future holds. I'm not committed, but at the present time I don't appreciate being pushed for change all the time.

The Shifting Spaces of the Zine

As mentioned above, the idea of moving the zine to an online site was initially met with resistance. Originally it was connected to the site "Homeless Nation"—an open social networking site for people on the streets (http://www.homelessnation.org/). However, several of the youth in the zine group felt that too many "yuppies" (a fairly open category that appears to include most non-street people) were voyeurs on the site. Interestingly, this concern mirrors the conversations currently taking place in research on the problem of the researchers and others as online "lurkers" and issues of privacy and trust. That is, the street youth engaged in various online communities to maintain relationships and connections (Leander & Kim, 2003) but were clearly aware that various groups might be using their sites for purposes other than what they were intended for and were wary of such practices.

The youth were also concerned that moving the zine online would cause it to "wither on the vine," according to the current Center arts program direc-

tor, and lose "its soul" as a street newspaper. As the group shifted to newer participants, there was less resistance and more positive reactions to the idea of having comments and feedback on their work. According the program director, although it is now fully online (www.anotherslice.ca), it still has a "do-it-yourself" culture in that all aspects are still under the control of the youth. In addition, postcards are produced that can be handed out on the street (see Figures 2 and 3).

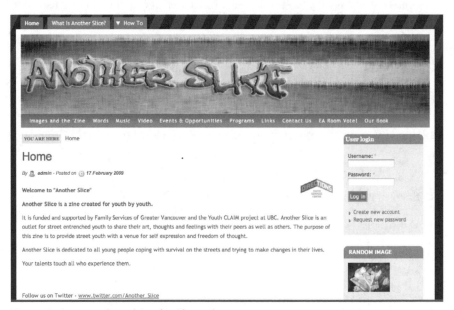

Figure 2. A screen shot of *Another Slice* website

The move from offline paper version to a more fluid on- and offline space brought into relief issues of audience that had intrigued us from the beginning of our project. Many youth seemed to be mainly concerned with reaching a local audience. While some youth were quite interested in a broader audience (one participant, for instance, often wrote sophisticated essays, participated in radio talk shows, and joined a locally sponsored UN conference on human rights), others were content to hand out copies locally to friends or strangers on the streets, sometimes in exchange for money for themselves or to support the production of new issues.

In fact, many street youth talked about living their lives in the city within a "14 block" radius—an area they knew well. They knew how to navigate within this area to stay safe; for instance, it included a bridge where they often

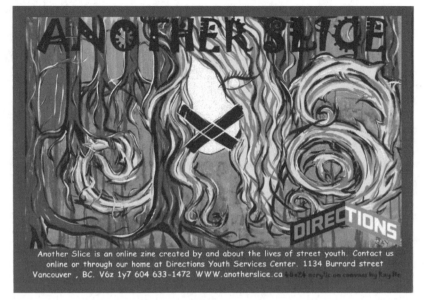

Figure 3. Postcard for *Another Slice*

slept, calling its underside their "sanctuary" (Rogers & Winters, 2008). This deep connection to the local, along with a fascination with the responses they received online with hundreds of hits per month, speaks to the current debate among literacy researchers—to what extent local literacies are hybridized with more distant literacies (e.g., Brandt & Clinton, 2002; Street, 2003). In this case the very "soul" of the zine—the street newspaper aspect—had in fact traveled from more distant sites historically and geographically and is now traveling outward again in a new form. The online site now includes the words and images of the zine along with youth-produced music, videos, information and events, sites for blogging and tweeting, and a page publicizing a related poetry anthology (Mills & Rogers, 2009).

Literacy Practices of a Street Zine: Textual Play, Satire, and Counter Discourses

It was ideal for us, as researchers, to witness and participate in the offline iteration of the zine as it gave us a deeper understanding of the processes behind the development of the online presence (Leander & Kim, 2003). The focus here is on the energy and power of the literacy practices and forms represented in the zine and the implications for thinking about it as an informal or alterna-

tive literacy-learning site. The use of textual play, satire, and counter discourses was often intertwined as a set of critical literacy practices (Freire, 1970), as is evident in the examples below, in which we highlight each aspect separately.

Textual Play

We were struck by the sophisticated textual play the youth engaged in as they produced various works. Theories of genres as flexible cultural forms and social practices that are hybridized into new genres (Bakhtin, 1986; Briggs & Baumann, 1992) provide a lens for examining the ways the youth juxtapose and transform literacy genres and forms across modalities (Buckingham & Sefton-Green, 1994; Lemke, 1995; Manovich, 2001; Stein, 2008).

For instance, the youth often used hybrid genres and forms while also using print literacies juxtaposed or layered with multimodal literacies for particular critical effect. Below are two examples. In Figure 4, the youth have used an already hybridized form—a visual puzzle—that asks the viewer to locate used needles ("rigs") in the Downtown Eastside of the city—an area well known for poverty, drug use, sex workers and crime as well as for community activism, see http://en.wikipedia.org/wiki/Downtown_Eastside.

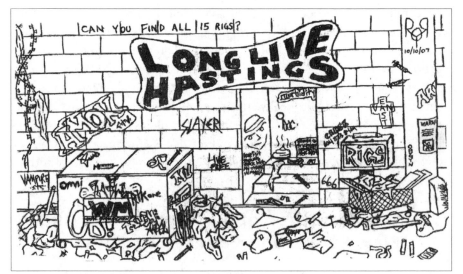

Figure 4. Visual puzzle from paper version of zine

The disposal of rigs is a particular issue for street youth who often pick up part-time work through the Center cleaning up used needles. Though many are drug users or former users themselves, they resent those who carelessly dispose of nee-

dles in public places, including schoolyards and parks where children are put at risk when there are needle disposal boxes available, as is represented in the puzzle. The effect here is to provide immediate engagement by the viewer into the problem without proselytizing, but rather with the more sophisticated approach of using an ironic tone ("Long Live Hastings") that makes reference to the street that is most well known for drug-related activities. The use of "Long Live…" may reference issues of continuity of "power" or in this case, a kind of powerlessness to address a social issue. The mix of visuals and text throughout signals meaningful cultural references (graffiti, trash, a stairwell, etc.) to the destitution along a street that they avoid and often see as a kind of warning sign—a life many clearly say they do not want to emulate as adults.

Another example of textual play is from the tattoo issue (Figure 5) from the online version of the zine.

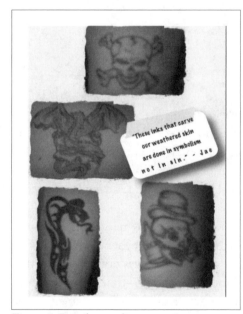

This page has photographs of actual tattoos of participating youth overlaid with a poem by a young woman named Jae that is written in classical rhyming couplets: "These inks that carve/our weathered skin/are done in symbolism/not in sin." The poem provides a clear and simple yet highly eloquent statement of resistance to being stereotyped by choosing to sign their identities on their bodies. These two examples are among many that incorporate textual play—the combination of genres, forms, and modalities.

Figure 5. Page from online tattoo issue

Satire

Irony (as illustrated in the visual puzzle above) and parody as forms of satire are another set of linguistic and semiotic tools often used by the street youth in the zine. Figure 6 illustrates the way the youth readily parody and transform popular culture and media forms. Here, for instance, the familiar credit card advertisement is appropriated effectively to make a statement about homelessness.

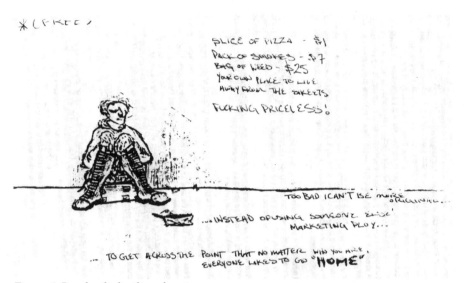

Figure 6. Parody of a familiar advertisement

The slogan in Figure 6 reads: "Slice of Pizza—$1/ Pack of Smokes—$7/ Bag of Weed—$25/ Your own place to live away from the streets/FUCKING PRICELESS." The youth visually represented is sitting on a street wearing a style of boots popular among street youth. The appropriation and parody of the credit card ad genre are original and powerful—pointedly contrasting the gulf between those that live on the margins of society and the assumed audience of the original ad.

Nonetheless, the creator laments her "lack of originality" and use of a "marketing ploy," a kind of self-critique that adds another layer of literate commentary and awareness. And in case the meaning was not fully grasped by less sophisticated readers, a clearer version is appended—that everyone wants a home. This zine page repositions the creator of the ad as someone who "speaks back to power" with humor (parody), awareness, insight and with a pointed message (that reaches toward satire. These linguistic tools of irony, parody, and satire were often incorporated into the zine pages, along with a playfulness with text forms, resulting in clear and powerful messages that ran counter to common discourses about street youth.

Counter Discourses

While many of the youth we worked with would be considered highly literate,

there were zine participants whose print literacies were limited yet had powerful messages to convey and often did, sometimes with our support or the support of other youth workers. For instance, one youth who told us he was a "pretty outspoken person" but was "still learning to read and write" created a provocative page about the problem of needle disposal. His page includes a picture of a "rig" with the slogan: "Rigs go in a box, not in my parks and schools"— a statement that reiterates the views expressed through the visual puzzle in Figure 4. He later explained: I was talking about finding rigs and Kari asked if there was a way I could put it on paper.... I don't care about the reaction. If it's offered that's cool. Street people are interested in writing, art and shit like that. People on the streets do more than shoot up and fall down all day."

What is of interest here is that this youth was consciously producing discourses that ran counter to the way they were being constructed by others in media and in lived experiences and interactions with people on the streets. Looking back at all of the examples above, it is clear that by appropriating traditional discourses, hybridizing genres and forms, and using satire, the creators were talking back or disrupting "repetitive citations" (Davies, 2008) about street youth that disempower them, and thereby repositioning themselves in relation to their audiences. These counter discourses (Deleuze & Foucault, 1977) resist and challenge the legitimacy of the original discourses and "presuppose a horizon of competing, contrary utterances against which it asserts its own energies" (Terdiman, 1985, p 36).

Another clear example of this energetic counter discourse that presupposes an awareness of the lenses through which street youth are being viewed is a longer poem by Jae, again written in couplets, entitled "Yuppy Muck":

Yuppy Muck

Tripping time to waste away
Broken souls rot to decay
Cityscapes the goal [sic]* of me
Fringed with lies and vanity

You bastards walk with noses high
Lamb skin coats, no wonder why
A travesty mole on your city face
"Souls of the Street are such a disgrace"

We are proof this city's fucked
Chill for a while, now we're stuck
Watch the needles shoot the drug
Another problem swept under the rug

Know this in heart you sorry fuck
My feet are trapped in your city muck
You don't care, think your [sic] so wise
You who cause your cities [sic] demise
typo [goat]

Although Jae has chosen here to use one of the most traditional print genres—a ballad-like poem with four-line stanzas (quatrains) with a consistent meter (eight beats per line with occasional nine or 10 beats as a kind of refrain, stress on first syllables) and rhymed couplets—the statement is both fresh and confrontational. Jae exploits the contrasting stereotypical discourses defining "yuppies" and "homeless" for her own purpose. Yuppies are "time-wasting," have "broken souls, and are narcissistic liars "fringed with lies and vanity." Street people are drug addicts (shooting up) and are ruining the city—are a "disgrace." At the same time the poem is held together by the idea that street people are simply the scapegoats for a host of societal ills—that blame is in fact misplaced in the discourses about "problems" the city faces.

Zines as Alternative Literacy and Learning Spaces

To explore this street zine as a fluid cultural space where youth engage in highly literate and sophisticated uses of textual play, satire, and counter discourses reveals much about the lives and literacies of youth on the margins of society. *Another Slice* can be seen as a kind of alternative or informal learning space that is created by "self-educating communities" (Burbules, 2007) and has the potential to transform our understanding of educational theory and practice (Bekerman, Burbules & Silberman-Keller, 2007). For instance, the study of informal learning can help us to better understand (1) connections between education and public life, (2) the relationship of learning and identity, (3) the role of "new literacies" (Coiro et al., 2008), including multimodal, digital and online literacies, in youth participatory culture (Jenkins, 2006), and (4) the importance of alternative pedagogical approaches and ways to access education.

Education and Public Life

It could be argued that the creators of *Another Slice* are, in many ways, more engaged in public life than many middle-class, housed adolescents who attend schools every day. For instance, in addition to actively producing public counter

discourses in virtually every issue, they created a special issue of their zine that addressed those becoming social workers:

> This edition of *Another Slice* is an outlet for street entrenched youth to share their thoughts and feelings about the system created to serve them; a system that is often less than ideal. We hope that social work students can learn from these words. We hope you take them to heart. (From the inside cover).

In this issue are poems about homelessness, stories of inadequate counseling, interviews that talk about the problem of attempting to change rather than support street youth and the danger of shelters, and essays by youth suffering from addiction and mental illness about the "school of the streets." A new, related project at the Center, called "In Our Shoes," takes this project even further by educating the public about homelessness and how they can make a difference (http://www.inourshoes.ca).

Identity and Literacy Learning

The various affiliations and identity positions the youth express are central to what they produce in the zine. It has often been pointed out that the ways in which adolescents engage in literacy work reflect their affiliations and identity positions (e.g., Alvermann, 2001; Gee, 2004). This is particularly true of these street youth. Their literacy practices and forms reflect both the local, mobile and tenuous affiliations of the community and their broader social and political awareness and concerns and their active engagement in participatory culture (Jenkins, 2006)—that is, as producers of culture in a connected community.

The New Literacies

The advent of new media and digital technologies lowers the barriers for youth who engage in participatory culture through literacy production, particularly through online and Web 2.0 platforms. Even in the paper version of the zine, the street youth had ready access to popular culture and media that enabled them to appropriate discursive resources, use multiple, layered modalities (old and new), and borrow and hybridize genres. They effortlessly moved toward parody as a form of satire (Buckingham & Sefton-Green, 1994), as counter pedagogies (Kellner & Share, 2005), and, in turn, as a form of citizenship (Boler, 2008). However, the connected space of the online platform lowered the barriers even more for immediate sharing of their work and ideas with a broader audience without sacrificing the DIY aspect.

Alternative Pedagogies

Alternative pedagogies such those that took place in the zine spaces echo Freire's distinction between systematic education, which can only be changed by those in power, and *educational projects* in which oppression can be transformed through "praxis" involving both a change in the way oppression is perceived and the "expulsion of myths" of the oppressor (Freire, 1970, pp. 54–55). In many ways the zine is an informal educational project within which the street youth engage in dialogue that "names the world" around them. From this perspective it is less surprising and quite significant that the participants have welcomed a shift in the physical and cultural location to an online space that broadens this dialogue.

Implications for Educators

What might educators take away from a deeper understanding of the literacy practices of street youth? First, it is clear that even the most marginalized youth are participating in sophisticated and powerful textual practices outside of formal learning environments. There are traces of close, engaged reading of popular culture and public discourses surrounding the youth in their everyday lives. The ability to engage in textual play, satire and counter discourses is based on a savvy ability to read these cultural texts and transform them. What similarly innovative and critical reading, writing and multimodal literacy practices can we find in formal educational settings? If the "voluntary" literacies of these youth are at once artful, playful and critical, why are in-school literacies often lacking in these qualities?

Second, what would happen if teachers and mentors in schools and other formal learning sites were more attentive to the various and shifting affiliations and identity positions of the adolescents they work with? How might we create spaces for adolescents to engage in tactical discursive appropriations and the creation of counter-discursive claims to claim identity positions, to (re)position themselves and others, and to engage them in public dialogue and social critique as part of schooling?

Finally, educators across a spectrum of "disciplines" can no longer ignore the powerful integration of media, literacy, and digital technologies produced and consumed in the daily lives and interactions among adolescents. Today's youth are wired, connected, digital natives who engage in complex literacy performances across social, cultural and global spaces. How do we rethink and remake our curricular engagements with adolescents to capture, encourage, and

keep up with these fast-moving and powerful literacy practices and cultural productions? How do we engage *with* youth in ways that continue a critical dialogue about the role of these practices at the intersection of education, democracy, and social justice?

References

Alvermann, D. (2001). Reading adolescents' reading identities: Looking back to see ahead. *Journal of Adolescent & Adult Literacy, 44*(8), 676–690.

Bakhtin, M.M. (1986). *Speech genres and other late essays.* Austin, TX: University of Texas.

Bekerman, Z., Burbules, N., & Silberman-Keller, D. (2007). Introduction. In Z. Bekerman, N. Burbules, & D. Silberman-Keller (Eds.), *Learning in places: The informal education reader* (pp. 1–8). New York: Peter Lang.

Black, R.W., & Steinkuehler, C. (2009). Literacy in virtual worlds. In L. Christenbury, R. Bomer, & P. Smagorinsky (Eds.), *Handbook of adolescent literacy research* (pp. 271–286). New York: Guilford Press.

Boler, M. (2008) *Digital media and democracy.* Cambridge, MA: MIT Press.

Brandt, D., & Clinton, K. (2002). The limits of the local: Expanding perspectives on literacy as a social practice. *Journal of Literacy Research, 34*(3), 337–356.

Briggs, C., & Bauman, R. (1992). Genre, intertextuality and social power. *Journal of Linguistic Anthropology, 2*(2), 131–172.

Buckingham, D., & Sefton-Green, J. (1994). *Cultural studies goes to school.* Bristol, PA: Taylor & Francis.

Burbules, N. (2007). Self-educating communities: Collaboration and learning through the internet. In Z. Bekerman, N. Burbules, & D. Silberman-Keller (Eds.), *Learning in places: The informal education reader* (pp. 273–284). New York: Peter Lang.

Coiro, J., Knobel, M., Lankshear, C., & Leu, D. (2008). Central issues in new literacies and new literacies research. In J. Coiro, M. Knobel, C. Lankshear, & D. Leu (Eds.), *Handbook of research on new literacies* (pp. 1–21). New York: Routledge/Taylor & Francis.

Davies, B. (2008). Re-thinking "behaviour" in terms of positioning and the ethics of responsibility. In A. M. Phelan & J. Sumsion (Eds.), *Provoking absences: Critical readings in teacher education* (pp. 173–186). Rotterdam: Sense Publishers.

DeCerteau, M. (1984). *The practice of everyday life.* Berkeley, CA: University of California Press.

Deleuze, G. & Foucault, M. (1977). Intellectuals and politics. In D. E. Bouchard (Ed.), *Language, counter-memory, and practice* (pp. 205–217). Ithaca, NY: Cornell University Press.

Dodge, C. (1999). Words on the street: Homeless people's newspapers. *American Libraries, 30*(7), 60–62.

Freire, P. (1970). *Pedagogy of the oppressed.* New York: Continuum.

Gee, J.P (2004). *Situated language and learning: A critique of traditional schooling.* New York: Routledge.

Guzzetti, B., & Gamboa, M. (2004). Zines for social justice: Adolescent girls writing on their own. *Reading Research Quarterly, 39*(4), 408–436.

Hermer, J., & Mosher, J. (2004). *Disorderly People: Law and the Politics of Exclusion in Ontario.* Halifax, NS: Fernwood Publishing.

Hull, G., & Schultz, K. (2001). Literacy and learning out of school: A review of theory and research. *Review of Educational Research, 71*(4), 575–611.

Jenkins, H. (2006). *Confronting the challenges of participatory culture: Media education for the 21st century.* The MacArthur Foundation. Retrieved March 15, 2008, from http://digital-learning.macfound.org/atf/cf/%7B7E45C7E0-A3E0-4B89-AC9C-E807E1B0AE4E%7D/JENKINS_WHITE_PAPER.PDF

Kellner, D., & Share, J. (2005). Toward critical media literacy: Core concepts, debates, organizations, and policy. *Discourse: Studies in the Cultural Politics of Education, 26*(3), 369–386.

Knobel, M., & Lankshear, C (2002). Cut, paste, publish: The production and consumption of zines. In Alvermann, D. E. (Ed.), *Adolescents and literacies in a digital world* (pp. 164–185). New York: Peter Lang.

Leander, K.M., & McKim, K. (2003). Tracing the everyday "sitings" of adolescents on the internet: A strategic adaptation of ethnography across online and offline spaces. *Education, Communication & Information, 3*(2), 211–240.

Lefebvre, H. (1974). *The production of space.* Oxford: Blackwell.

Lemke, J. (1995). *Textual politics.* London: Taylor & Francis.

Manovich, L. (2001). *The language of new media.* Cambridge, MA: MIT Press.

McCarthey, S.J., & Moje, E. (2001). Conversations: Identity matters. *Reading Research Quarterly, 27*(2), 228–238.

Mills, E., & Rogers, T. (Eds.) (2009). *Words from the street: Writings from Another Slice.* Vancouver, B.C.: SPN Publishing.

O'Brien, D. (2005). "At-risk" adolescents: Redefining competence through the multiliteracies of intermediality, visual arts, and representation. *Reading online.* Retrieved March 20, 2005, from http://www.readingonline.org/newliteracies/obrien/

Rogers, T. (2009). Theorizing media productions as complex literacy performances among youth in and out of schools. In D. Pullen & D. Cole (Eds.), *Handbook of research on multiliteracies and technology enhanced education.* Hershey, PA: IGI Publishers.

Rogers, T., & Schofield, A. (2005). Things thicker than words: Portraits of youth multiple literacies in an alternative secondary program. In J. Anderson, M. Kendrick, T. Rogers, & S. Smythe (Eds.), *Portraits of literacy across families, communities and schools* (pp. 205–220). Mahwah, NJ: Lawrence Erlbaum.

Rogers, T., & Winters, K. (2008). Within 14 blocks: Zining with street youth in the YouthCLAIM project. Paper presented at the National Reading Conference, Orlando, FL.

Rogers, T., Winters, K., LaMonde, A., & Perry, M. (in press). *Pedagogies: An International Journal, 5*(4).

Rogers, T., Winters, K., Perry, M, & LaMonde, A. (2009). The YouthCLAIM project: Researching critical literacies and arts-integrated media production among youth in classroom and community sites. Paper presented at the annual meeting of American Educational Research Association, San Diego, CA.

Rottmund, K. (2009). A little bit about everything you need to know about zines. *Visual Literacy.* Retrieved August 21, 2009, from http://aclayouthservices.pbworks.com/Visual-Literacy

Schofield, A., & Rogers, T. (2004). At play in fields of ideas: Teaching curriculum and the lives of youth. *Journal of Adolescent & Adult Literacies, 48,* 238–248.

Sefton-Green, J. (2000). *Young people, creativity and new technologies.* London: Routledge.

Sefton-Green, J. (2006). Youth, technology and media cultures. In J. Green & A. Luke (Eds.), *Rethinking learning: What counts as learning and what learning counts. Review of research in education* (pp. 279–306).Washington, DC: American Educational Research Association.

Soja, E. (1989). *Postmodern geographies: The reassertion of space in critical social theory.* London: Verso.

Stein, P. (2008). Multimodal instructional practices. In J. Coiro, M. Knobel, C. Lankshear, & D. Leu (Eds.), *Handbook of research on new literacies* (pp. 1–22). New York: Routledge/Taylor & Francis.

Street, B. (2003). What's new in new literacy studies? Critical approaches to literacy in theory and practice. *Current issues in comparative education, 5*(2), 77–91.

Terdiman, R. (1985). *Discourse/counter-discourse: Theory and practice of symbolic resistance in nineteenth century France.* Ithaca, NY: Cornell University Press.

Torck, D. (2001). Voices of homeless people in street newspapers: A cross-cultural exploration. *Discourse and Society, 12*(3), 371–392.

· 6 ·

Digital Literacies and Hip Hop Texts

The Potential for Pedagogy

JAIRUS JOAQUIN

"It's not our hip hop," my old college roommate told me as he described how today's adolescents participate in hip hop with their readily available digital technologies. Up to this point in our conversation we had been "talking hip hop" much like we had done 10 years ago in the living room of our apartment. Our conversations back then often centered on the dynamic world of hip hop music. In those days we had endless discussions on every conceivable detail of the hip hop music of which we were both intense fans. The topics ranged from who was the greatest lyricist of all time and why, to whether hip hop was a reflection of American and/or African American culture, to the musical ingenuity of a producer's use of the horn, keyboard, or bass drum during the chorus of a particular song.

But on this particular day I turned our conversation to a different topic when I asked him how he thought technology had changed hip hop. My old friend, now a high school football coach, responded by telling me that adolescents today had instant access to hip hop anytime that they wanted it, and this access had, as he put it, "totally changed the game." He told me today's youth have so many more choices than we had and that the ways that they can connect to the world of hip hop are endless. Providing me with a quick example, he said, "Remember when if you wanted to hear a particular song or see a video

you had to wait all day until they played it on the radio or on TV? Those days are over now. These kids can watch any video on YouTube anytime they want."

After our conversation ended, I thought long and hard about what we had discussed. I had been thinking a lot about hip hop because I had been working on a paper that addressed critical literacy and controversy within hip hop culture. But now I wondered about the vast amount of texts in the digital world of today's hip hop adolescent. I thought about the potential for literacy education embedded within those texts. I thought about the sociocultural approach to literacy that serves as the framework for this chapter. I thought about language, culture, social relationships, learning, and literacy. I surmised that today's adolescents have more access to hip hop texts with which to make meaning than I ever would have dreamed of when I was listening to my favorite hip hop tapes and CDs in my parents' basement as a teenager. Yet, I noticed a striking similarity in the way that I used hip hop as a social avenue through which I developed relationships with my friends at the high school lunch table, while waiting to get my haircut in my friend's college dorm room that also functioned as a barbershop, and in late night living room conversations with my roommate.

Young fans of hip hop still have these same opportunities for social interaction, but they also have much more. With access to new digital technologies, they can interact with others on a global scale in rapidly changing networked worlds that make use of broadened definitions of what it means to be literate in the 21st century. In fact, some educators contend that adolescents' digital literacy practices have potential pedagogical significance. For instance, Alvermann (2008) theorized that classroom teachers who are open to appreciating the literacy skills young people use to communicate online are more likely to channel those skills into educationally appropriate content than teachers who are not so inclined.

In this chapter, which draws on data from an inquiry project I conducted on hip hop texts viewed from a sociocultural perspective, I provide a close look at some of the digital literacies adolescents use to interpret and socially interact around hip hop texts. I do so in order to formulate new ways of thinking about how educators can apply this information for pedagogical purposes.

A Sociocultural Perspective on Hip Hop Texts

Proponents of the New Literacy Studies (NLS) hold that literacy practices are closely tied to social purposes and cultural norms (e.g., Gee, 1996; Street,

1995). Viewed from this perspective, it comes as no surprise that adolescents' literacy practices can, and often do, extend beyond school walls (Hull & Schultz, 2001) and traditional print texts (Alvermann, 2002). In Szwed's (1981) "Ethnography of Literacy", the argument is made that individuals and their places within a social group largely determine what counts as reading and writing. Given this line of reasoning, a school's continuous privileging of print texts could lead some students to believe that interpreting images, sounds, gestures, and other non-linguistic texts does not count as literate behavior.

The New London Group (NLG) (1996) theorized that the concept of texts had to be broadened to include the "burgeoning forms of [meaning making] associated with information and media technologies" (p. 61). Using the term *multiliteracies* to frame their work, members of the NLG sought to account for the "increasing multiplicity and integration of significant modes of meaning making" (p. 62). Yet, when these expanded notions of text and literacy are ignored or openly contested, a more narrow view of what it means to be equipped for success in school often becomes the norm. As Heath (1983) pointed out, more than two decades ago, this situation can lead to labeling students as incompetent readers and writers despite the fact they may be competent and fluent interpreters and designers of texts in another culture, such as hip hop.

The Hip Hop Phenomenon

Hip hop is an organic art form and culture that emerged from the streets of the Bronx, New York, in the 1970s (Keyes, 2002). The birth of hip hop was a response to the economic and social deprivation occurring in post-industrial American urban environments (Kitwana, 2002). The performance of hip hop, which included rapping, DJ-ing, breakdancing, and graffiti art, mainly occurred at parks, on street corners, and in alleys (Keyes, 2002). As hip hop gained popularity, it ignited the economically depressed community in the Bronx. Hip hop provided a space for the young people in the area to express their emotions and frustrations in relation to their circumstances. Hip hop artists performed at local shows, talent contests, and festivals. Rapping, the delivery of rhythmic poetry against music, became one of the most popular components of hip hop.

The conflict between hip hop's responsibilities as an avenue for pro-social empowerment, and its existence as "simply entertainment" was evident from the start, and it continues to be an issue today. Although some believe that hip hop exists mainly for entertainment and commodification, others believe that

it is the responsibility of hip hop to illuminate the social issues present in urban centers (Rose, 2008). Little by little, hip hop became wildly popular across the U.S. in the 1980s. Music industry executives recognized that hip hop music was not a passing fad but a valuable commodity that could be marketed to mainstream audiences (Watkins, 2005). In the 1990s hip hop exploded as one of the music industry's most popular genres. Today it is a global phenomenon and a multi-billion dollar industry. Hip hop is not limited to music but is instead a general lifestyle that takes into account fashion, cosmetics, movies, marketing, scholarship, and political activism.

Although hip hop is a global phenomenon and its fans include people of assorted races, ethnicities, and social classes, the majority of popular American-based hip hop artists continue to be African American men (Watkins, 2005). In the genesis of hip hop the artists were predominantly African American men, and hip hop was an expression of African American youth culture. Hip hop has maintained its popularity among African American youth throughout its growth, in part because it provides a voice for the issues of inner city life (Kirkland & Jackson, 2009).

Hip Hop Texts

A growing number of scholars have proposed that hip hop texts can and should be used as instructional resources in formal and informal educational settings. For instance, some have advocated that hip hop be used for critical media literacy pedagogy (Parmar, 2005; Stovall, 2006) in which hip hop texts such as rap lyrics are deconstructed and used as empowering and liberating educational tools. Others have experimented with students' production of hip hop texts, ranging from writing lyrics to producing songs and videos (Mahiri, 2002; Weinstein, 2006). Because hip hop music and culture are sources of pleasure for many adolescents, they serve as potential connections to learning that go beyond traditional forms of instruction. Young people who engage in producing hip hop texts find an avenue for identity construction and an outlet for expressing resistance to norms that are placed on them, as well as a pathway to vent about the many issues and challenges that they face (Weinstein, 2006).

Hip hop music can also be used as a means to develop academic literacy skills that will transfer to school learning. Morrell and Duncan-Andrade (2002) argued for a broader definition of school-based literacy that takes into account students' cultural awareness, values, and social consciousness. Urban students who are marginalized in society often struggle to merge their cultural identities

with the school curriculum. Morrell and Duncan-Andrade implemented a literacy unit with high school seniors in which they juxtaposed rap lyrics (a form of poetry) with canonical poetry. They found that the students were often able to deconstruct the text (the rap songs as well as the canonical poetry) using critical literacy skills that are highly valued and taught in the regular curriculum.

Kirkland (2008) also found that literacy educators can make use of students' experiences with hip hop to engage them in critical literacy for the purpose of advancing their academic literacy skills. For the students that Kirkland worked with, hip hop music informed their multiple literacies through the music itself and its poetic features. Kirkland suggested that many students in today's multicultural classrooms resist having to conform to schooling practices that reinforce the primacy of White-centered patriarchal texts. In taking the stance that hip hop texts can be used to meet curriculum requirements and standards for literacy, Kirkland (2007) demonstrated the willingness of youth to engage in a critical study of texts and issues that hold relevance for them.

Interview Study: Adolescents' Uses of Hip Hop Texts

In order to assess how educators can draw upon the digital hip hop texts that many adolescents read on a daily basis, we must first learn how adolescents use their digital literacies to access these hip hop texts. Toward that goal, I interviewed three African American male high school students enrolled in a Saturday morning mentoring program sponsored by an alumni chapter of my historically African American fraternity. The mission of the program is academic and stewardship improvement, career development, and leadership training for young males in middle school and high school. The students and/or their parents volunteered to take part in the study. The following is a brief description of the participants and their core internet activities discussed in the interviews.

Participants

Bob (all names are pseudonyms) was a 15-year-old sophomore who was fairly familiar to me as I had worked with him in the past when leading literacy activities within the program. His involvement in hip hop texts centered mostly on his downloading of "mix tapes" and songs from the internet. Mix tapes are a collection of songs compiled by a DJ. On the two websites DJdownloadz.com (http://www.djdownloadz.com), and Datpiff (http://www.datpiff.com) Bob was

able to choose from a wide variety of mix tapes from several genres of music, including R&B, hip hop, reggae, and reggaeton. Bob, who at one time wanted to be a professional DJ, considered himself a true lover of music.

Dwayne, a 17-year-old high school sophomore, knew me well as I served more as a direct mentor to him in the program. He liked to browse the Web to listen to his favorite hip hop artists and preferred to listen to songs on a file sharing site YouTube (http://www.youtube.com), or the digital music service website Rhapsody (http://www.rhapsody.com). He liked listening to music on the file sharing sites like Frostwire (http://www.frostwire.com) because he enjoyed listening to the most current music for free. He also liked to go to his favorite artists' MySpace pages to listen to their songs and also to learn about them.

Dee was a 14-year-old freshman who liked to shop and buy hip hop music on the music service software iTunes (http://www.itunes.com) and also liked to view music videos on YouTube. I had no previous contact with Dee prior to the interview, although I knew his fathe, who served as a mentor within the program. Dee appreciated the complicated stories and topics hip hop artists often told in their songs. He sometimes printed out song lyrics from the Web and memorized them because they served as a source of inspiration for him to face challenges within his life.

The Interviews

The interviews were conducted in front of a computer with Web access, providing the participants the chance to demonstrate the activities that they described. I followed up on the participants' answers to my questions with probing questions, seeking to clarify and extend their statements (Kvale, 2007). I asked them questions about how they came to like hip hop, why they continued to like hip hop, and what meaning hip hop had in their lives. We discussed how they accessed hip hop texts, focusing on how they used digital technologies to do so. They showed me some of the websites that they used and demonstrated for me what they did on the websites. We explored how the websites were organized and how each participant read the information within the websites. We discussed digital technologies and what they believed are the advantages and disadvantages of them. They showed me some of their favorite hip hop texts including music videos, songs, and social networking pages. The interviews were carried out in person and not in the presence of any other participants, peers, mentors, or parents.

Hip Hop as a Social Literacy

For each of these three young men their participation in hip hop was highly social. They all reported that they began to like hip hop at around the age of nine or 10, partly because an authority figure such as a parent or older relative listened to hip hop music and consequently they were drawn to it. The social nature of hip hop has continued to provide them a source of daily interaction with their friends.

Dee, in particular, seemed to learn about hip hop from his friends. Once he became interested in hip hop music, he was aided by a friend who would get music for him and put it on a flash drive so that Dee could listen to it on his computer. Dee was mentored into the world of hip hop, and most of his favorite artists were recommended to him by this same friend. However, his mother introduced him to Jay-Z, who became his favorite rapper. Although some might find it unusual for an adolescent male to so closely identity with the musical tastes of his mother, both Bob and Dwayne also reported first learning about hip hop music from their mothers. Bob, like Dee, was also mentored into a new musical genre by a friend. He spent a great deal of time in his interview discussing reggaeton, a musical genre that is a mixture of Latin American music, Jamaican dancehall, and hip hop (Rivera, Marshall, & Hernandez, 2009).

Bob was first introduced to reggaeton by a Mexican American friend of his. Although reggaeton is performed exclusively in Spanish, Bob gravitated to the music immediately because of its Caribbean rhythms, Spanish delivery, and hip hop edge. Bob began downloading reggaeton mix tapes and songs from several websites that he showed me. He played several reggaeton songs and explained the musical differences between traditional reggae and reggaeton. At one point in the interview the wireless connection on my laptop computer failed when Bob was about to play one of his favorite reggaeton songs for me. Bob then took out his iTouch device and showed me the musical video of the song on his iTouch. I was intrigued by the idea that Bob, like many other adolescents, had constant access to the hip hop texts that play such a prominent role in their social worlds.

Although Dwayne often went to MySpace to interact with his friends, he also liked the site because it offered him opportunities to view the profiles of his favorite hip hop artists and to listen to music from their playlists. Dwayne demonstrated how he could take a song from an artist's page and play it on his own profile. He said that he usually changed the song on his profile on a week-

ly basis. The combination of MySpace and hip hop allowed him to network with others while learning about his favorite artists and gathering new music.

Perceptions of Digital Technologies

Each of the three participants believed that the internet had made hip hop more accessible for consumers. However, they differed in how this affected hip hop artists and the industry. Dwayne discussed the economic repercussions of the internet for hip hop artists.

> *Dwayne*: I think it's (hip hop) changed cuz a lot of people don't buy albums because of the internet and stuff. And they have stuff like Frostwire. Like you wouldn't have to go out and pay for a album. You just go to Frostwire or Rhapsody or YouTube or something and just listen to it, and you don't even have to pay. You can listen to any song you want to on the computer.
>
> *Jairus*: So you have more access to songs and hip hop. Do you think that's good or bad?
>
> *Dwayne*: It's good for us cuz you don't have to pay. But it's bad for the artist cuz they're not making any money.

Bob, on the other hand, felt that the Web was valuable for amateur artists because it provided a forum for them to showcase their music. This is consistent with the idea that the internet fosters an environment for amateur artists to freely market themselves on a global scale fostering a sense of grassroots creativity (Jenkins, 2006). Bob told me about several artists who had been discovered by marketing themselves on the internet as he described its benefits:

> A lot of people are found on the internet, like you may have um MySpace where people create profiles and stuff like that, and these people, they can go to a music session, and post their music on there. You may not be able to download certain people's music, but it helps introduce that person.

The mass media and capitalistic marketplaces also benefit from the grassroots efforts of fan culture because they depend on consumers to disburse information about new products in an increasingly crowded media market (Jenkins, 2006). Dee, like Dwayne, believed that the internet and technology negatively affected hip hop artists because people were more likely to listen to their music for free rather than purchase an album. However, Dee also recognized the benefits for the artist and the music that came with a participatory culture:

> The bad thing about that though is that person that made the song now is making less money because it's on like, you can get on the internet . . . So that's the bad thing about it. But it also kinda spreads, like if you get more famous. You won't make the same amount of money but you do get more famous. Because like me I didn't know who Drake (hip hop artist) was but now that I heard about him, like I know who he is. And

I would recommend him for somebody else.

Critical Readers

All three participants were well aware that they had almost unlimited access to a variety of hip hop texts. And with this access came many opportunities to read the texts critically—to think deeply about complex issues embedded in hip hop content and to relate those issues to their own lives. For example, Bob acknowledged that hip hop artists focused on social and political issues, such as violence, sex, drugs, money, and trying to survive within urban ghettos. In discussing the role of the internet and its impact on hip hop, Bob noted:

> Um well the internet is a worldwide thing, so many people are able to access hip hop and everything. And if you look around the world hip hop has affected several places. You may have some positive, and you may have some negative effects to it.

Dwayne called attention to how hip hop had made its way into popular culture worldwide and how it had affected him as a young African American man. For example, he discussed its influence on the way he and his peers dressed, noting that as hip hop style and fashion shifted, so did people's willingness to integrate elements of rock and hip hop cultures, as well as Black and White cultures:

> Like people started wearing like a mixture of Black and a mixture of kind of like what Caucasians wear and stuff like that. Like a lot of people, a lot of kids are wearing Mohawks and stuff like that now. Like back then we didn't even think twice about getting Mohawks or whatever. Now they see rappers and people getting Mohawks so they want to get Mohawks too.

Dee drew inspiration from critically analyzing hip hop texts and applying what he learned to his own life. For example, he showed me a music video by rapper T.I. entitled "No Matter What" (Lopez & Harris, 2008), which has a storyline that takes place in a dark underground setting. Dee said the video represented a situation T.I. had recently experienced and that the song was a narration of T.I.'s pending felony gun charges. Dee said that just as T.I. had used the song to get through his particular situation, so, too, had he (Dee) drawn on the song for personal reasons on a regular basis. Dee explained that he sometimes prints out song lyrics from the Web, reads them, and memorizes them so that he'll have them handy in times of adversity:

> Well actually most of the time I listen to what they're saying and it kind of like tells a story. And you know you kind of benefit from it in life. . . . so that one actually like, that one I usually listen to when I'm like, when I feel like, I'm not ready for something.

But I don't feel like doing anymore. Then I like to put that music on, and just go ahead and do my work, and try to finish what I'm doing.

As I listened to the participants in my study discuss how they critically analyzed hip hop lyrics for use in their own lives, I began to think of opportunities educators have for taking that critical learning even further. Believing like Freire (2007) that we must be willing to learn along with our students, I devised an assignment for myself as a learner and a teacher.

Opportunities for Teaching: Analysis of a Hip Hop Video

During my interview with Dee, he asked if he could show me a music video that he had never seen, but had wanted to since he liked the song and artist. The video, entitled *Roc Boys (And the Winner Is)* (Robinson, Fox, & Jay-Z, 2007), was performed by Dee's favorite artist, Jay-Z. We watched the video together, and I asked him to explain its plot and some of the themes. Although he could tell me about some portions of the video, he struggled to interpret its message(s). I decided that I would analyze the video as a way of providing an example of how other educators might guide students through an analysis of their favorite hip hop videos and use the resulting texts to teach about critical literacy.

The music video *The Roc Boys (And The Winner Is)* was obtained from the video sharing website YouTube. In analyzing this video for its underlying themes, symbols, social meanings, and processes (Altheide, Coyle, DeVriese, & Schneider, 2008), I looked for recurring patterns or messages that I later used in formulating categories (e.g., the category of celebration). After identifying the emergent categories, I searched for the most telling examples of each category, being mindful of my subjectivity as a fan of hip hop and of the particular artist who performed in the video. According to Beringer (1986), a level of familiarity with a particular culture is necessary when analyzing images, metaphors, and symbols common to that culture; thus, my familiarity with the hip hop scene, while producing a certain subjectivity, may also have aided in the analysis.

Reflections on the Past

The video begins with the performer of the song (Jay-Z) narrating a description of the social environment of an urban housing project in Brooklyn, New York, in 1988. Accompanying Jay-Z's narration are visual artifacts that serve

as representations of the environment and time period that he is describing. He says that 1988 was "a great year for hip hop, but an even better year for the neighborhood hustler." Three young men who represent him and his friends walk to their car and get in. Jay-Z describes how he and his friends formulated a "crew" because "we wanted in." Calling themselves the Roc Boys, the three young men get into the car. As the song begins, the video fast forwards to the present time and an older Jay-Z. Throughout the video, the scenes move back and forth between the present and the past to indicate how the Roc Boys' activities of the past both mirrored and led to the realities of the present. For example, as the older Jay-Z walks through the back entrance of a nightclub in a three-piece suit and trench coat, the younger Jay-Z is shown walking to the club in his 1980s sweat suit and baseball cap.

Celebration of the Present

The main theme of the song and video is celebration of the successes of illegal drug entrepreneurship. Jay-Z announces "and the winner is Hov." Hov has long been known to be Jay-Z's nickname, and he is simulating the announcement of his winning an award. Before beginning his rap he then yells "speech!" He begins rapping by formally thanking others who have helped him achieve this success. He begins by thanking his "connect" as "the most important person with all due respect." (Connect is short for connection, or the supplier who is able to help the drug dealer obtain drugs for distribution.) He also thanks the various individuals who help him distribute the drugs, his enemies and rivals, and the corrupt political system that allows the drug trade to happen. For example, he thanks the "boys in blue who put green before the badge," thus playing on the use of colors to represent cultural meanings such as blue for police and green for money. He also calls attention to how some police officers dishonorably participate in the drug trade due to greed and opportunism. Lastly and "most importantly" he thanks the customers or drugs users without whom his success would be impossible. In doing so he is acknowledging that he does not feel guilt or shame about the effects that drugs have on the individuals who abuse them, but rather he is more concerned about his ability to earn money. At the same time that he is offering these thanks, he is seen walking through the back entrance of a nightclub. He is presumably the owner of the club because all of the employees nod to him with respect as he walks by. As he makes his entrance into the nightclub, an attractive woman stares at him as he surveys the environment. People in the club have already begun partying and dancing; however, they all look at him and raise their glasses in a toast as he

enters the club. He is greeted by friends and well-wishers including his nephew. Throughout the rest of the video and song, the theme of celebration is reiterated. The second verse focuses on how a successful drug entrepreneurship can appeal to women. He is seen rapping directly and descriptively about the luxuries that his wealth can bring and how his female companions can benefit from such wealth. There is a scene in the back of the club where Jay-Z and two other friends get away from the club atmosphere in order to talk and smoke cigars. It is assumed that these are the two friends who helped him form his crew at the beginning of the video in 1988. The friends are played by P. Diddy and Nas, two other highly successful hip hop artists and entrepreneurs. The trio joke around with each other, reflect on their coming-of-age story, and celebrate their mutual success.

Consequences of Those Actions

The video acknowledges the danger that jealousy and envy pose as a result of drug entrepreneurship. At one point in the middle of the video two men look enviously upon Jay-Z and his party. Jay-Z's nephew approaches him because he is concerned about the men who are giving these looks. When the nephew calls them to his attention, Jay-Z waves his hand as if to say that this is typical of his success and that he will just ignore them and enjoy his evening. At the end of the video, Jay-Z stands up and looks over suspiciously at one of the men who has been staring at him, as his nephew observes. At this point the music stops and a slow melodramatic song begins as the following actions take place in slow motion: the man reaches inside his coat as if he were about to pull out a gun; the nephew observes an imminent assassination and darts toward Jay-Z in order to save him; the nephew's breathing can be heard as he runs over to save his uncle; and he pushes his uncle out of the way and onto a nearby couch. At this point panic ensues as everyone rushes to leave the club. Following the mass exit, "to be continued" appears on the screen. Although it is clear that Jay-Z has not been shot, the viewer is left wondering about the fate of his nephew. At the conclusion of the video both the younger and present-day Jay-Z is shown standing alone in a dark corridor. The implication is that one of the major consequences of drug entrepreneurship is the danger associated with it. Despite the presence of many friends throughout the celebration and party, Jay-Z stands alone and is responsible for the consequences of his actions. These consequences put not only him in danger, but also loved ones such as his nephew who may have been shot.

At first glance the obvious themes (besides celebration) are materialism,

hedonism, and partying. However, a careful analysis of the symbolisms within the video reveals a critique of the structural and systematic business of drug trafficking, as well as the benefits and consequences of that industry. But why would educators care to discuss such a non-school-related topic with adolescents? The reality is that many adolescents deal with exposure to drug-related issues on a daily basis. Some feel that drug entrepreneurship is their best available option for employment given the economic and social hardships that they face. It is important for educators to dialogue with students about these issues. Although I had not discussed my analysis of the music video with Dee at the time of this writing, I will use it in preparation for my future work with him and other students in the mentoring program.

Using Hip Hop Texts in the Classroom: Implications for Educators

Kirkland (2007) emphasized the importance of teacher preparation when using hip hop texts in the classroom. Hip hop is not a passing fad, but a topic worthy of serious scholarly study that should not be tokenized. Moreover, Kirkland warned that the usage of hip hop texts does not guarantee that all students will automatically be engaged in or relate to hip hop in the same way.

The use of popular culture texts within classrooms can be an effective pedagogical tool if educators recognize its importance in students' lives and use it to incite critical discourse (Alvermann, Moon, & Hagood, 1999). It is important for students to explore the themes within hip hop texts so that they can critically assess the messages that are being sent through a popular musical and cultural phenomenon that many of them enjoy. Moreover, Kirkland's (2007) work has demonstrated that "hip hop texts can be used to promote writing and critical classroom dialogue among urban students around serious social issues pertaining to resistance and struggle, race and gender, and cultural exploitation" (p. 132). These very pressing issues have the potential to motivate adolescents to use critical literacy skills in the classroom and beyond.

In my interviews with Dee, Bob, and Dwayne I realized that hip hop was an important force in their lives. They used hip hop to connect with and learn from friends, to present themselves as a certain type of person and to motivate themselves to stay on track in times of adversity. In some ways listening to hip hop was just a fun activity that they enjoyed. In other ways they recognized that hip hop's embedded messages could be powerful and influential forces in the world. In my own analysis of a hip hop text, I gained insight into some of those

messages and how they might be used for motivational and instructional purposes, especially in inquiry-oriented classrooms that have internet access. Beach and Bruce (2002) defined inquiry-based learning as a "a broad set of practices in which learners extract meaning from experience as they engage in efforts to address questions that are meaningful to them" (p. 153). Drawing from Dewey's (1956) notion of a learner-centered curriculum, they illustrated how students benefit from a cycle of critical inquiry in which teachers foster discussions and reflections through modeling how they arrive at answers to questions or something they wonder about. Teacher modeling that makes use of digital tools, according to Beach and Bruce, fosters critical inquiry in ways that traditional media cannot.

Providing future inquiry-based learning experiences around hip hop texts for the young men in the Saturday morning mentoring program will require some advance planning on my part. Youth who have not been exposed to critical inquiry previously will need encouragement and some direct instruction in how to analyze the lyrics of the music videos they choose to work with. As starters, I will use the following questions that I derived from analyzing *The Roc Boys (And the Winner Is)*:

1. The protagonist in the video (Jay-Z) formulates a goal and eventually accomplishes it. What are some underlying assumptions about the benefits and complications associated with his success?
2. How does *The Roc Boys* video, or hip hop in general, promote materialism and consumerism?
3. In accepting his "award," Jay-Z thanks many people for helping him achieve his goals. At the same time, he seems to be critiquing the various players responsible for the illegal drug trade. What assumptions can you (the viewer) identify in Jay-Z's critique?

By modeling for my students in the mentoring program how I went about answering the questions that *The Roc Boys* video raised for me, I will be scaffolding the process that I expect them to use in critically analyzing other hip hop videos, song lyrics, and images.

Concluding Thoughts

In a time of intense accountability, some teachers may be hesitant to deviate from their school's prescribed curriculum by bringing hip hop texts into the

classroom. Others may want to avoid co-opting students' interests in hip hop by turning what is "their thing" into "a school thing." To my way of thinking, there is a middle ground wherein hip hop texts can be used effectively to explore real life issues that motivate students to ask questions they want to answer. Standards need not be compromised in the process; most state literacy standards call for developing students' critical awareness of how texts of various kinds attempt to position them as readers. Not every teacher may feel comfortable discussing a Jay-Z video in class, or even assigning a video analysis, but most would probably not object to having students discuss the controversies surrounding hip hop music, censorship, and media exploitation. In sum, as I have tried to show in this chapter, the academic literacy goals that educators have for students can unite with students' longings to make sense of their world through hip hop. It is in this place where student culture, digital literacies, and education can converge.

References

Altheide, D., Coyle, M., DeVriese, K., & Schneider, C. (2008). Emergent qualitative document analysis. In S.N. Hesse-Biber & P. Leavy (Ed.), *Handbook of emergent methods* (pp. 127–151). New York: Guilford Press.

Alvermann, D.E. (Eds.). (2002). *Adolescents and literacies in a digital world*. New York: Peter Lang.

Alvermann, D.E. (2008). Why bother theorizing adolescents' online literacies for classroom practice and research. *Journal of Adolescent & Adult Literacy 52*, 8–19.

Alvermann, D.E., Moon, J.S., & Hagood, M.C. (1999). *Popular culture in the classroom: Teaching and researching critical media literacy*. Newark, DL: International Reading Association.

Beach, R., & Bruce, B.C. (2002). Using digital tools to foster critical inquiry. In D. Alvermann (Eds.), *Adolescents and literacies in a digital world* (pp. 147–163). New York: Peter Lang.

Beringer, R.E. (1986). *Historical analysis: Contemporary approaches to Cilo's Craft*. Malabar, FL: Robert E. Krieger.

Datpiff. (n.d.). Retrieved May 2, 2009 from *http://www.datpiff.com*

DJdownloadz.com. (n.d.). Retrieved May 2, 2009 from http://www.djdownloadz.com

Dewey, J. (1956). *The child and the curriculum/The school and society*. Chicago: University of Chicago Press.

Freire, P. (2007). *Pedagogy of the oppressed* (M.B. Ramos Trans.). New York: Continuum. (Original work published in 1970)

Frostwire. (n.d.). Retrieved May 30. 2009 from http://www.frostwire.com

Gee, J.P. (1996). *Social linguistics and literacies: Ideology in discourses*. (2nd ed.). Bristol, PA: Taylor & Francis.

Heath, S.B. (1983). *Way with words: Language, life, and work in communities and classrooms*. New York: Cambridge University Press.

Hull, G., & Schultz, K. (2001). Literacy and learning out of school: A review of theory and research. *Review of Educational Research 71*, 575–611.

iTunes 8. (n.d.). Retrieved from http://www.itunes.com.

Jenkins, H. (2006). *Convergence culture: Where old and new media collide*. New York: New York University Press.

Keyes, C.L. (2002). *Rap music and street consciousness*. Urbana, IL: University of Illinois Press.

Kirkland, D.E. (2007). The power of their texts. Using hip hop to help students meet NCTE/IRA national standards for the English Language Arts. In K.K. Jackson & S. Vavra (Eds.), *Closing the gap. English educators address the tensions between teacher preparation and teaching writing in secondary schools* (pp. 129–145) Charlotte, NC: Information Age.

Kirkland, D.E. (2008). "The rose that grew from concrete": Hip Hop and the new English education. *The English Journal 97*, 69–75.

Kirkland, D.E., & Jackson, A. (2009). "We real cool": Toward a theory of black masculine literacies. *Reading Research Quarterly 44*, 278–297.

Kitwana, B. (2002). *The hip hop generation: Young Blacks and the crisis in African American culture*. New York: Basic Civitas.

Kvale, S. (2007). *Doing interviews*. Thousand Oaks, CA: Sage.

Lopez, J. (Producer), & Harris, C. (Performer). (2008, June 27). *No Matter What*. [music video]. Retrieved May 21, 2009 from http://www.youtube.com

Mahiri, J. (2002). *What they don't learn in school: Literacy in the lives of urban youth*. New York: Peter Lang.

Morrell, E., & Duncan-Andrade, J.M.R. (2002). Promoting academic literacy with urban youth through engaging hip hop culture. *English Journal 91*, 88–94.

New London Group. (1996). A pedagogy of multi-literacies: Designing social futures. *Harvard Educational Review 66*, 60–92.

Parmar, P. (2005). Cultural studies and rap: The poetry of an urban lyricist. *Taboo: The Journal of Culture and Education 9*, 5–15.

Rivera, R.Z., Marshall, W., Hernandez, D.B. (Eds.). (2009). *Reggaeton*. Durham, NC: Duke University Press.

Robinson, C. (Director); Fox, A. (Producer); & Jay-Z (Performer). (2007, November 7). *The Roc Boys (And the Winner Is)*. [music video]. Retrieved May 28, 2009, from http://www.youtube.com/watch?v=qCDJ85DJJAs

Rose, T. (2008). *The hip hop wars: What we talk about when we talk about hip hop and why it matters*. New York: Basic Civitas.

Stovall, D. (2006). We can relate. Hip-hop culture, critical pedagogy, and the secondary classroom. *Urban Education 41*, 585–602.

Street, B.V. (1995). *Social literacies: Critical approaches to literacy in development, ethnography, and education*. London: Longman.

Szwed, J.F. (1981). The ethnography of literacy. In M. F. Whiteman (Eds.), *Writing: The nature, development, and teaching of written communication. (Vol. 1) Variation in writing: Functional and linguistic-cultural differences* (pp. 13–24). Hillsdale, NJ: Lawrence Erlbaum.

Watkins, S.C. (2005). *Hip hop matters*. Boston: Beacon Press.

Weinstein, S. (2006). A love for the thing: The pleasures of rap as a literate practice. *Journal of Adolescent & Adult Literacy 50*(4), 270–281.

Digital Media Literacy

Connecting Young People's Identities, Creative Production and Learning about Video Games

MICHAEL DEZUANNI

The first week was overall exciting and boring. It was exciting when we started to design our game, coming up with ideas and playing, oh, I mean, 'researching' our games. But it was boring because there was too much theory involved.
—RBIMDXE—15-YEAR-OLD STUDENT

This chapter outlines examples of classroom activities that aim to make connections between young people's everyday experiences with video games and the formal high school curriculum. These classroom activities were developed within the emerging field of digital media literacy. Digital media literacy combines elements of 'traditional' approaches to media education with elements of technology and information education (Buckingham, 2007; Warschauer, 2006). It is an educational field that has gained significant attention in recent years. For example, digital media literacy has become a significant objective for media policy makers in response to the increased social and cultural roles of new media technologies and controversies associated with young people's largely unregulated online participation. Media regulators, educational institutions and independent organisations[1] in the United States, Canada, the United Kingdom and Australia have developed digital media literacy initiatives that aim to provide advice to parents, teachers and young people.

Advocacy for digital media literacy is also motivated by the seductive notion of the 'digital generation' that, it is claimed, has a natural affinity for

new media that can be 'tapped into' for educational purposes. Initiatives like the MacArthur Foundation's Digital Media and Learning project in the United States and Education Queensland's Games in Learning project in Australia represent attempts to investigate the possibilities for digital media literacy as a legitimate educational field. This chapter explores the connections that can be made between young people's enthusiasm for digital media in their everyday media use and formal schooling by outlining specific strategies used in one Australian secondary school classroom.

The chapter begins with a brief overview of traditional approaches to media literacy education and explains the need for digital media literacy. It then outlines a case study, the Video Games Immersion Unit project, which I use to explore the possibilities for digital media literacy. This exploration includes analyses of three activities: (1) students' reflective blogs, written while learning about, designing and producing video games; (2) students' use of online pseudonyms and the design of online web spaces; and (3) an online chat the students undertook about gender and video games.

From Media Literacy Education to Digital Media Literacies

Media literacy educators are well placed to assist with the development of the emerging educational field of digital media literacy. Over several decades, media literacy educators have developed curricula that aim to enhance young people's media-related critical and functional literacies by making connections between young people's popular culture experiences and the formal curriculum. Media consumption, in particular young people's consumption of film, television, advertising, news media, comics, popular music and radio, has been the main target of media education. A key classroom technique for this type of intervention has been 'critical reading' or 'decoding,' which has been motivated by an assumption that media consumption is a largely passive activity. Media literacy educators have assumed that young people should be taught to protect themselves from the corrupting (Leavis & Thompson, 1933), trivialising (Hall & Whannel, 1967/64; Hoggart, 1984/58; Williams, 1966) or ideological (Masterman, 1980, 1990) influences of media. In these contexts, critical reading aims to assist young people to become more 'active' or reflective media consumers.

However, developments in media studies scholarship, and the arrival of digital technologies, have made it increasingly implausible for media education scholars to accept young people as merely passive consumers of media. Since at least the 1970s, cultural studies scholarship about media audiences and

youth cultures has argued that audiences are active producers of meaning when they consume media. Rather than media and popular culture being a trivialising or corrupting influence in young people's lives, they are significant symbolic resources for young people's active identity formation. Media and popular culture texts work alongside other symbolic systems operating in young people's lives, for example, written texts and everyday dialogue, to enable young people to produce their identities and make sense of themselves and others. In this vein, U.K. media education scholar David Buckingham (2003, 2007) has identified productive identity work as a significant focus for media literacy educators. He argues that media education should focus on the relationship between media production, critical reflection and analysis.

Furthermore, digital media technologies are a potential 'game changer' for media literacy educators in relation to both analytical and production work. It is only since the availability of new media technologies that young people's everyday media participation has so specifically involved media production, rather than primarily consumption. Digital media technologies potentially change the ways in which young people participate socially and culturally through creative and playful activity (Burn, 2009). Young people's uses of the symbolic materials of media and popular culture become tangible instances of what Jean Burgess calls 'vernacular creativity' (2007). Digital media technologies provide the means to make symbolic work more public, more distributed and more 'participatory' (Jenkins, 2006). In this context, the emerging field of digital media literacy must go beyond media literacy education's focus on decoding to make connections to young people's social media content creation.

Therefore, digital media literacy is a departure from traditional media literacy education because it places more emphasis on young people as producers and distributors of media (Burn, 2009). It recognises young people as users of a much vaster array of media content than was available only a few short years ago. Digital media literacy focuses as much on the ways in which young people produce media for themselves and each other as on young people being better informed media consumers or as preparation for career trajectories. This brings me to a theoretical aspect of these considerations that I will mention very briefly here and come back to as I discuss examples of student work later in the chapter.

Some Brief Theoretical Considerations

It is necessary to locate this discussion about 'traditional' media literacy education, specifically decoding practices, and the 'participatory' nature of digital media literacy in broader theoretical frameworks in order to understand the

nature of the relationship between young people and media. From one perspective, this discussion occurs at the fault lines between structuralism and post structuralism. Structuralism and post structuralism are concepts that may not seem immediately relevant to the classroom, but most classroom media educators would recognise the consequences of considering young people's relationships with media through structuralist and post structuralist lenses. For example, decoding or pulling apart media texts shot by shot and angle by angle to identify underlying meanings within a text is a media education strategy informed by structuralism. The most influential incarnation of the 'decoding' strategy within media literacy education is derived from Len Masterman's (1990) 'demystification' approach. The 'demystification' approach draws on Marxist structuralist accounts of social and cultural processes (Althusser, 1971; Barthes, 1972), which suggest that individuals are incorporated into ideology through language. Masterman argues the media incorporate subjects into dominant ideological formations and, to counteract this, media education needs to teach students how to decode, or demystify, media texts in order to uncover the media's hidden ideological functions.

Theories associated with post structuralism provide different perspectives on the relationship between people, language, ideology and education to those of structuralism (Davies, 2000). They argue that people produce their subjectivities[2] through ongoing processes of negotiation and that subjectivities are never fixed or stable, but are in a constant state of 'becoming' (Butler, 1990, 2004). From this perspective, users of digital media are not incorporated into the ideologies of media, but use media as a resource for the ongoing formation of their subjectivities. For example, Turkle (1995) argues that post structuralist theories effectively account for the fluid and unstable production of subjectivities in online spaces. Likewise, Jenkins' theories of cultural poaching and participatory culture (1992, 2006) suggest that the formation of subjectivities through the downloading and remixing cultures of the Internet can best be explained using post structuralist conceptions of cultural production.

Most media educators who have included media production in the classroom would recognise the creative and playful ways young people use media resources in meaningful ways that cannot be explained through the language of 'demystification' or even 'critical reading.' Viewed in this way, the digital media literacies associated with participatory culture are likely to rely less on text-centered decoding practices that aim to reveal hidden ideological agendas and more on cultural production through creative, social, and technological practices. This is relevant to digital media literacy and classroom practice because it informs how connections can be made between young people's everyday media use, the production of identities, and the formal curriculum.

Later in the chapter, I will use the post structuralist theories of Michel Foucault and Judith Butler to help illuminate students' responses to specific classroom tasks that were undertaken by students as part of the Video Games Immersion Unit.

The Video Games Immersion Unit Project

The Video Games Immersion Unit project was conducted at Independent Boy's College (IBC), a Catholic boys' school in Brisbane, as part of the school's middle years and boys' education curriculum reforms. I collaborated with the head of Information Technology studies to offer a combined media and technology studies unit that included a range of online and classroom-based activities focused on designing and producing video games and critically reflecting on some of the social and cultural issues associated with this popular medium. During the three weeks, the students did not attend usual classes, wear uniforms or have specific lesson times and they were not assessed using the school's usual reporting structures. The content and structure of the unit are outlined below in Table 1:

Table 1. Summary of learning activities during the Video Games Immersion Unit

WEEK 1	Introduction to the IBCMoo; Building Team Moo Rooms; Building individual rooms; Games genre activity (design task) – using codes and conventions; Game design principles; Online chat about gender and games; Survey of younger students' games preferences (audiences); Game design for team project; Visit to local university – lecture about games; Online 'Speaker's square' activities – responding to games violence, gender and race representations; Visit to games production company; Visit to games arcade; Online chat about games violence and classification and regulation; Pitching game design concepts	Ongoing blog reflections about each of the learning experiences
WEEK 2	Flash animation training at an off campus multimedia training institution	
WEEK 3	Game Maker training; Bryce training; Wings 3D training (all at school); Games production in teams; sharing games with parents; sharing games with younger students	

The unit included a significant online component because we wanted to creatively experiment with the school's online learning environment, which the

information technology (IT) teacher had developed using a MOO[3] platform. We wanted to try out new strategies in the areas of social networking and online multimedia to engage the students in new learning experiences. Drawing on the 'immersion' theme of the three-week specialised programme, we aimed to immerse the students in online technological experiences. We explicitly discussed the students' enthusiasm for online media, and we suspected that they were heavily involved in the download, remix and social networking cultures of the Internet.[4] We aimed to make connections to the students' informal online practices through the online activities.

It should be noted that although we used a MOO space, the functionality of the MOO could be replicated in freely available and easily accessible online spaces. The MOO allowed the students to customise their own online 'rooms' to represent themselves and to create a repository of their work to share with their peers, teachers and families. They could include links to websites and embed media, including links to playable games and they could leave each other comments and messages. The students also had team 'rooms' that operated like wikis in which they could collaborate, share ideas and present their group design work. They could take part in a range of communications processes, including email, instant messaging, forum discussions, chat and upload multimedia files. These are resources that are replicable in a range of social, cultural and educational contexts, whether or not a MOO space is available, to make similar connections to young people's everyday online experiences.

From a media literacy perspective, the initial aim of the Video Games Immersion Unit was to use 'technological' activities to help the students to reveal the ideological influence of video games. My theoretical assumption was that students should learn to become more 'critical' about aspects of video games and gender, and I drew on an approach underpinned by Masterman's demystification discourse. I speculated that the intensive focus on video games production processes and the development of technological skills would enthuse students to consider theoretical issues related to video games study. I also speculated that students would engage with social and cultural issues related to video games and gender, particularly if 'theory' lessons were presented in unconventional and 'technological' ways.

However, as I began to analyse the students' responses to the learning activities devised for the Immersion Unit, I realised that there was another essential layer of connection (and disconnection) that needed to be investigated: the role of identity formation in the learning process. I realised that the mere inclusion of video games and technological experiences did not make an

authentic connection to the students' media cultures. For example, as the analysis of blog reflections below indicates, the students were no more enthusiastic about media analysis than in more traditional media literacy education approaches. Consequently, my research objectives for the Immersion Unit changed due to my exposure to post structuralist theories, including Michel Foucault's (1988/84) theory of 'technologies of the self' and Judith Butler's (1990, 2004) theories of performativity and recognition. These theories allow me to show how classroom strategies can make identity-related connections not just to students' everyday media experiences but to students' motivations for learning.

The research sample includes 17 Year 10 male students, all 14–16 years of age, who were all technology early adopters. This was an unavoidably specific sample. However, the implications of the analysis for the conceptualisation of digital media literacies and connections to young people's media cultures have implications that go beyond the narrow confines of this specific study.

Blogging the Video Games Immersion Unit

Throughout the Video Games Immersion Unit, the students were required to complete an online reflection, or blog entry, after each learning session ended. Each student completed approximately forty reflections, with some consisting of responses to specific questions and others requiring more open-ended responses. These blogs involved more overtly academic responses than many other activities throughout the unit, such as designing and making aspects of games, and therefore had the potential to be less relevant to students' informal online practices. However, blogging was popular in the Immersion Unit, with some students writing thousands of words of entries.

Blogging proved to be a highly effective classroom strategy to make connections between the Immersion Unit learning activities and the practices and processes valued by students not just in their everyday media experiences but in terms of what the students were motivated to learn. That is, blogging helped to make connections between the students' informal learning through their media and technology experiences and the Immersion Unit learning. The students used their blogs to compare practical technological activities with theory-based activities they undertook throughout the Immersion Unit.

The focus on practical involvement with technology throughout the Immersion Unit was well received by the students, and they often use their blog reflections to create a binary between theory and practice. For example, *rbimdxe*[5]

completed the following reflection at the end of the first week of activities that included a variety of 'theory' and practical activities:

> The first week was overall exciting and boring. It was exciting when we started to design our game, coming up with ideas and playing, oh, I mean, 'researching' our games. But it was boring because there was too much theory involved :((rbimdxe).

It is clear from the reflection that *rbimdxe* prefers production and design work to 'theoretical' tasks. It is tempting to read this as a reasonably straightforward rejection of school work in contrast to the fun and pleasure offered by games culture. His construction of a binary between theory and practice, his use of the 'sad face' emoticon to indicate displeasure with theory and his 'knowing' comment about game play as 'research' might be read as nothing more than a rejection of intellectualism in favour of pleasure. In Masterman's (1990) terms, it might be argued that *rbimdxe* is being seduced and mystified by corporate culture as he desires to repeat the dominant ideologies of games culture and rejects 'critical' thinking about games.

However, such a reading ignores *rbimdxe*'s potential motivations for rejecting theory in favour of game play, design and production. Foucault (2000/84) argues that subjects conduct work upon themselves to make themselves 'intelligible' to others. That is, subjects aim to be recognisable to other people in the communities they participate in. Foucault (1988/84) argues that the 'care of the self' includes continual self-monitoring, governance and work on the self. From this perspective, blogging allowed the students to 'bring themselves into being' as technological subjects, and *rbimdxe* may be using the reflective blog as a 'technology of the self' to conduct work upon himself to become recognisable to the other students and teachers in the Immersion Unit community. Therefore, *rbimdxe* repeats norms, like rejecting conventional schoolwork, that are likely to be repeated by other members of the Immersion Unit community.

Rbimdxe's attraction to technological practice when compared with media 'theory' most likely comes from the alignment of technological practice with the community norms favoured by the Immersion Unit students such as those of video games professional practice. For example, the pleasure associated with practical participation as a member of a team of games designers is evident in the following reflection by *Nicodemus*:

> This was a fun session :0 We started creating the concept for our game and split up tasks in our group using our basic skill as a guideline. We also started the idea of PROJECT X and put our ideas up on the MOO. This session was one of the most enjoyable as it allowed us to start putting together our own idea for a game and started working as a

group to get these ideas working effectively. (Nicodemus).

This reflection repeats norms of video games professional practice by showing approval for the opportunity to work in a team to achieve the goal of developing a video game; to make a contribution to the team by offering particular skills; to creatively use video games conventions as a designer and producer; and to participate in the online MOO space to share ideas.

The activity provides a context for the construction of self as a co-designer and co-producer in the context of video games professional practice. The repetition of 'we,' 'our' and 'us' places emphasis on the pleasure of working with others to reach a common goal through group talents, in which each individual's strengths are drawn on for the common good of the team. For the group to work effectively, members have to make a contribution, repeating the practices of the division of labour within video games professional practice. *Nicodemus'* enjoyment likely comes from having something to offer the team, which is the ability to complete specific tasks with existing skills. From this perspective, the group design process is a successful classroom strategy because it allows the students to take part in a community of technological practice, and this is central to the students' productive identity formation.

The connections and disconnections *rbimdxe* and *Nicodemus* make in their blog reflections between schoolwork, the Immersion Unit community and technology and gaming practices operate at the level of identity formation. In this sense, blogging is a classroom strategy that facilitates the social production of self through the use of digital media technologies. It is a strategy that enables an authentic and meaningful connection to be made between the students' everyday media practices and their motivations for learning in formal contexts. Furthermore, as I will illustrate in subsequent sections, the use of digital media technologies potentially opens up possibilities for alternative constructions of self that may vary from socially sanctioned norms. That is, the digital media literacy classroom may become a space for experimentation with identities and for challenging harmful and restrictive norms.

Pseudonyms and Online Spaces

One of the first activities the students were required to undertake during the Immersion Unit was to choose a pseudonym to use in the IBCMOO online community to use throughout the course of the Immersion Unit. Young people often use pseudonyms in online spaces, and we wanted to provide the students with the opportunity to form an online identity as part of their learning

in the Immersion Unit. It was one strategy we used to make a connection with the students' informal online practices and to provide them with an opportunity to have a virtual presence in the Video Games Immersion Unit.

In this section of the chapter, I want to explore the students' use of pseudonyms and online spaces as instances of creative and playful media production and as examples of Butler's (1990) concept of performativity. Performativity expands Foucault's 'technologies of the self' and involves the repetition and potential 'variation' of social and cultural norms, undertaken by individuals as they aim to become 'socially viable,' or acceptable in particular social contexts. Where Foucault suggests individuals conduct work upon themselves to become 'intelligible' to others, Butler argues that individuals 'take up' social and cultural norms and repeat or vary them. She calls these 'performative variations.' Of course, the problem with varying norms is that individuals risk becoming less recognisable to other members of the community.

The concept of performative variation is potentially highly useful to media literacy educators. This is because Butler's approach suggests that rather than media teaching being a process of students aiming to gain 'critical' distance from texts, there is much to be gained from providing students with opportunities to creatively and playfully participate with media and to provide students with scenarios in which they have opportunities to undertake performative variation of norms. Undertaking digital media production to vary norms may constitute alternatives to the notion of 'critical thinking' because students may 'try out' different identities in a relatively safe space. Experimenting with different gender-related norms may be more meaningful to students than a critical discussion about gender. Such theoretical musings may not seem immediately relevant to classroom practice. However, the students' use of pseudonyms, and the decoration of their MOO spaces, is very interesting, because analysis of them helps to identify what the students may or may not be willing to risk in relation to gender norms. This may enable the development of strategies to challenge these norms in authentic and 'connected' ways.

The pseudonyms chosen by the students for use in the IBCMOO space present interesting examples of the variety of ways in which they repeat (and/or vary from) the masculine norms in circulation at IBC. Some chose nicknames that shortened or changed their original names in ways that are common at IBC. This included the 'blokey' shortening of surnames to nicknames in which the end of their surname was replaced with an 'ey' sound forming an informal cognomen. These included *Costay, Rhysay* and *Hodgie*. Others relied on sexual innuendo, including the ostensibly humorous reference to the size of male

genitalia, often repeated in the jocular masculine culture of IBC, in the names *The Big Damon* and *Big Nuttz*.

However, these 'playful' examples are not the only ways in which students responded to the task. There was a complex interplay of what counted as masculine norms in the IBC Immersion Unit for some students. While some students' citations repeat aspects of heroic masculinity, for example quoting characters that are physically strong, brave and loyal, the cited characters also have traits that potentially exceed and therefore transgress normative IBC masculinities because they expand the notion of what counts as masculine practice. An example of the citation of a well-known character with potentially complex masculinity is the use of *The One*, the heroic main character in the popular science fiction *Matrix* films who must save humankind from domination by computers.

The character 'The One' is a computer hacker called Neo who eventually gains superhuman powers through acquiring various software applications, such as fighting drills, which are uploaded to his 'memory.' However, for Neo to become 'The One' he cannot rely on brute strength, force and technology; he must discover his humanity and 'inner strength' to 'find' himself. Furthermore, he relies on female assistance to help him discover his true self. At the climax of the film, when he has been physically defeated, he must recognise his love for the female character, who brings him back to life with a kiss.

Neo's strength is therefore at least partly defined through a romance narrative that varies from action adventure stories that are typically recounted in the masculine culture of IBC. Choosing to cite 'The One' is therefore not necessarily an option without risk for this student. I am not suggesting that the citation of the name 'The One' is a conscious 'acceptance' by the student of all aspects of that character's seemingly contradictory masculine traits. I am suggesting that the student cites a character that reiterates complex masculinities that may not be entirely accepted in the IBC context.

In addition to using the name *The One*, this student decorated his online MOO space with images from the *Matrix* films and included a cartoon version of the main character from the films (Figure 1), which also repeats aspects of both heroic and potentially variational masculinity. The cartoonish nature of the main figure of Neo in this representation tends to undercut, or at least soften, the character's aggressive fighting pose. While the character is in a combat stance, the drawn representation de-emphasises his masculine traits by displaying him with narrow shoulders, cinched waist, and quite small hands. It

is a quite effeminate representation of Neo. The drawing emphasises the dress-like nature of the character's costume and places emphasis on it through its dominance within the frame. In contrast, the film representation of Neo depicts him wearing a long leather overcoat, which is more typically masculine than this cartoon version. It is interesting that *The One* has appropriated this version of Neo from the web rather than a photographic still from the feature film that emphasises more masculine traits. An online search for Neo provides a myriad of images of the popular character, many of which are potentially more normatively masculine than the one used by *The One*.

Figure 1. Screen grab of *The One*'s web space in the IBCMOO

However, *The One* adds other elements to his web space that repeat masculine norms of the Immersion Unit community because it is designed to emphasise its tech-culture aspects. The space is called 'The Matrix,' and the use of green code on a black background that surrounds the image of Neo is taken directly from the film. This mirrors the 'code' that appears in the left hand column of the MOO interface. The unique aspect of this style of MOO is that the written commands make transparent the work being done in the graphical space or with the MOO's navigation buttons. As the students use the space and navigate around it, a flow of written 'code' appears in the left hand column. In addi-

tion, if the students know the correct commands, they can type directly into the code to change the graphical space, or to navigate to other sections of the MOO. This makes the space more 'technological' than a typical website does. By calling his space in the MOO 'The Matrix,' *The One* continues the technological metaphor established by the MOO space and the MOO becomes connected to The Matrix and vice versa. *The One*'s display of technological sophistication might be interpreted as repeating the hacker prowess of the character Neo. In a technological community, like the Video Games Immersion Unit community, hacking is generally considered to be a masculine trait.

The key point to make is that the pseudonym choice and web space design activities clearly do not aim to intellectualise gender. Rather, they provide *The One* with the opportunity to repeat and challenge aspects of normative gender representation through the creative/productive variation of masculinities. From this perspective, the activities do not become opportunities to repeat intellectual discourse around gender but provide the opportunity to produce gender in creative and potentially variational ways. These are digital media literacy activities that allow *The One* to creatively play and experiment with aspects of the narratives and masculinities familiar to him in everyday media contexts. He has taken cues from one of his favourite films to remix representations of a character in ways that both repeat and challenge the versions of masculinity presented in the film. As examples of performativity, *The One*'s citations of complex masculinities repeat aspects of masculinity that are likely to be both recognisable and less recognisable, and acceptable and less acceptable in the IBC community. At the level of planning for digital media literacies in the classroom, this suggests that opportunities for creative play with technologies are important in circumstances where teachers want to make authentic connections to their students' online media experiences.

The Online Chat

In this section of the chapter, I want to outline a media literacy activity that involves dialogue about gender norms. This is a more overtly 'academic' activity than the activities described in the previous section. It focuses on talking about social norms rather than creatively repeating or varying norms through media production. However, because the activity involved an online chat, it is also an example of how digital media technologies can provide opportunities for dialogue that would otherwise be unlikely.

Online communications in the form of chat, forum discussions and email

are well established as a significant aspect of youth culture and the formation of social identities (boyd, 2008). These communication forms are part of the digital media culture that allows individuals to extend existing 'off line' communities or to create new online communities. As with the creation of online spaces discussed in the previous section, they provide young people with opportunities to repeat and vary norms within communities and to make themselves socially viable to others. They also provide opportunities for educators to make connections to young people's everyday media experiences and to develop digital media literacies that go beyond the use of technologies to include experiences that might otherwise be unavailable to the students.

The activity involved an online chat about gender representations in video games between the male IBC Immersion Unit students and female gamers from a local university. The activity was called 'Gendered games—Are video games sexist?' The activity was organised so that the Immersion Unit students were physically located on individual machines in a computer laboratory at IBC, and the university students were on individual machines in a laboratory at the university. The teachers were also on individual machines. Each Immersion Unit production team was allocated to its own chat room along with two university students. The students were required to discuss a number of questions in relation to the overall topic.

The intention was to present students with females' perspectives on video games so they might gain a sense of gender differences in the gaming context and to challenge discourses of femininity established at IBC. In the IBC context, girls and women are often constructed as nurturing, loyal mother figures or as objects of sexual desire. These norms are repeated through religious discourses, for example, in the maternalistic figure of the Virgin Mary[6]; and through popular cultural discourses that repeat sexualised images of girls and women. Theorised using Butler's theory of performativity, the aim of the chat was to provide students with opportunities to experience variation in the repetition of gender norms. Put another way, the activity aimed to connect the students with people they might not usually connect with, with the aim that this would open up possibilities for the variation of norms.

Analysis of the students' blog reflections about this activity suggests several students did respond in a manner that varied from the usual repetition of gender norms after completing the chat room activity. For example, *NosfaratuAlucard* says:

> This session was interesting, Female gamers are as varied as the male ones. Our group talked to two QUT students. One liked story-driven games like Final Fantasy and the

other liked shooting games and strategy games. They said that there is a place in games for all types of characters, stereotypical and non stereotypical. (NosfaratuAlucard)

This reflection suggests that the online dialogue between *NosfaratuAlucard*'s group and the female gamers led to variation in that he brings himself into being as a complex masculine subject, at least for the task of writing his blog reflection. His recognition that female gamers are a diverse group that enjoys a variety of games is variational in comparison with the norms of masculinity and gaming in which females are largely recognised through discourses of maternity and sexuality. *NosfaratuAlucard*'s reflection contrasts with many male assumptions about female gamers (Jenkins, 2003). *NosfaratuAlucard* recognises the legitimacy of the female gamers in the broader gamer community because of their ability to discuss their preference for games and genres that are popular with male gamers.

Of course, an activity like the online chat includes the risk that some students will respond in ways that simply reinforce gender norms. After all, it is impossible to work towards predictable outcomes when students' responses are bound up in the formation of identities. Therefore, some students responded to the chat by refusing female authority, and this potentially led to the repetition of existing gender norms. For example, *Rouge Splitter* responded with the following reflection:

> I found this session very frustrating as the person I was chatting to ('Lady') told me to 'broaden my view on human nature and life in general,' or something like that! I found it intensely difficult not to slam back abuse at her as I know for a fact that by the way she talked showed I would have a far wider outlook than her on life. Having experienced 4 years of living in London (from 10–14 years old) I understand different cultures reasonably well. When she payed me out over being an 'SBS Newsie' or whatever (our family only watches SBS World News—no 7 or 9 news at all), I was on the verge of exploding!!! I think she used the situation to string people along and make up a whole load of crap over 'isolated opinions that weren't going to change' but she never seemed to give her own experiences or provide examples of others she knew. In fact, she said she rarely played games so I can't see how she can present her view so strongly (Rouge Splitter).

In this reflection *Rouge Splitter* threatens violence against *Lady* after constructing her as not worthy of recognition in the IBC community. He uses his blog entry as an opportunity to repeat practices of normative masculinity, where norms act as 'violations' (Butler, 2004) that are potentially harmful to *Lady*. Furthermore, he aims to achieve this by justifying and naturalising his behaviour by aiming to bring himself into being as an intelligent and sophis-

ticated person who is able to control himself in response to what he constructs as extreme provocation. His references to living in London and watching SBS[7] news with his parents can be read as metaphors for being worldly and educated. The cultural capital (Bourdieu & Passeron, 1990) acquired through these middle class experiences is constructed as intelligence and education in *Rouge Splitter*'s reflection. It is perhaps ironic that he makes a claim for understanding different cultures, but he does not recognise the exchange with *Lady* as an opportunity to gain new insight and understanding, as *NosfaratuAlucard* did. Rather, *Rouge Splitter*'s anger, evident in his use of violent language, results from *Lady* strongly putting forward her own views and refusing to accept his authority or to legitimise his position. In Butlerian terms, *Rouge Splitter*'s reflection is a performative act that aims to establish a hierarchy in which he is more legitimate than *Lady*. He aims to establish his intellectual acumen over hers through what he believes is the logic of his argument. He questions her understanding of video games and her legitimacy within the video gaming community.

Rouge Splitter's response demonstrates that although the conditions for variation may be developed, there is no guarantee that variation of the type valued by media literacy educators will eventuate. This is not a 'failure' on the part of the student or teachers. Rather, it shows that if we accept the post structuralist position that subjectivities are in a state of continual formation, students will sometimes respond in ways we would prefer them not to. Any attempt to connect to students' online literacies via identity work involves some risk on the part of teachers. After all, the students' learning experiences are just one invitation, in competition with many others, for students to repeat the norms of different discursive systems. It should not be surprising to media literacy educators that students will often choose to repeat norms that differ from those the teachers would prefer them to repeat.

Despite *Rouge Splitter*'s quite extreme response to the chat, the majority of responses to this activity show that using online chat as a strategy can make a clear connection to students' online practices and can provide a powerful means of experiencing difference. Most students enjoyed it as a playful and productive experience as it was a novelty for them to discuss a topic with female university students. It is often difficult for boys in an all boys' school context to be exposed to females' opinions about topics like video games. This type of activity would usually be completed by the boys in class as a small group or whole class discussion, without the benefit of the inclusion of a broader range of perspectives. The chat room activity was perhaps similar to the students'

informal online activities because it enabled participation in a broader social context and access to social interaction and knowledge communities. Therefore, one of the things young people like about the online media was brought into the classroom in a controlled way. In this sense, the activity helped to make a connection to the students' online practices and was an effective and meaningful learning experience for many of the students.

Conclusion

The relationship between young people and media increasingly involves young people as media producers rather than mere consumers. The activities and student responses outlined in this chapter demonstrate that new approaches to media literacy education are necessary if meaningful connections are to be made to young people's online experiences. From a theoretical perspective, digital media literacy may make successful connections to young people's media experiences where it provides the space for young people to creatively and productively explore aspects of identity. Playing with and exploring digital media technologies provides opportunities to vary norms in specific social and cultural contexts. This is a move away from media literacy education's focus on developing 'critical' capacities and reflects the changing nature of the relationship between young people and media technologies.

The reflective blogging activity provided students with the opportunity to show what they valued in the specific learning context of the Video Games Immersion Unit. Subsequent analysis of their blog reflections suggested that the students' preference for practical work was directly related to their desire to be accepted in their learning community. This has implications for similar learning contexts in which teachers may overemphasize 'theory' based activities. Providing students with the opportunity to give themselves a pseudonym and to design their own online space aimed to help the students feel more connected to their learning context. Analysis of the students' responses shows that many of them made quite elaborate connections to their everyday media experiences. However, the students also responded by repeating and varying the gender norms of the Video Games Immersion Unit context in complex ways. This is an important observation because it suggests that students will respond variously to any activity they are required to undertake because identity formation is unpredictable. It suggests that versions of media literacy education that presume to know how students will respond to specific activities are likely to misconnect with students' actual use of media and popular culture.

The students' responses to the online chat also demonstrated that it is impossible to predict how students will respond to activities that aim to make authentic connections to students' media experiences. Many of the students responded to the task in a manner that would please traditional media literacy educators. They demonstrated a greater awareness of female gamers and gaming and seemed to respect the opinions of female gamers. However, teaching and learning in the area of media literacies are bound to be 'messy,' unpredictable and involve risks because they involve the ongoing formation of identities.

From this perspective, media policy makers, regulators and educationalists calling for the development of digital media literacies will need to accept that making connections to young people's culture will always occur in specific social and cultural contexts. Furthermore, it may not be possible to predict or identify specific measurable outcomes or achievements. This is not to say there are no benefits to setting goals and objectives for teaching about digital media literacies. In fact, it is likely to be more important to design curriculum well in order to provide students with 'connected' experiences. This chapter aimed to demonstrate some examples of strategies that worked effectively, if not predictably, because they were carefully planned and used some creative approaches to engaging students with digital media technologies.

References

Althusser, L. (1971). *Lenin and philosophy and other essays.* New York: Monthly Review Press.

Barthes, R. (1972). *Mythologies.* New York: Noonday Press.

Bourdieu, P., & Passeron, J. C. (1990). *Reproduction in education, society and culture* (Rev. ed.). London: Sage.

boyd, d. (2008). Why Youth [heart] Social Network Sites: The Role of Networked Publics in Teenage Social Life. In D. Buckingham (Ed.), *Youth, Identity, and Digital Media* (pp. 119–142). Cambridge, MA: MIT Press.

Buckingham, D. (2003). *Media Education: Literacy, learning and contemporary culture.* Cambridge: Polity.

Buckingham, D. (2007). *Beyond Technology: Children's learning in the age of digital culture.* Cambridge: Polity.

Burgess, J. (2007). *Vernacular creativity and new media.* Brisbane: Queensland University of Technology Brisbane.

Burn, A. (2009). *Making new media: Creative production and digital literacies.* New York: Peter Lang.

Butler, J. (1990). *Gender trouble: Feminism and the subversion of identity.* New York: Routledge.

Butler, J. (2004). *Undoing gender.* New York: Routledge.

Davies, B. (2000). *A body of writing, 1990–1999.* Walnut Creek, CA: AltaMira Press.

Foucault, M. (1988/84). *Technologies of the self: A seminar with Michel Foucault.* Amherst, MA:

University of Massachusetts Press.

Foucault, M. (2000/84). The ethics of the concern of the self as a practice of freedom. In P. Rabinow (Ed.), *Ethics, subjectivity and truth* (pp. 281–302). New York: Penguin Books.

Hall, S., & Whannel, P. (1967/64). *The popular arts*. Boston: Beacon Press.

Hoggart, R. (1984/58). *The uses of literacy : Aspects of working-class life with special reference to publications and entertainments* (New ed.). Harmondsworth: Penguin Books in association with Chatto & Windus.

Jenkins, H. (1992). *Textual poachers, television fans and participatory culture*. New York: Routledge.

Jenkins, H. (2003). From Barbie to Mortal Combat: Further reflections. In A Everett and J.T. Caldwell (Eds.) *New Media: Theories and practices of digitextuality*. New York: Routledge.

Jenkins, H. (2006). *Fans, bloggers and gamers: Exploring participatory culture*. New York: New York University Press.

Leavis, F. R., & Thompson, D. (1933). *Culture and environment*. London: Chatto & Windus.

Masterman, L. (1980). *Teaching about television*. London: Macmillan.

Masterman, L. (1990). *Teaching the media*. London; New York: Routledge.

Turkle, S. (1995). *Life on the screen: Identity in the age of the internet*. New York: Touchstone.

Warschauer, M. (2006). *Laptops and literacy: Learning in the wireless classroom*. New York: Teachers College Press.

Williams, R. (1966). *Communications* (Rev. ed.). London: Chatto & Windus.

Notes

1. These include: the Office of Communication (Ofcom) in the United Kingdom; the Australian Communications and Media Authority (ACMA) in Australia; Harvard University's Berkman Center Internet Safety Taskforce in the United States and the Media Awareness Network in Canada.

2. The term 'subjectivity' is generally used within post structuralist theory instead of identity.

3. A MOO is a 'Multi Object Orientation' online system that allows for user interaction and collaboration.

4. A questionnaire completed by the students confirmed that they were early adopters of technology with high levels of home access to the latest information technologies.

5. To retain students' anonymity, I have used the pseudonyms students chose to use in the MOO.

6. The Virgin Mary is a venerated figure in this Catholic boys' school.

7. SBS is the Australian Special Broadcasting Service that screens international news and other programmes for Australia's multicultural population.

· 8 ·

'EXPERTS ON THE FIELD'

Redefining Literacy Boundaries

AMANDA GUTIERREZ AND CATHERINE BEAVIS

As literacy researchers continue to explore the rapidly changing and prolifer-
ating world of online texts and literacies, the challenges for classroom teach-
ers and curriculum assessment and design are twofold; first, how to learn more
about these forms and young people's participation and engagement with
them, even as they are changing, and second, what to do about them, and in
response to them, in the classroom. Increasingly, literacy and English curricu-
lum guidelines in many parts of the world call on teachers to incorporate
attention to multimodal and electronic texts into their classrooms and curricu-
lum. Curriculum guidelines addressing the 'new literacies' are structured around
an expanded view of literacy that recognises the changing and dynamic nature
of text and textual forms (Luke, Freebody, & Land, 2000; Kress 2006; Bearne
2006) and call on research into the textual, communicative and cultural prac-
tices of young people as they engage with online popular culture and the dig-
ital world. Such studies have provided powerful glimpses into multimodal and
emergent literacy and textual forms, and into the power and significance of
such sites and literacies in many young people's lives (Alvermann, 2002; Gee,
2003; Leu et al., 2008; Willet, Robinson, & Marsh, 2009). Conceptualising lit-
eracy as socially situated cultural practice, they provide insights into new and
emergent forms of literacy and literate practices ('e-literacies'; 'multiliteracies'

and literacy conceptualised as 'design'). They raise questions about the kinds of expectations about texts, participation and literacy that characterise students' experience of online digital culture and communication, and about what their expectations and understanding of reading, making and participating in texts and utilising literacies might be. Also significant are questions about the ways in which meanings are made that draw on a mix of on- and offline texts, media and forms of knowledge, as are issues of authority, identity and relationships and the ways these are configured across and between participation in on- and offline worlds.

The significance for curriculum of researching digital literacies, participation and online culture, then, lies not only in learning about 'new' forms of text and literacy, literacy and learning practices and design that communication in the digital world entails but also in learning about the ways in which young people are engaged and shaped by participating in these worlds and the kinds of dispositions and expectations this involvement generates, with attendant challenges to think through the implications of this immersion more broadly for what we might need to teach, and they to learn. In part this concerns recognising and incorporating the expertise young people are developing in digital contexts, with their attendant texts and literacies. It also means attending to issues of identity, community and cultural and symbolic capital; the ways in which young people live their lives, establish relationships and positions and try out emergent versions of self and represented identities through a mix of on- and offline participation and communication, and the acquisition and display of knowledge, as 'experts in the field.'

This chapter describes insights arising from a curriculum unit designed to explore different aspects of online games and students' engagement with them. The unit, designed as an action research project, was part of a larger research project exploring what might be learnt about 21st century literacies from studying students' engagement with video and computer games.[1] The project entailed cooperative work with ten teachers across five secondary schools, exploring many aspects of online literacies and digital cultures, centred around computer games. This paper focuses on the class of the teacher Joel who worked in an all boys Catholic High School. It describes his research and classroom project focusing on different aspects of (computer) games-based digital texts and culture, briefly discusses the growing genre of fantasy competitive online sporting games and their importance in Australia, and examines the online and offline socially situated literacy experiences of some case study students in one of Joel's classes.

The Curriculum Unit

For his unit Joel capitalised on his students' avid engagement with the fantasy sports game *AFL* (Australian Football League) *SuperCoach* to explore convergences between different media forms, the ways in which players drew on data from multiple sources and their own judgements to play the game, and the ways in which their 'real world' relationships were shaped and mediated by their demonstrated expertise and the authority they drew from their proficiency with the game.

Recognising students' fascination with this game, in a city saturated nine months of the year with wall to wall AFL coverage, Joel provided class time for students to play and reflect on the online game *AFL SuperCoach*, and to discuss the links between other media sources and the ways these merged to influence their decisions in the game. As a Media as well as an English teacher, Joel was interested in making students more aware of the phenomenon of convergence and the rapid proliferation of convergence across media forms, and in learning more about the ways they negotiated the multiple texts and literacies required to navigate transmedia texts such as these.

He began the unit by looking at elements of control over students' access to and use of media products, and followed this by watching an episode of the Australian sitcom *Summer Heights High* (Lilley, 2007) filmed in a nearby school with 'real' life students and teachers mixing with the cast of actors and crew. From here he discussed with the students their thoughts about new media and how this media is influencing adolescents' lives. This led to a discussion on online communities, with the analysis of several YouTube clips. Due to the students' interest in AFL and their immersion in the *AFL SuperCoach* game he chose to look more closely at online communities and convergence using this game as a case study. He asked the students to reflect on the kinds of skills they were forming through the use of this game and the ways they participated in the online game and the various media sources that were converging to create a particular online AFL game community. Joel was also interested in how identity constructed online is not necessarily linked or indicative of the students' physical body, in that the student may not participate in sport themselves but rather use *SuperCoach* as a viable replacement of the physical sporting experience. The *SuperCoach* unit acted as a way to launch an investigation into notions of convergence, identity and virtual worlds, as well as an occasion to observe the range of literacies students needed to call upon to play the game, on the mix of literacy skills and practices across and between different textual forms, and the flow between on and off line worlds.

AFL *SuperCoach* and Fantasy On-Line Sports Games

While fantasy sport has become a multimillion dollar industry in countries such as the United States and the United Kingdom, it has only recently become popular in Australia. This has come about through Australians' love of the Aussie rules game AFL, which began as state competitions, with the Victorian competition (VFL) avidly watched by those in other states, and has grown to include teams from all states (except Tasmania, although games are played in and televised from this state). Prior to the competition taking on national status, most football fans outside of Victoria not only barracked for a local state team but also supported a team from the VFL. This study occurred in Victoria, which is regarded as the most 'football mad' state in the nation, with loyalty to one's team as a high priority in generational support for the game. The poem 'Life Cycle' by Australian poet Bruce Dawe (2006) ironically captures the sense of loyalty and importance of a football team to their lives and their children's lives, particularly this passage;

When children are born in Victoria
they are wrapped in the club colours, laid in beribboned cots,
having already begun a life-time's barracking
Carn, they cry, Carn...feebly at first
while parents playfully tussle with them
for possession of a rusk: Ah, he's a little Tiger! (And they are...) (p. 86)

The *SuperCoach* Fantasy AFL game was first launched by VirtualSports in 2006 on behalf of the Victorian tabloid newspaper the *Herald Sun* and has grown in popularity from 91,619 registrations in its first year to 152, 317 registrations in 2007 (Montgomery, 2008). Like other fantasy sports games it is a game in which the players (in this case the students) attempt to take the role of an AFL coach. The creators of the game suggest that '*Herald Sun* TAC SuperCoach is easy to play but difficult to master.' (http://supercoach.herald-sun.com.au/). The ease of play can be seen in the fact that the controls are relatively simple. All that is physically required of the player is to create and name a football squad of 30, with 22 on the field, from a list of football players currently on an AFL team in the year of playing, with the aim of creating the ultimate team and becoming the 'SuperCoach.' The only real confine is that the team created has a salary cap, and the cost of each player varies depending on his statistics from previous real world games. The suggestion that the game is difficult to master is due to the knowledge needed of the real world of the game,

which requires not only an understanding of AFL specific language but also a critical wide reading across all media sources surrounding the game. There is also the added difficulty of ignoring one's loyalty to a particular team, as this could taint the ability to be an 'objective' judge of players' abilities. The end of the virtual season concurs with the end of the real life season, with the overall winning coach attaining the status of 'SuperCoach' with their friends as well as winning cash prizes. As the website (http://supercoach.heraldsun.com.au/) states, 'While success will earn you bragging rights over friends and colleagues, you'll also be in the running for great cash prizes. The highest-scoring SuperCoach each week will win $1,000. The overall winner picks up $30,000.'

A Literacy Framework

As many literacy theorists have argued, students' social practices in or out of the school world are literacy practices that can (and should) be a part of classroom literacy experiences. It is important to recognise that there is not one form of literacy, but several, and these 'literacies' do not exist in isolation; instead 'Any number of literacies may coexist differentially within social spaces...' (Carrington & Luke, 1997, p. 99). Students' literacies from their out of school worlds coexist with their in school literacies, yet often the classroom does not value or acknowledge the complex ways these literacies work and can be utilised to improve student learning. Joel's program allowed his students to explore the ways out of school literacies cross into the world of school and gave the students the opportunity to demonstrate their mastery of literacy in a particular part of their social world. Again Carrington and Luke (1997) argue, '...literacy and the literate person are social constructions, formed within the context of dynamic social fields and as the cumulative result of participation with a range of discourses and social relationships.' (p. 98). The case study students in this class were active participants in and experts on the world of AFL. This went beyond simply watching the games and understanding the language of the game. Their involvement with *SuperCoach* extended their engagement to encompass a wider range of discourses available on AFL and impacted on their social relationships, hence redefining their literate selves.

As with Carrington and Luke (1997), we felt a literacy framework using Bourdieu's notions of field, capital and habitus allowed an investigation of the ways students' out of school literacies were impacting on their social construction as literate identities in their school world. Bourdieu's formula [(habitus)(capital)] + field = practice (Bourdieu cited in Carrington & Luke,

1997) was applied to this classroom situation to examine how students' out of school 'AFL' world or field, the habitus they drew on when in this field and the cultural and symbolic capital associated with their control of AFL resources and knowledge, when crossing into the field of the classroom equated to a particular literacy practice, and how it impacted on their sense of power and agency when this capital became a valued commodity in the classroom. 'When various forms of capital are perceived and recognised as legitimate by institutions, groups and individuals, their acquisition results in accumulations not only of the particular capital itself, but also of social prestige and standing' (Bourdieu cited in Carrington & Luke, 1997). As will be discussed in the analysis of the case study students, one particular student's control of cultural capital afforded him a higher status, and thus symbolic capital, not only with his peers but also with others who would normally be in higher positions of power. For these students the field, or social sphere, of AFL is an integral part of their habitus. As Bourdieu (1998) argued, habitus is a 'structured body' that determines the way one walks, talks, feels, perceives and acts within a particular field or world. For these students their habitus when in the field of AFL was demonstrated through '...the ways in which not only is the body in the social world, but also the ways in which the social world is in the body' (Bourdieu cited in Reay, 2004, p. 432). These students displayed a particular habitus that coexisted in the field of the classroom when the cultural capital they possessed became valued as not only an important part of their outside school social practices but also their in school literacy practices.

This particular instance of social literacy and the capital from this field has been further expanded by Consalvo in the coining of the term 'gaming capital,' an adaptation of (and with close ties to) Bourdieu's (1984) notion of cultural capital. It is a concept that has provided a generative framework within the larger project for conceptualising important aspects of game play (see Walsh & Apperley, 2008). As stated earlier, the successful playing of *SuperCoach* requires not only the 'capital' that comes with being a dedicated fan of the sport but also '...the skills and habits of mind characteristics of gamers...' (Halverson & Halverson, 2008), which translates into what Consalvo (2007) calls 'gaming capital.' As Consalvo (2007) describes it, gaming capital provides:

> a key way to understand how individuals interact with games, information about games and the games industry, and other games players. The term is useful because it suggests a currency that is by necessity dynamic—changing over time and across types of players or games....knowledge, experience and positioning help shape gaming capital for a particular player and in turn that player helps shape the future of the [games] industry....Players themselves further shape gaming capital, especially as new media

forms offer individuals more opportunities to share and the games world grows even larger. (p. 4)

This gaming capital involves not only being able to physically master the controls, rules and limits of the computer game, but one can increase their gaming capital through immersion in the gaming world beyond the game by becoming a part of what Jenkins (2006) describes as 'participatory culture.' This 'participatory culture' comes about with the convergence of the world of the game and the real world creating a '...place where old and new media collide' (Jenkins, 2006, p. 2), and students can actively participate '...in shaping the creation, circulation and interpretation of media content.' (MIT Convergence Culture Consortium, 2008). In the case of the *SuperCoach* game, the case study students in Joel's class, who are avid fans of AFL and are also experienced game players, are able to actively participate in the convergence of two fields important in their out of school lives. Joel was able to examine this convergence with the students by looking at the ways these fields converge, which includes the 'paratexts' (Consalvo, 2007; Genette, 1997) that pop up surrounding the *SuperCoach* game. In relation to the field of game play, 'paratexts' are a new form of text related to the game that game players, in this case the students, encounter and actively produce in this field. Consalvo (2007) used the term to describe the 'communication and artefacts relating to [a game, that] spring up like mushrooms' (p. 8) around the game. These texts can range from cheats on the games through to blogs. For example in the context of *SuperCoach* one game player posted a copy of his squad that was created due to an anomaly with the salary cap allowance onto the *Fanfooty* blog (http://www .fanfooty.com.au/blog/). He managed to create a squad that exceeded the salary cap several times over. He wanted to share his 'luck' but was unable to explain to other interested players of the game how to replicate the anomaly.

The literacies of the students working in the game world of *SuperCoach* are complex and require dedication not only to the real life AFL game but also to the multifaceted worlds that surround the real game and the online game. The analysis of the students' literacies in the next section uses the framework and concepts discussed here to not only create an understanding of how they are functioning in this world but also to validate the worth of exploring these kinds of literacies in the classroom.

Social Literacy and the World of *SuperCoach*

The students in Joel's class were immersed not only in the virtual game but in

all aspects of the game. They positioned themselves in relation to their 'coaching' abilities which related to their knowledge of the 'virtual' world of the game but also the 'real' world of the game. Students were involved in the participatory culture in the process of creation and consumption of texts surrounding the real world AFL game and paratexts surrounding the *SuperCoach* game. Their active participation with these texts worked to increase their cultural capital, gaming capital and hence their symbolic capital in these fields.

As Consalvo (2007) notes, 'Games aren't designed, marketed, or played in a cultural vacuum.' (p. 4), which is clearly apparent when discussing with students their immersion in the game and the world around it. The virtual 'game,' for the students interviewed and observed in this study, influenced their relationships with peers, their family, other students at their school (Duncan High School), and their teachers as they played with and against these other 'coaches' in their daily lives. The students not only had teams in the larger 'Victorian' league consisting of approximately 200,000 teams, but had also set up a competition just for the school and a competition against their teachers. So in essence these students had multiple teams for each 'field' of their lives; as one student stated, '…as well as competing against everyone in Australia, everyone in Victoria, everyone that barracks for Richmond, we're also competing against 16 Duncanians.' (Jason). The students' AFL habitus in the 'game' world and the texts they engaged in around this world played an important role in their exploration of self. As Walsh and Apperley (2008) argue, 'These are the experiences, actions and texts youth often draw upon in the construction of their identities and subjectivities in an increasingly networked and globalised world where games matter' (p. 5). Students created their own 'football identity' for each social group they associated themselves with.

Taking on the role of coach allowed students to take up positions of expertise and authority in relation to both football and their peers. The role of a 'professional' coach, rather than just being a fan, provided them with the chance to experiment with the 'expert' knowledge needed in that profession, and the status that it affords one in society, or in their own social groups that they had formed. For some it afforded them an authority over those who would usually control the power, particularly their teachers and older 'known' participants such as parents, as they advanced higher in the game, and demonstrated more control over the gaming capital than these traditional authoritative groups. When students' gaming capital was combined with their AFL cultural capital, particular students' knowledge became valuable commodities. The way this increased their reputation in these social fields reflected their increased sym-

bolic capital, which is described by Carrington and Luke (2007) as 'the social phenomenon of prestige, status and reputation which accompanies the accumulation and recognition of other forms of capital' (p 103). The power these students attained in their social groups through symbolic capital created a situation where they would often guard their knowledge from their peers if they felt their status would be challenged. As Dale stated:

> Well Jason went into the season as the favourite and at the start he didn't tell me anything. He didn't tell me one player that was going to be in his team but as the season opened up he was open about his trades, but then when it came to finals and he thought I might be able to beat him, he just shut off from me completely. He wouldn't tell me anything he was doing but I think there was about three of us who pretty much had no competition from the other Duncan High boys and all the other Duncan High boys were just open but us three were pretty closed because we didn't want to lose really. (Dale)

These students, who displayed the most control of capital in the school league, were serious competitive fans. Like the fantasy baseball players in the Halverson and Halverson (2008) studies, the students spent '…countless hours preparing for the season and managing their team, not just so their favourite real-world team will do better and not just to produce something that represents their ideas about baseball or baseball players but rather to win' (p. 295). Winning against peers and other players escalated these students' capital in this social field and the habitus required to achieve this while in this field is displayed through these students' strategies while in the field. They would 'share' information as long as it did not challenge their status. The students displayed

> …'embodied competence' [that] figures differentially in knowledge/power relations within and beyond the school—a competence which may include the ability to reproduce specific textual forms, to cite particular culturally valued texts, to demonstrate the physical demeanour of a literate, or to maintain normalised relationships with other students and those in positions of authority.' (Carrington & Luke, 1997, p 107)

Control in the field of *SuperCoach*, and hence maintaining symbolic capital, requires a literacy beyond the traditionally valued reading instruction that happens in schools. The skills students learn in the field of school reading once added to their habitus are transformed and integrated into pre-existing social world habitus such as acquired through the AFL field. For these students it meant distancing oneself from allegiances to particular teams and instead attempting to position oneself as a follower and objective judge of 'players' rather than 'teams.' Success in fantasy sporting management games 'requires a deep knowledge of, and the capacity and desire to follow, the statistics of many

individual players over the course of time' (Halverson & Halverson, 2008, p. 304), and this knowledge needs to '…extend beyond the marquee players to up and coming players and even players who have not yet cracked the major leagues' (Halverson & Halverson, 2008, p. 304). Dale explained how playing *SuperCoach* has impacted on the way he follows AFL:

> …obviously I barrack for a football team and I go to support them but if there's play-ers in the other team, I'm like man I hope they lose but I hope he has a good game… it changes your support a little because you stand back and you want individual players…

and in relation to his selection of *SuperCoach* players:

> I try to steer clear of the team I barrack for like Collingwood players because I don't want to get stuck in barracking for an individual player…but when it's an Essendon vs Fremantle game I just barrack for individuals, not for an actual team. So that's how I've found myself to be successful.

Dale's reflections demonstrate that playing the game *SuperCoach* has meant he follows players, rather than barracking for a team, which is why he has chosen not to select players from his favourite team to be on his *SuperCoach* team. He does not want his dedication towards his favourite team influenced by his competitive need for individual players to perform. His habitus in the AFL field has changed as he becomes more invested in individual players and uses liter-acy strategies, such as reading and tracking players' statistics, when watching games to enable him to become more powerful and successful in the online AFL world. This also impacts on the kinds of individual players he watches in the game. While there are 'star players' fans would traditionally enjoy watching and following, Dale's reading practices when watching the game changed as he began to focus on other 'under the radar' players producing the kinds of statis-tics valued in the world of *SuperCoach*, yet only requiring small salaries:

> Yeah I think it definitely changed the way I looked at certain players. Like stats, like tackles and stuff very much come into play when you're playing the game *SuperCoach* and so you rate the players that go under the radar a bit. Yeah good to find the play-ers not so much highlighted cause they're cheaper in money and they score just as much points as the star players.

By selecting these players he improves his score and keeps within the required salary cap. It is the use of strategies such as these in the online game and changing the way one views the real games that demonstrate the kind of liter-acy skills these students use in their social construction. They need to seek out and master the language of this field to be able to interpret statistics and opin-

ions, predict the real coaches' decisions about player selections (or to put it another way, predicting and following narratives of the teams and the AFL game as a whole), make judgements on how injuries and suspensions will impact on their *SuperCoach* performance, and to critically view the images from the game and the AFL world beyond the game.

This mastery of the language of the field, which comes from being active participants in the fantasy game, paratexts surrounding the fantasy game and texts surrounding the real game, was displayed by the case study student Dale, but also by Jason. Jason said his success in the game came from

> ...dedicating my whole life to football so just watching. Pretty much everything in the winter was about footy

and felt that

> ...people who are heavily involved with football and live football would have no problem doing *SuperCoach*, footy cards, stick books, playing footy, doing whatever. It's just your passion for the game especially growing up in Melbourne, that's what we were brought up around, football...I do the *SuperCoach* thing and I do, there's another thing called *Dream Team* which is pretty much the same thing and I go on all the forums but yea it definitely is a part of your life.

The case study students were so integrated into the *SuperCoach* world during the months of the AFL season that their social group regarded them as game experts of the real and online game. They had the gaming and cultural capital required in this field to be successful at the practice of playing the game and were able to replicate the kind of language that demonstrates a deep understanding of the real life game and its rules. In a video recorded extract from one of Joel's classes Dale demonstrated his linguistic prowess when imitating a coach being interviewed about his *SuperCoach* team's performance. In front of his peers and his teacher he took on the tone, gestures and language typical of a coach's habitus, displaying how this form of literacy had become a part of his own habitus. Carrington and Luke (1997) argue that 'Language interactions, on whatever scale and in whatever context, are highly complex social events heavily laden with symbolic significance that lead to the articulation and exercise of symbolic power' (p 104). Whenever Dale stepped into the social identity of the role of 'coach' he drew on the linguistic devices and language that would commonly be seen in interviews with coaches before and after the games. For Dale, the virtual game and the real game were his passion, even though, as one of the other students commented, he did not 'play the game' in real life. But he did not need to 'play the game' in real life to be an expert on the 'field,' and

even with the real game and other professional sports, it appears a professional coach does not need to have been a 'legend' on the physical field, but instead needs to be an expert on how to best play the game, know the players and position them effectively on the field to win games. This game allows those who may not be able to master the real game to become experts on the field in a way that allows them to have a sense of achievement and feel deeply connected to the real game.

This habitus and capital gained from being a highly 'literate' person in this field would not have come about without critically viewing the online game, the paratexts surrounding the online game, the real game and the texts surrounding the real game. The reason Jason and Dale were seen as experts, the people the other students and teachers went to for advice, was due to their critical understanding, and hence cultural capital, not only over the traditional texts existing around the world of AFL such as newspaper articles, television shows, AFL books and radio commentary but also due to their control over converging paratexts surrounding the virtual game, tying into their gaming capital. As quoted earlier, Jason played other online fantasy AFL management games and interacted with the online forums. On top of this he also actively

> …read the *Herald Sun* because they run it and they have a special column dedicated to *SuperCoach*, I think Kevin Sheedy wrote it, so he'd give his opinions and then you can compare them against your own…

and

> …always read the different sports columns in the paper. But I definitely analyse the games much more and definitely the stats because before this year I never really worried about how effective a player was in the field but then that comes into *SuperCoach* points now so you have to really watch.

Dale also followed the information in the *Herald Sun* and sports columns:

> I make sure I watch the *Footy Show* every Thursday night to see the ins and outs of the players. So if a player gets dropped or he's injured or something you know whether to trade him that week.

The teacher, Joel, also noted the kind of dedication successful players like Jason and Dale had to have to remain 'experts' and keep the symbolic capital that afforded them power in this field.

> The actual world of the game is quite small. Where it becomes complicated is the type of information you have to deal with is continually being updated, continually changing, and that's the challenge for the students. So the students have to be on the ball. If they slip up for a week, if they choose not to put the time in, then they're likely to

be less successful…so they draw on the old media, so print, television, radio, they draw upon that to help boost their chances within the online world.

And

> This type of game encourages them to absorb themselves in a football world on a daily basis. During the day, during class, at night, when they get home spending their leisure time doing it.

Playing *SuperCoach* relies heavily on the intertextual traversing of a variety of texts. Yet, to become an expert of the *SuperCoach* game and acquire gaming and symbolic capital one needs to know not only how to access the various paratexts surrounding the game but also how to critically judge the paratexts and traditional texts. Jason and Dale were critical judges of the texts they sourced, they did not believe all 'opinions' they found, but, as Jason stated earlier, instead compared them and viewed them in light of their own 'expert' knowledge. Dale made judgements about the texts available to make choices about which were reliable sources:

> [I go with] whoever I think has the more valid…whoever I valued their opinion more. I suppose certain people like Sam Newman he tends to know not that much compared to someone like who's an actual expert like a columnist or something. Their background, like their background of the game, most experienced within the game I'll probably value more.

Students need to have skills that extend beyond the basic literacy required to simply decode textual material from traditional sources such as newspapers like *The Herald Sun* and television shows like *The Footy Show*. They also need to be critically literate to make judgements about the purpose of each text, any underlying biases the 'expert' commentators may have as well as the possible reasons not only in traditional forms of texts but also in the growing world of paratexts surrounding the online game. The paratexts surrounding this game have become extensive and inclusive of many generic forms. *SuperCoach* has become such a popular game that there are now columns specifically written for *SuperCoach* players in the *Herald Sun* by experts, who are regarded as having acquired a large amount of cultural capital, such as Kevin Sheedy, the well regarded ex-coach of Essendon whose 'real' expert status as a coach is further compounded by the release of the video game *Kevin Sheedy Coach* (Acclaim Entertainment, 2002). There is also a radio show dedicated to discussing the statistics of the players, as well as websites, forums, blogs and online articles dedicated to fantasy AFL that players can explore. On top of this the students create their own paratexts, and increase their gaming capital, as they contribute

to some of the online activities. These students are a part of a participatory culture where 'All of that knowledge, experience, and positioning helps shape gaming capital for a particular player, and in turn that player helps shape the future of the industry.' (Consalvo, 2007, p. 4). There is a symbiotic relationship between the *SuperCoach* player, the paratexts, and traditional forms of texts that surround them. The more engaged and involved the players become with the consumption of these texts and contribution to the paratexts, the more capital they acquire and the closer they come to being regarded by others as an 'expert' coach in the game. The students need to be able to synthesise material from a vast array of sources and genres, ask questions of the texts and make their own judgements about these texts. The more developed their skills are in relation to this, the better their chances of success.

Experts in the Field—Final Statements

Students' playing of *SuperCoach* provides a compelling instance of the convergence of on- and offline worlds, media convergence and the need for students to be adept in reading, bringing together and analysing information presented in a variety of forms, from a variety of sources. Playing the game has material effects on students' sense of self, the ways they manage information, knowledge and authority, their relationships in the real world, and the seamless integration of technology into their everyday lives. The expertise they establish through playing *SuperCoach* is knitted into the ways they interact with each other and others who do and do not play the game, and is highly valued. In order to 'win' they need to develop the capacity for detached evaluation of players and games, in a context where football is an integral part of Melbourne culture, and passionate attachment to teams and players is the norm. In a city where 'play' encompasses not only *SuperCoach*, the online game, but also the actual AFL games on ovals around Australia on a weekly basis, the seamless integration of on- and offline stances and expertise into everyday friendships and the realities of the classroom world point up the degree to which game play becomes part of the building of relationships and identities that play a major role in teenagers' lives in these years.

 SuperCoach, and the playing of it, exemplifies a range of new and traditional texts, literacies and literacy practices, in relation both to the mastery of 'paratexts' necessary to play the game and in the new texts students created as they did so. To succeed, to become 'expert,' players need to draw on texts from across a range of media and to read information presented in a wide range of repre-

sentations, ranging from the somewhat dubious TV commentary of *The Footy Show* through to statistical accounts of different players' performance in each week's play. In a game where play depends literally and extensively on what happens in both on- and offline contexts, where players need to be literate in multiple ways and read across multiple texts types and media, Lemke's observations of the nature of online reading seem particularly apt: 'You can't really get at the meaning of various forms piecemeal: you have to integrate the text with its fellow travellers, cross-contextualising them by one another, to get at the kinds of meanings being made and stored' (Lemke cited in Alvermann, 2008, p. 15).

A central challenge for literacy research and literacy and English education is to understand the ways meaning is made across traditional and digital literacies, in ways that avoid hard and fast boundaries distinguishing off- from online forms, or of the ways in which meaning is made in the cross flow between them. As Alvermann (2008) notes:

> Communication through images, sounds and digital media, when combined with print literacy may be changing the way we read certain kinds of texts, but online and offline literacies are not polar opposites. To reify distinctions between them serves mainly to limit understandings of how each informs the other. (p. 16)

Luke, Freebody, and Land (2000) describe contemporary literacies as '...the flexible and sustained mastery of a repertoire of practices with the texts of traditional and new communications technologies via spoken language, print and multimedia.' (p. 9). Playing the game shows or develops a set of literacy practices that include the capacity to read across media, read information presented in different forms (print, visual, statistics, aural, etc.), evaluate material that is or may be heavily invested in other issues (e.g., *The Footy Show*, reportage of individual players, the parade of media commentary and 'expertise'), to interpret and translate this information into play, and to constantly modify and reappraise in the light of new information. It requires sustained attention to multiple factors over an extended period of time and is both a compelling example of situated literacy practice with real world consequences and of the fluidity of game play, literacies and identity across on- and offline worlds.

For students such as Jason and Dale, games function as sites for exploration and 'serious play'—the establishment of authority, status and relationships amongst their peers and in the world of the game. Allowing students' social practices to become a part of the literacy practices in the English or Media classroom gives them the opportunity to tap into their gaming and cultural capital. The literacy practices that these students are immersed in when acquiring and reproducing these forms of capital are complex and should be given space for

exploration in the classroom. It is important that teachers acknowledge that 'To make consequential differences in students' life trajectories, educational interventions thus may have to extend far beyond the classroom door' (Carrington & Luke, 1997, p. 110). It is not as challenging as it seems to include these kinds of texts in the classroom. As Joel says '…it's such a part of their cultural world that they don't need much encouragement to participate in the research vigorously.' As Lingard and Rawolle (2008) argue, 'The effect of a field on an agent [then] is dependent on their habitus, their position in particular fields and the strength of the field relative to other fields in which the agent is active' (p. 732). If teachers allow the literacy of the AFL field (or other sporting fields in different contexts), and the world of video games and gaming capital, both worlds in which many male students have embodied capital, to have currency in the possibly uncomfortable field of the classroom, they will be able to draw on their strengths in one field to become stronger in another.

Note

1. Beavis, C., Bradford, C. O'Mara, J. and Walsh, C. S.: *Literacy in the Digital World of the Twenty First Century: Learning from Computer Games*. Australian Research Council 2007–2009. Deakin University. Industry partners: The Australian Centre for the Moving Image, The Victorian Association for the Teaching of English, The Department of Education and Early Childhood Development, Victoria. Research Fellow: T. Apperley, Research Assistant: Amanda Gutierrez

References

Acclaim Entertainment. (2002). Kevin Sheedy AFL Coach 2002.

Alvermann, D. (Ed.). (2002). *Adolescents and literacies in a digital world*. New York: Peter Lang.

Alvermann, D. (2008). Why bother theorising adolescents' online literacies for classroom practice and research? *Journal of Adolescent and Adult Literacy, 52*(1), 8–19.

Bearne, E. (2006). Texts and technologies. Retrieved 3 June, 2009, from http://www.qca.org.uk/libraryAssets/media/12124_texts_and_technologies.pdf

Bourdieu, P. (1984). *Distinction: A social critique of the judgement of taste*. Cambridge, MA: Harvard University Press.

Bourdieu, P. (1998). *Practical reason*. Cambridge: Polity Press.

Carrington, V., & Luke, A. (1997). Literacy and Bourdieu's sociological theory: A reframing. *Language and Education, 11*(2), 96–112.

Consalvo, M. (2007). *Cheating: Gaining advantage in videogames*. Cambridge, MA: MIT Press.

Dawe, B. (2006). *Sometimes gladness* (6th ed.). Melbourne, VIC: Pearson Education Australia.

Fanfooty blog. Retrieved 21 February, 2009, from http://www.fanfooty.com.au/blog/

Gee, J. (2003). *What video games have to teach us about learning and literacy*. New York: Palgrave Macmillan.

Genette, G. (1997). *Paratexts: Thresholds of interpretation*. London: Cambridge University Press.

Halverson, E., & Halverson, R. (2008). Fantasy baseball: The case for competitive fandom. *Games and Culture*, 3, 287–308.

HeraldSun TAC (2008). SuperCoach. Retrieved 28 November, 2008, from http://supercoach.heraldsun.com.au

Jenkins, H. (2006). *Convergence culture: Where old and new media collide*. New York: New York University Press.

Kress, G. (2006). Communication now and in the future. Retrieved 3 June, 2009, from http://www.qcda.gov.uk/libraryAssets/media/12292_commun_now_and_in_the_future.pdf

Lemke, J. (2007). New media and new learning communities: Critical, creative and independent. Paper presented at the annual meeting of National Council of Teachers of English Assembly for Research (NCTEAR) Nashville, TN Retrieved 28 November, 2008, from http://lchc.ucsd.edu/mca/Mail/xmcamail.2007_01.dir/0354.html

Leu, D., Corio, J., Knobel, M., & Lankshear, C. (Eds.). 2008). *Handbook of research on new literacies*. New Jersey: Lawrence Erlbaum.

Lilley, C. (Writer) (2007). *Summer Heights High*: Australian Broadcasting Corporation.

Lingard, B., & Rawolle, S. (2008). The sociology of Pierre Bourdieu and researching education policy. *Journal of Education Studies*, 23(6), 729–741.

Luke, A., Freebody, P., & Land, R. (2000). *Literate Futures*. Retrieved 21st March 2003. from *http://education.qld.gov.au/curriculum/learning/literate-futures/*.

MIT Convergence Culture Consortium (2008). About C3: Convergence. Retrieved 24 February, 2009, from http://convergenceculture.org/aboutc3/convergence.php

Montgomery, P. (2008). A short history of fantasy Aussie Rules football. Retrieved 12 March, 2009, from http://www.fanfooty.com.au/blog/2008/02/11/a-short-history-of-fantasy-aussie-rules-football

Reay, D. (2004). 'It's all becoming a habitus': Beyond the habitual use of habitus in educational research. *British Journal of Sociology of Education*, 25(4), 431–444.

Smith, B., Sharma, P., & Hooper, P. (2006). Decision making in online fantasy sports communities. *Interactive Technology & Smart Education*, 4, 347–360.

Walsh, C. S., & Apperley, T. (2008). *Researching digital game players: Gameplay and gaming capital*. Paper presented at the IADIS International Conference Gaming 2008: Design for engaging experience and social interaction.

Willet, R., Robinson, M., & Marsh, J. (Eds.). (2009). *Play, creativity and digital cultures*. New York; London: Routledge.

· 9 ·

"I Think They're Being Wired Differently"

Secondary Teachers' Cultural Models of Adolescents and Their Online Literacies

KELLY CHANDLER-OLCOTT AND ELIZABETH LEWIS

The American media have shown significant interest in young people's online literacies in the past few years. A columnist in a major paper framed social networking sites such as Facebook and MySpace as "drugs" to which youth were addicted (Zimmerman, 2009). "Technology leaves teens speechless," read the headline for another story about oral communication skills declining among adolescents who text message extensively (Barker, 2006). In spring 2009, reports appeared on television and in print about adolescents' engagement in sexting, sending sexually explicit pictures of oneself via cell phone or posting them online (Richmond, 2009). The images that emerge from such coverage are of youth who are technologically proficient but whose choices threaten the development of their intellect, language, relationships—even their safety.

Qualitative research in education confirms the centrality of online literacies to many adolescents' daily lives, but it often presents a more positive spin on their practices than reporters do. Lewis and Fabos (2005), for example, found that teens who participated in instant messaging (IM) demonstrated sophisticated thinking "as they critically analyzed the language of IM in terms of the rhetorical context within which it was framed, and in terms of what the texts could do for them" (p. 493). Other researchers have documented the value of literacy practices associated with zine authorship (Guzzetti & Gamboa, 2005), online fanfiction (Black, 2008), and online role-playing games

(Thomas, 2007), with some arguing that skills and habits of mind developed in these contexts overlap with, and sometimes exceed, expectations for academic literacies in school.

Less attention has been paid to the sense that secondary teachers are making of these trends and patterns. Like members of the public at large, educators are influenced by media coverage of adolescents' use of online technologies. Teachers' constructions of adolescence are further shaped by their firsthand experiences with students in their classes, interactions with adolescents in their own families, and, perhaps less often, empirical research on adolescent literacy and technology. Little is known, however, about how teachers articulate their views of adolescents and their online literacies in light of information from these sources (see Stolle, 2008, and Bailey, 2009, for two notable, though small-scale, exceptions).

This chapter, then, has several purposes and parts. First, we draw on Gee's (2001, 2008) idea of cultural modeling to explore and theorize about teachers' constructions of adolescents and their online literacies. We discuss these cultural models in the context of two themes that were salient in a study we conducted with secondary educators. Finally, we suggest strategies that classroom teachers and library media specialists might use to inform and enrich their cultural models in ways that go beyond the limited perspectives offered by typical media. By taking our participants' views and experiences seriously (including their cautions and concerns as well as the successes they report), we hope to increase the chances that literacy instruction will be responsive to both practitioners' and adolescents' needs as well as sensitive to the secondary contexts in which it will be implemented.

What Are Cultural Models?

In considering teachers' constructions of adolescents and their online literacies, we find James Paul Gee's (2001, 2008) construct of cultural models very helpful. As part of a larger theoretical framework he calls New Literacy Studies, Gee (2001) defines cultural models as "schemata, storylines, theories, images, or representations (partially represented inside people's heads and partially represented within their materials and practices) that tell a group of people within a Discourse what is typical or normal from the point of view of that Discourse" (p. 721). Discourses, in Gee's view, are "ways of behaving, interacting, valuing, thinking, believing, speaking, and often reading and writing, that are accepted as instantiations of particular identities (or 'types of people') by specific groups" (2008, p. 3).

People who are members of a given Discourse use cultural models to guide behavior in social contexts. These cultural models are often "tacit in the sense that people have not thought about them much and take them for granted. They seem 'obvious,' even commonsense" (Gee, 2008, p. 25). As Heath (1983) revealed, parents from different class and racial backgrounds drew on significantly different cultural models about the role they should play in developing their children's language and literacy, despite sending those children to the same elementary school. In classrooms, teachers' cultural models of students, their subject matter, and adult authority influence how they design and enact their pedagogies.

Gee (2008) distinguishes between a cultural model and what he calls a "primary theory" (p. 25), a more explicit version of a cultural model that has been informed by discussion, reading, and original research. He points out that the difference between a cultural model and a primary theory is not whether one is more "right" than the other but rather whether the holders of a primary theory have "allowed their viewpoints to be formed through serious reflection on multiple competing viewpoints" (p. 25). He also insists that scholars do not have a monopoly on the generation of primary theories. A well-informed baseball fan may have a primary theory about the impact of the designated hitter on the game, while a jazz aficionado may have one about the best jazz saxophonists of the 20th century.

While cultural models are no less valid than primary theories, Gee (2008) argues that the development of the latter is often desirable because unexamined cultural models can contribute to inequity: "One always has the moral obligation to change a cultural model into a primary theory when there is reason to believe that the cultural model advantages oneself or one's group over other people or other groups" (p. 26). If individuals are unaware of the basis for their decisions, they may also be unaware of how those decisions privilege some and disadvantage others. For instance, teachers whose cultural models of reading revolve around transactions with book-length print texts may inadvertently send the message to students who are committed and engaged readers of online text that such reading is less valuable. Before we discuss our participants' cultural models about adolescents and online literacies, we briefly describe the study itself.

Our Study

Our research was grounded in a longstanding interest that we, both former secondary English teachers, have in adolescent literacy—more specifically, in

adolescents' pursuit of "new literacies," a term that some (e.g., Coiro, Knobel, Lankshear, & Leu, 2008) link to the increased influence of information and communication technologies (ICTs) in contemporary society, and others (Harste & Albers, 2007; Jewitt & Kress, 2003) link to the rise of representations using multimodality and the visual arts. As intrigued as we are by research documenting the complexity of youth's new literacies outside of school and as challenged as we have been as teacher educators by cutting-edge, technology-focused interventions with pre-service teachers, we are concerned that the new literacies-related perspectives of typical practicing teachers, those not enrolled in special courses or programs, have not been well documented. We wanted to conduct research capturing various views on integrating new literacies in secondary classrooms, including those of teachers who are nervous and even skeptical about such possibilities.

Participants for the collective case study (Stake, 1995) we conducted in one suburban high school included 13 of 15 teachers in the English department, one academic intervention teacher, and two library media specialists. All 16 were European-American, and none reported speaking a first language other than English. Thirteen were female, three male. They ranged in teaching experience from one year to nearly 30, and they taught classes across grades 9–12.

The student body was 97% European-American and 98% native speakers of English. About 5% of students were eligible for free lunch, although the combined wealth ratio—a figure drawing on both property value and adjusted gross income—was somewhat below the state median. The district tended to perform well on annual English examinations, with about 95% of students passing the 11th grade test in 2007. At the time of the study, district administrators had launched a three-year professional development focus on technology integration due to a perceived weakness in this area.

We saw the site as a good one for our research because members of the English department had a good reputation locally, had access to a range of technological resources, and expressed interest in discussing their practice with researchers. At the same time, our choice of this site, where teacher and student populations were largely homogeneous in terms of race/ethnicity, language, and social class, meant that our vantage point on the issues would be different than it would be in a setting with more cultural diversity.

We gathered data for the study via two rounds of interviews. First, all 16 participants were interviewed individually for 30–45 minutes. We used a think-aloud protocol on a text excerpt about new literacies (Leu, Kinzer, Coiro, & Cammack, 2004) and a series of six open-ended questions such as "In what ways

do you feel you are supported in your inclusion of new literacies in your pedagogy?" Next, all but one teacher participated in focus-group interviews of 40–60 minutes. Groups were constructed heterogeneously by grade levels taught, years of experience, and self-reported comfort levels with technology and new media from a questionnaire we designed. The focus-group questions were similar to those used in the individual interviews, minus the think-aloud, in hopes that teachers could share, reflect, and elaborate on previous points.

We analyzed the interview data in several ways. First, each of us read and reread the material, coding inductively (e.g., teachers' frustrations with technology, teachers' perceptions of support for new literacies), then we discussed the codes to develop consensus about how to describe them. Next, we constructed several graphic organizers around key themes, including one related to teachers' constructions of adolescence. With this last idea in mind, we returned to the original data for one more theory-driven analytical pass, identifying what we saw as examples of teachers' cultural models related to adolescents and their online literacies.

Teachers' Constructions of Adolescents and Their Online Literacies

Teachers' cultural models clustered into two related but different themes: (1) the impact of online literacies on adolescents' thinking and communication, and (2) the impact of adolescents' online literacies on teaching and learning in school. Each is discussed below.

"The Internet Is Constant with Them": Cultural Models about the Impact of Online Literacies on Adolescents

Asking study participants to articulate their perspectives on adolescents' online literacy practices elicited a multiplicity of responses that revealed depth and breadth beyond one simple cultural model. Participants viewed adolescents' online practices as being diverse in use and purpose. They understood the impact of those technology uses as situated on a continuum, with some affording gains and others presenting costs.

Nearly all participants remarked upon their students' adeptness with online and other digital technologies—what we, borrowing from a report by the American Association of University Women (2000), call their "tech-savviness." The cultural model of tech-savvy adolescent threaded through the media reports we cited at the beginning of this chapter is demonstrated by these

comments from Colin, a nine-year veteran:

> It's a part of their life, they grew up with it, they understand that they know it...their abilities are amazing. I think about when I went to school...I had to take a typing course in high school. We used typewriters, so it's been a big change since then. They're very proficient with their [technological] skills.

In addition to cultural models associated with adolescents' tech-savviness, many participants drew on cultural models about the role online technologies play in adolescents' social connectedness. Gail, a media specialist with 11 years of experience, argued that this generation of students was "so connected like they have never been before....[T]hey've got their headphones, they're walking doing their mundane things, but they're still connected to their friends." Jen, an English teacher for five years, described her students as using technologies that centered on communication and social interaction: "Obviously there is the Instant Messaging that they are doing all the time. A lot of my students actually *have* blogs of their own. They are all doing MySpace, which I'm not even familiar with, but that's a huge thing." She concluded, "The Internet is constant with them." Molly, the only first-year teacher in the department and a self-proclaimed user of new media and technologies in her personal life, echoed Jen's ideas, arguing that the appeal of blogs and MySpace was

> the huge social aspect of it, which is part of what keeps them interested in it, and then they form those skills. Those typing skills, those Internet skills, those research skills come in part from a social interaction...it's a way of reaching out and keeping yourself connected. It's a social thing, and socializing is very important to human beings, but especially when you're an adolescent.

In addition to a cultural model about ICTs as connective tools, Molly's comments draw on an older cultural model—one preceding the Internet—that positions adolescents as preferring social contact with their same-age peers over relationships with adults such as parents and teachers. Although research (e.g., Finders, 1997) has complicated this notion, it remains prevalent in popular culture (e.g., television shows with teen casts on *Nickelodeon*) and even in some literacy methods textbooks that describe adolescent development.

Linda, whose 29 years of teaching put her at the opposite end of the experience spectrum from Molly, nonetheless shared Molly's view that the typing, Internet, and research skills students developed from their online pursuits were beneficial to them. She went further, though, articulating that students' online literacies contributed to changes in their self-perception: "Young people [today]

don't see themselves as belonging to one area of the world. They see themselves as part of an entire *globe*. And the reason they do is because they have access to the entire world via the Internet and I think that's *awesome!*" She expanded the cultural model of adolescents as connected to actors in their immediate social world to include those with whom they interacted online but did not meet face to face.

In addition to pursuing relationships, several teachers commented on how adolescents use their online literacies to explore interests and issues that matter to them. Gail, a woman in her mid-forties who came to her career as a library media specialist after raising her own children, compared students' opportunities to pursue these topics to what she was afforded in her youth:

> I think they're more connected to what interests them than my generation was, because they have access to it immediately. These kids who are involved in sports, they'll come in here [to the library] and know exactly what's going on with the other high schools and the NBA, because they can check daily. There's so many places that provide the information that interests them....

Tom, an English teacher in his seventh year, concurred with Gail about students going online for information of personal interest: "Let's say a new gaming system is coming out and they want to find out what it's going to be like. I could see them getting online and looking up everything online about this gaming system." Lynne, a 15-year veteran, also noted that some students used the Internet to immerse themselves in topics beyond school-sanctioned curricula: "Some of what these kids know is phenomenal, because they're not getting it from [school]. It's because they are surfing the web and become experts [on things] that intrigue them."

Not all teachers saw students' online literacies so positively, however. Gail argued that adolescents' widespread use of the Internet could be detrimental:

> I hear from many teachers that the caliber of students...[has] changed dramatically within 20 years. And I tend to believe it. I'm not gathering data and that sort of thing, but I think we have to wait and see. I have a strong feeling that children today who are growing up connected, who are *not* interacting with print but are continually interacting with video and technology that change instantly....I think they're being wired differently. They *think* differently. They look at the world differently.

In her assessment of students' decreasing "caliber," Gail evoked concerns about literacy, technology, and cultural decay expressed by cultural critics such as Birkerts (2006). She was not alone among colleagues in subscribing to these cultural models. Similar concerns were shared by Lynne, who felt that some adolescents used the Internet to expand their knowledge base but that most did not.

She linked her perceptions of students' deteriorating academic preparedness to an explosion of media choices as well as increased technology use:

> [They have] a hundred channels to choose from, and the State of the Union Address comes on and, yeah, maybe no one really wants to hear that because it's not stimulating, but they need to hear it. It's a lot easier to flip the station and find something else that's entertaining and mindless....They have so many choices that they never have to stick with something that's uncomfortable, that is challenging, or makes them think in a way they don't want to think. [Our kids] are reaching graduation and don't have any *real* understanding of the world....they only know the parts they know well and they're comfortable with.

In contrast to Linda, who argued that Internet access shaped a global perspective, Lynne saw media transactions as contributing to many young people's narrow-mindedness toward ideas beyond their experience. In her view, they were less well-informed than previous generations with less access to information because contemporary teens could control the flow of that information and filter out what was not of immediate interest.

Numerous teachers also linked sustained use of online technologies to increased impatience in adolescents. This perspective linked the much-vaunted speed of new ICTs (think here about recent television commercials for 3G wireless networks) with older cultural models of adolescents as short-sighted and impetuous (Finders, 1998/1999; Lesko, 2001). Representative of this view are comments from Melissa, who said, "As the technology becomes quicker the kids become quicker and the demand is such that they want it now, now, now, now. They're not willing to wait to explore the technology [so] that they make sure they get the full effect of it." Although Molly appeared to be much tech-savvier than Melissa in her life outside of school, she discussed adolescents in much the same way—including multiple repetitions of a word ("quick" for Molly, "now" for Melissa) to emphasize their need for speed:

> Whether they're supposed to [use cell phones] or not, they're in the same building, and they're on their phones, and there's a constant communication and it's fast communication: "You're upstairs and I'm downstairs. Come meet me by the front doors by the library." And I find in class that's what they want, too; they want it to move fast. And that's tricky, because when they're learning something new you *can't* move too fast, but that attention span is like quick, quick, quick. "Okay, I got it! Let's move on!"

As Molly's comments indicate, teachers' ideas about the general impact of adolescents' online literacies on their thinking and communication were often intertwined with their ideas about the impact of these literacies on English instruction in school. We take up that topic in the next section.

"Our Students Are More Savvy Than We Are on Computers": Cultural Models about Adolescents' Online Literacies and School

For the teachers in this study, considering the integration of online literacies into secondary English pedagogy appeared to bring to light more complexities centered on cultural models of adolescents than if they were making a simple decision of whether or not to infuse technology into instruction. Participants often shared rich and nuanced perspectives on if, why, and how to integrate into school-based instruction the kinds of online literacies their students pursued outside of school. Although there were strong commonalities among participants' perspectives, distinctly divergent viewpoints emerged as well.

Nearly all participants claimed that students found the incorporation of online literacies into English class to be more engaging than print-driven pedagogy. Molly explained that her aim was to "try to incorporate" new technologies and media into her teaching "because if I can heighten their interest the minute they come in through the door, I feel like we're already off to a good start that day." Colin said that instruction linked to students' online literacies "connects the reality for them. Their reality is technology. It's fast paced, it's modern, as opposed to just sitting down and reading a book all the time. Your adding more of that makes it a positive experience." Linda argued that her use of Internet-based images and video clips juxtaposed with canonical texts such as *Beowulf* "can bring those old pieces *alive* to [students]. If we didn't have them, how many of them would we *lose* in the translation of it all? We'd lose *a lot* of them 'cause it's, as they say, 'boring' to them." These examples and others from the study suggest that most teachers saw integrating online literacies into the classroom as a way to create interest and motivation for school literacy tasks, even though they differed in their degree of willingness to pursue that integration in their own classes.

In addition, a number of teachers expressed the idea that incorporating online literacies into their pedagogy showed respect for students and helped to build relationships with them. Despite her hesitance to use technology in her instruction or personal life, Melissa worked to bond with students over their interest in gaming; she explained that her students saw her efforts in this way: "This relates to me—if you know about it, *you* relate to me." Linda argued that using the same technological devices as her students brought their culture into the classroom:

> If I say, "I downloaded this on my iPod," then they like that. If I say, "My daughter text messaged me last night because she's reading *Night*," which is what I'm teaching right now…OK, they like that. They text message *all the time*. If I incorporate a little video

into a PowerPoint, and it's something like an interview with Elie Wiesel or with
Oprah and I'm doing the PowerPoint and I'm teaching a point...they are engaged so
quickly.

The cultural model positioning students as eager to interact with media and
technology appeared to be a catalyst for some participants' pedagogical exper-
imentation. Teachers expressed concern about capturing students' attention,
and many were willing to explore new approaches to do so, even when those
approaches were less familiar—and hence less comfortable—for them.

At the same time, there were differences in participants' perspectives on
how well students' online literacies mapped onto the kinds of literacies current-
ly valued in schools and workplaces. Tom, for example, noted that students were
"kind of learning these things on their own and almost through more of a recre-
ational way." He saw skills learned in such contexts as potentially problemat-
ic in the classroom. "I think that some [students] are very knowledgeable and
very savvy in terms of these areas that we're talking about here. But I think that
others aren't so savvy or aren't so critical and so they have more—instead of
skills—more *habits*, and we have to teach them to undo those habits." He, like
a number of participants, cited Internet searching as a domain where his stu-
dents were less open to learning new approaches and more apt to rely on their
preferred strategies, which he saw as yielding less trustworthy information. For
this reason, he tended not to address their out-of-school literacies in the class-
room. "It would be easier to teach them these things if they had absolutely no
exposure to them," he lamented, "but because they have so much exposure it's
difficult."

Jen had roughly the same amount of teaching experience as Tom (five vs.
seven years), but she was more open to integrating her students' online litera-
cies into her teaching. (At the time of the study, Tom had yet to open his
district-provided laptop, while Jen was trying to coax her principal into permit-
ting students to blog in her journalism class.) But Jen, like Tom, wondered
whether the online literacies students reported were what they needed for
academic success: "They spend all of their time doing things of entertainment
value, but not a lot of time using some software that could really benefit them
in the future. So I think that might be where they're lacking."

Some similar issues were raised by Heath, a five-year veteran of the class-
room who, unlike Jen, claimed to use many of the same ICTs as his students in
his personal life, and unlike Tom, sought to use various ICTs frequently in his
teaching. Barb, the chair, reported that he was the catalyst for department-wide
use of Turnitin.com, a Web-based program that identifies examples of student

plagiarism as well as facilitates online feedback on student writing by teachers and peers. Heath himself described designing a reader-response assignment for his Advanced Placement class that required the creation of MySpace pages for characters from *Pride and Prejudice*. Nonetheless, he questioned whether many students' online literacies "extend past what they need to be a kid....I don't want to say we're naïve about it; we're just a little optimistic that kids use technology any more than to chat online or to do something fun or to create a MySpace account or Facebook." Unlike Tom and Jen, he raised the concern that most young people's online literacies were limited to "something that's already pre-formatted," where "you just have to plug in your stuff." In his view, a task such as designing a webpage from scratch was more challenging, and thus more valuable for learners, than maintaining a Facebook account or composing email, and he did not see many of his students engaging in such tasks.

Heath was the only participant in the study who questioned the widely held cultural model that adults, both parents and teachers, were significantly less adept with technology and media than adolescents. Although he acknowledged that his students lived in what he called a "technology-literate world," he noted wide differences among students in terms of their skill levels, and he acknowledged that he was tech-savvier than some of them. Everyone else in the department appeared to agree with Tom, who argued that "Now our students are more savvy than *we* are on computers," and Gail, who said the following:

> [W]e are in such a unique time in our history. This is the first time that students have had the ability to go out and do just about anything and everything from their desk at home. And the students know more than their parents. The children know more than their parents. Where else in history, *when* else in history, can you think of a parenting skill or a parenting need that the child knew more?

Gail argued that the need for distinctions like these would eventually pass away: "As this generation of teachers leaves, the next generation *is* already technology savvy. This is going to be a moot point. There will be new technologies, but they won't be afraid to learn them."

The cultural model on which both Tom and Gail drew is reminiscent of Prensky's (2001) conception of today's youth as "digital natives" (those who grew up with ICTs) compared with adults as "digital immigrants" (those who learned to use ICTs as adults). This idea was pervasive across participants' talk, although patterns within the department actually challenged it. For instance, Linda, with 29 years of experience, reported using Facebook, text messaging, video conferencing, PowerPoint, and iPods both professionally and

personally (she shared that she used many of these technologies to stay in touch with her very tech-savvy children, young adults who lived far from her). She was more tech-savvy than most of her students and all but perhaps Heath among her colleagues. Conversely, Tom and Melissa, both among the youngest teachers in the department, confessed to using ICTs very sparingly themselves. These "outliers" to the cultural model were rarely discussed by participants, most likely because the cultural model of new-teacher-as-tech-savvy was so dominant. It is also possible, however, that participants did not discuss them out of fear of offending or "outing" another colleague as failing to use technology in the classroom when this had been articulated as a district goal by the central administration.

There was less uniformity across the department in how teachers constructed pedagogical responses to the perceived gap between students' techsavviness and their own. Several framed students' skills as an instructional resource on which to draw in the classroom. Colin reported that students were "always teaching me something new every day. I ask them about shortcuts or how do you do this and they always tell me, which is nice. It makes my life easier." Molly also noted that students could be counted upon to assist her with less familiar tools or applications:

> They're eager to help me if I'm setting up the laptop or trying to get the movie to play, or fast forwarding to a part. If I ever struggle with that, the first thing [I ask] is, "Does somebody want to do this for me?" They are up there like I wish they were for everything else.

Others in the department found students' skill with and commitment to online literacies to be discomforting. Melissa, for instance, said that "students' new literacies are distracting to some extent....I'm a veteran teacher of about eight years, and it is hard for me to tell when a kid is doing something that they shouldn't be." She welcomed the building-level ban on cell phones that administrators were enforcing with new vigor because "That eliminates text messaging, picture taking, and I don't think we need iPods...That's a new literacy, but you don't need it for school." Ginny, who had 22 years of experience, shared that one reason she was considering retirement was that she felt pressure from both students and administrators to integrate ICTs into her teaching. She lacked confidence in her own ability to use the tools ("I don't know if I will be able to get the hang of it....there is just some sort of aversion in my genes or something") and in her ability to manage a technology-rich classroom ("I would like to [use the laptop cart, but] I'm just so afraid they are going to destroy [the computers]").

Barb, a 24-year veteran and the department chair, laughed when we asked her to describe her students' new literacies, saying, "It's very funny [that you ask] because I don't have any of those competencies." She was confident, though, that her students and her teenage children did:

> So, I am often saying to my children, "Can I assign something like this, and can people do it?" So, for instance…my son downloaded video clips onto my [class website] because I didn't know how to do it. And then I went into class…and said, "OK, I need someone who's going to be able to hook up this projector and these speakers to my laptop so that we can watch a video because if not, we're going to listen to Mrs. Giamatti lecture for 15 minutes." And I have one designated student in each one of my classes who hooks up the DVD, hooks up the whatever.

For Barb, the fact that students knew more about technology than she did contributed to a flattening of hierarchy in her classroom, reflecting a move away from a cultural model of teacher as expert and toward one of teacher as learner (Alvermann, Moon & Hagood, 1999). This, in her view, necessitated a rethinking of not just the teacher's role but also of how curriculum and instruction might be reorganized to take advantage of the expertise and habits of mind that tech-savvy students bring to the classroom. As she explained,

> You can't know everything anymore. And you better not try to say that you do. And some of the kids that you have know quite a bit. It's who they are and the way they think and they're not afraid to….So, I think we give much more…open-ended type of, "create something" [assignments] without a lot of criteria. Because then what they bring in is what they know.

As these comments from Melissa, Ginny, and Barb indicate, in our study participants' age and amount of teaching experience did not predictably influence whether they addressed online literacies in their pedagogy and the degree of comfort with which they did so. Seven out of the thirteen English department members had ten or more years of teaching experience; four out of those seven reported making a concerted effort to incorporate online literacies into their planning and instruction with a high level of comfort. Three out of those four teachers were over the age of 45 and did not necessarily fit the cultural model of veteran teachers as resistant to the incorporation of new technologies in instruction. In contrast, four of the six remaining teachers in the department voiced discomfort with or questioned addressing online literacies in their instruction and/or did not consider themselves to be tech-savvy. This group of younger teachers also did not fit the cultural model predicting greater adeptness and comfort with online literacies for them than their older peers. Tom, one of the younger teachers who did not fit this cultural model, explained:

I'm still a new teacher, I think, after only 7 years, and...I *already* feel kind of set in my ways... and part of that is because the *way* I teach came from the way I *learned*....I kind of base my English classroom on what *my* English classroom was like when *I* was in high school.

Tom's comments remind us of the significant influence on teachers' thinking and planning of longstanding cultural models related to the discipline of English and to secondary schooling in general. In this case, Tom's age and experience levels appear to be trumped by cultural models about secondary English that privilege print-based, schooled literacies, not online literacies. The example provides further evidence for a finding by Lewis and Finders (2002) that newer teachers sometimes struggle to integrate digital literacies into their pedagogy because that integration challenges their conception of what it means to be a "real" teacher—a conception deeply rooted in traditional cultural models. In addition to needing to develop a sense of authority in the classroom in ways that veteran teachers such as Linda and Barb did not, Tom did not have young-adult children in his family like they did, thus cutting him off from another source of information, providing new perspectives on adolescents and their online literacies beyond those traditional cultural models.

Developing Primary Theories about Adolescents' Online Literacies

Most of the participants in our study would not, in Gail's words, claim to be "gathering data" about adolescents' online literacies, at least not formally. Although some had participated in technology-focused professional development sponsored by the district, they reported that it tended to be focused more on how to use a device or piece of software, not on broader questions such as the changing nature of literacy or the impact of adolescents' out-of-school practices on pedagogy. But it would be a short step for these teachers and media specialists, many of whom had clearly done important thinking on their own about such issues, to develop the cultural models they held about adolescents, their online literacies, and English/literacy instruction in school into what Gee (2008) would call primary theories. That process would likely assist educators in moving beyond constructions of adolescents and their online literacies that were often quite essentialist—for instance, assuming universal tech-savviness or uniform interest in online literacies being integrated into the English classroom or the school library. In turn, researchers and theorists in the field of literacy education stand to learn much from their work with practitioners who have developed primary theories centered on these issues.

We think that the following four sources of information would be helpful

in such work, whether it was done individually (through self-directed inquiry) or collaboratively (through department-wide inquiry).

Reports from the Pew Internet & American Life Project

Some of the richest information about adolescents' online literacies is provided by the Pew Internet & American Life Project (http://www.pewinternet.org). Since 1999, Pew staffers have conducted a wide range of scientific research on the social impact of the Internet, using national telephone surveys and issuing numerous reports of interest to educators. For instance, a report called *Writing, Technology, and Teens* (Lenhart, Arafeh, Smith, & Macgill, 2008) offered findings like these:

- 85% of teens aged 12 to 17 engage at least occasionally in some form of electronic communication.
- 60% of teens do not see these communications as "writing."
- 78% of teens believe that their writing skills would be improved if their teachers used more computer-based approaches to teaching writing.

Because these reports draw on data from large, diverse populations purposefully sampled, we see their findings as more trustworthy and nuanced than the conclusions drawn by many of the journalists and columnists we discussed at the beginning of this chapter.

Student Surveys

National samples have limitations, however. They tend not to help teachers and librarians figure out what kinds of online literacies are pursued by students in a particular community. For this localized information, educators need to collect data themselves. In our study, Colin reported learning about his students' online literacies when he asked seniors to write about their typical day:

> I have them list what they do from the morning when they wake up to the moment they go to bed to see how they can organize information. That's part of my course. The majority is they get up and do their normal getting ready to come to school and always at the end it's—TV sometimes, but—the majority now is the computer. They always go home and they're chatting [and surfing] online.

Educators might also choose to survey students more formally with an existing instrument—we like several developed by the New Literacies Research Team at the University of Connecticut (http://www.newliteracies.uconn.edu /index.html)—or perhaps with a tool that students themselves help to create.

Classroom Observations

Another way for educators to enrich their cultural models about adolescents' online literacies is to observe them in the classroom. In a book about teaching secondary English, Sara Kajder (2003) described her approach to assessing students' current skill levels and experience with various technologies rather than relying on self-reports or broad assumptions about contemporary teens. Kajder asked her students to rate themselves on a 1–5 scale in areas such as communication tools and Web design. After using their self-assessments to assign students to one of three technology-mediated tasks of varying complexity, she observed them as they completed those tasks. We like this approach because it combines self-assessment with performance-based data. We also think that teachers and media specialists may learn new strategies themselves (strategies they can then pass along to other students) from observing what especially tech-savvy youth do to complete a task.

Online Investigations

In our own work, we find it valuable to conduct online investigations of the literacies in which adolescents report engaging. For example, Kelly learned from face-to-face discussion with Eileen, a seventh-grade anime fan, that she belonged to an anime art-focused electronic mailing list (Chandler-Olcott & Mahar, 2003). With Eileen's permission, Kelly joined the list, allowing her to follow the group's conversations (including but not limited to Eileen's contributions) as their messages popped into her email box. She could also search the group's archives to get a sense of its history. These messages helped Kelly to develop more of an insider's view on fan art and fanfiction, online domains that were previously unfamiliar to her.

Similarly, when the two of us wrote a chapter on how sociocultural theories can be applied to new literacies (Chandler-Olcott & Lewis, in press), we used scrapbooking as a case, although neither of us scrapbooks. In addition to interviewing family members who do scrapbook avidly, we searched the Internet for online instructional resources, share sites, and blogs. In the process, we learned a great deal about scrapbooking, including how digital tools have influenced typical practices, that our relatives might not have known themselves.

In addition to pursuing online inquiries focused on specific topics, teachers and media specialists can benefit from regularly browsing a website such as YPulse (http://www.ypulse.com), which specializes in tracking trends in youth

culture and includes contributions from members of a youth advisory board. Such sites can be helpful to secondary educators who want to open a window into their students' worlds without having to be intrusive about their requests for information.

Concluding Thoughts

We believe that gathering data about adolescents and their online literacies via the means we have suggested will support secondary educators in designing and delivering responsive literacy instruction for all learners. Teachers and librarians who seek such data will likely complicate their cultural models, troubling essentialist and even stereotypical notions such as "All adolescents are tech savvy" or "Online reading makes students less likely to engage in sustained reading of print texts" that are often reinforced by media coverage of adolescents. Those who use these data to guide their pedagogy will be less likely to reteach (often in a less engaging way!) what students already know how to do from their personal practices, and they will be more likely, given the gaps in students' skill sets that will almost certainly be revealed, to offer instruction that will help individuals refine, extend, and reflect upon their existing competencies.

Improved practice in a discrete number of classrooms or libraries is not the only benefit that can accrue from educators' development of nuanced primary theories about youth's online literacies, however. Everyone with an interest in adolescent literacy reform stands to gain from such inquiries if teachers and media specialists are able to share them widely. K-12 practitioners have a vantage point on youth and their development that university-based researchers, even those who spend considerable amounts of time in the field, can rarely match (Fecho & Allen, 2003; Hubbard & Power, 1999). Experienced professionals like Barb or Lynne or Gail who work with students year after year in the same community can often detect changes over time in youth's language, attitudes, and knowledge that others do not apprehend. How teachers and librarians see and articulate those changes is clearly tied to the cultural models on which they draw; when those cultural models are unexamined, educators' conclusions about, say, decreases in the "caliber" of students are suspect, and they should be. At the same time, the near-unanimous belief among our participants that students' online literacies affect how they think and communicate—and not always for the better where academic achievement is concerned—begs closer scrutiny. Scholars cannot argue that ICTs have the power to transform literacy practices (Coiro, Knobel, Lankshear, & Leu, 2008) without also

considering the notion that some of those transformations may have unintended and even negative consequences. When these perspectives have been raised in professional conversations by teachers and librarians we know, they have too often been dismissed as defensiveness by technophobic Luddites. We don't think this is a fair characterization of the perspectives raised by even the most cautious of our participants where online literacies in school are concerned. The diversity of perspectives on adolescents and their online literacies shared by members of the single English department we studied suggests that literacy researchers need to move beyond essentialist thinking about teachers, just as we do about adolescents.

School-based practitioners who transform their cultural models into primary theories by collaborating with each other and with university-based researchers can help us understand and learn from different perspectives on adolescents and their online literacies. Such conversations can help all of us to avoid romanticizing, on the one hand, or dismissing as irrelevant, on the other, the skills and habits of mind that youth develop while pursuing online literacies in out-of-school contexts. Only then can we leverage these skills and habits of mind to design more sensitive and powerful instruction in our classrooms.

References

AAUW Educational Foundation. (2000). *Tech savvy: Educating girls in the new computer age.* Washington, DC: American Association of University Women.

Bailey, N. M. (2009). "It makes it more real": Teaching new literacies in a secondary English classroom. *English Education, 41*, 207–234.

Albers, P., & Harste, J. (2007). The arts, new literacies, and multimodality. *English Education, 40* (1), 6–20.

Alvermann, D., Moon, J., & Hagood, M. (1999). *Popular culture in the classroom: Teaching and researching critical media literacy.* Newark, DE: International Reading Association.

Barker, O. (2006, May 29). Technology leaves teens speechless. *USA Today.* Retrieved April 19, 2009, from http://www.usatoday.com/tech/news/techinnovations/2006–05–29-teen-texting_x.htm

Birkerts, S. (2006). *The Gutenberg elegies: The fate of reading in an electronic age.* New York: Faber and Faber.

Black, R. (2008). *Adolescents and online fanfiction.* New York: Peter Lang.

Chandler-Olcott, K., & Lewis, E. (in press). Screen and scrapbook: Sociocultural perspectives on new literacies. In B. A. Baker (Ed.), *New literacies from multiple perspectives: Exploring opportunities for research and pedagogy* (pp. 194–216). New York: Guilford.

Chandler-Olcott, K., & Mahar, D. (2003). Tech-savviness meets multiliteracies: An exploration of adolescent girls' technology-mediated literacy practices. *Reading Research Quarterly,*

38(1), 356–385.

Coiro, J., Knobel, M., Lankshear, C., & Leu, D. (2008). *Handbook of research on new literacies*. Mahwah, NJ: Lawrence Erlbaum.

Fecho, R., & Allen, J. (2003). Teacher inquiry into literacy, social justice, and power. In J. Flood, D. Lapp, J. Squire, & J. Jensen (Eds.), *Handbook of research on teaching the English language arts* (pp. 232–246). Mahwah, NJ: Lawrence Erlbaum.

Finders, M. (1997). *Just girls: Hidden literacies and life in junior high*. New York: Teachers College Press.

Finders, M. (1998/1999). Raging hormones: Stories of adolescence and implications for teacher preparation. *Journal of Adolescent & Adult Literacy, 42*, 205–223.

Gee, J. P. (2001). Reading as situated language: A sociocognitive perspective. *Journal of Adolescent & Adult Literacy, 44*(8), 714–725.

Gee, J. P. (2008). *Social linguistics and literacies: Ideology in discourses* (3rd ed.). New York: Routledge.

Guzzetti, B., & Gamboa, M. (2005). Online journaling: The informal writings of two adolescents. *Research in the Teaching of English, 40*(2), 168–206.

Heath, S. B. (1983). *Ways with words: Language, life and work in communities and classrooms*. Cambridge: Cambridge University Press.

Hubbard, R., & Power, B. (1999). *Living the questions: A guide for teacher researchers*. Portland, ME: Stenhouse.

Jewitt, C. & Kress, G. (2003). *Multimodal literacy*. New York: Peter Lang.

Kajder, S. (2003). *The tech-savvy English classroom*. Portland, ME: Stenhouse.

Lenhart, A., Arafeh, S., Smith, A., & Macgill, A. R. (2008). *Writing, technology, and teens*. Washington, DC: Pew Internet and American Life Project. Retrieved June 9, 2008, from http://www.pewinternet.org/pdfs/PIP_Writing_Report_FINAL3.pdf

Lesko, N. (2001). *Act your age! A cultural construction of adolescence*. New York: Routledge.

Leu, D. J., Jr., Kinzer, C. K., Coiro, J., & Cammack, D. W. (2004). Toward a theory of new literacies emerging from the Internet and other information and communication technologies. In R. B. Ruddell, & N. Unrau (Eds.), *Theoretical models and processes of reading* (5th ed.) (pp. 1570–1613). Newark, DE: International Reading Association.

Lewis, C., & Fabos, B. (2005). Instant messaging, literacies, and social identities. *Reading Research Quarterly, 40*(4), 470–501.

Lewis, C., & Finders, M. (2002). Implied adolescents and implied teachers: A generation gap for New Times. In D. Alvermann (Ed.), *Adolescents and literacies in a digital world* (pp. 101–113). New York: Peter Lang.

Prensky, M. (2001). Digital natives, digital immigrants. *On the Horizon, 9*(5). Retrieved January 12, 2010, from *http://www.marcprensky.com/writing/Prensky%20-%20Digital%20Natives, %20Digital%20Immigrants%20-%20Part1 .pdf*

Richmond, R. (2009, March 29). Sexting may place teens at legal risk. *New York Times*. Retrieved April 29, 2009, from http://gadgetwise.blogs.nytimes.com/tag/sexting/

Stake, R. (1995). *The art of case study research*. Thousand Oaks, CA: Sage.

Stolle, E. (2008). Teachers, literacy, and technology: Tensions, complexities, conceptualizations, and practices. In Y. Kim, V. Risko, D. L. Compton, et al. (Eds.), *Yearbook of the National Reading Conference* (pp. 56–69). Oak Creek, WI: National Reading Conference.

Thomas, A. (2007). *Youth online: Identity and literacy in the digital age*. New York: Peter Lang.

Zimmerman, J. (2009, March 19). Teens overdose on Facebook "drug." *Atlanta Journal-Constitution*. Retrieved January 12, 2010, from *http://ac360.blogs.cnn.com/2009/03/19/teens-overdose-on-facebook-%E2%80%98drug%E2%80%99/*

· 1 0 ·

Minding the Gaps

Teachers' Cultures, Students' Cultures

Andrew Burn, David Buckingham, Becky Parry, and Mandy Powell

The story of the digital generation gap is a familiar trope in debates about young people and new media. Its rhetoric of cyberkids, digital natives and immigrants, and the Net generation, is already beginning to sound tired; and the excessive optimism about the redemptive power of computer technologies on which it depends has been comprehensively critiqued (Buckingham, 2007; Livingstone, 2009). It may now be time to ask some more specific questions, not least in relation to education. How distinct and different are these generations? How do they (or don't they) map on to the teacher-student relationship? How aware are teachers of students' media cultures? Are these cultures, in any case, as unremittingly rooted in 'new media' as is often claimed? What part do the 'old media' of print, television, film and radio play? Are new media really enabling young people to become producers of media, rather than 'mere consumers'? And how does any of this make its way into the school curriculum and, specifically, the media education curriculum?

Popular advocates of the use of ICT in education frequently argue that there is a significant gap between children's out-of-school experiences and the forms of learning that are currently available in schools (e.g., Heppell, 2000). While children's everyday lives are suffused with electronic and digital media, they suggest, the school has remained dominated by the medium of print.

While some versions of this argument focus at a structural level on the school as an institution, others suggest that it is teachers who are out of touch and largely ignorant or incompetent when it comes to dealing with new media.

To some extent, this can be seen as a variant of a much older argument, which tended to focus primarily on *culture* and *social class*. Historically, sociologists of education have repeatedly argued that schools are bastions of middle-class culture, and are largely indifferent—if not actively hostile—towards the cultures of working-class children (Jones, 2003). The need to recognise and engage with the everyday experiences of working-class students has been a major theme in the history of media education (Buckingham, 2003), although it is also a strong emphasis within progressive English teaching, out of which media education in the UK has largely grown (e.g., Goodson & Medway, 1989). More recently, work in the field of New Literacy Studies has also argued for the need to engage with popular media culture as a means of developing children's literacy practices more broadly (e.g., Marsh & Millard, 2000). Such work increasingly looks to the potential of popular media as a means of reconstructing 'subject English' as it is traditionally defined (Ellis, Fox, & Street, 2007.

In the past decade or so, however, this argument has to some extent been recast as an argument about *technology*—in which young people are represented as a 'digital generation' or as 'digital natives,' while teachers ('digital immigrants') are seen as largely ignorant of, or resistant towards, new media technologies (e.g., Oblinger & Oblinger, 2005; Prensky, 2001). This argument displays a strong 'generational rhetoric' (Buckingham, 1998), rather than placing an emphasis on social class; although it is worth recalling that earlier advocates of media education also looked to generational change as likely to promote the development of the field (e.g., Murdock & Phelps, 1973).

The use of media in education—both education *through* media and education *about* media—has frequently been presented as a way of bridging this gap. Popular advocates of ICT in education tend to suggest that using computers will in itself automatically motivate recalcitrant students, making 'difficult' areas of study accessible and relevant to them. Historically, of course, such arguments have also been made about older media such as television and film (Cuban, 1986). Education *about* media (media education) has generally adopted a more critical and less instrumental approach; but here too, there has been a recurring argument about *relevance* and the need to validate students' cultural experiences. In both cases, teachers are urged to engage with the forms of media and popular culture central to students' out-of-school experience, thereby recon-

necting them with the culture of the school.

This chapter seeks to explore some of these arguments further in a context of significant cultural change. We want to argue that the gap between teachers' and students' cultures may not be quite as large, or as simple and straightforward, as some of the arguments referred to above tend to imply. We will also suggest that the task for media educators in bridging that gap might be more complex and more difficult than is sometimes assumed. The assumption that we might construct a 'common culture' that is shared between teachers and students seems to hark back to an earlier era of national 'mass' media; and in a period of cultural fragmentation and individualisation, such an aim might be seen as increasingly problematic.

To conceptualise the various 'gaps' between teachers' and students' media cultures, we will draw firstly on Bourdieu's notions of habitus and cultural capital to consider how the cultural preferences of both groups represent particular dispositions, tastes and values related to their social roles (Bourdieu, 1984). Secondly, we will employ the idea of the 'third space' of culture (Bhabha, 1994; Gutierrez, 2005) to consider what happens when these two different (but overlapping) cultural spheres come together in the media classroom.

Three-Year Research Project on Media Literacy

We draw on research from a three-year project on media literacy, funded by the UK Economic and Social Research Council. The project will research and develop a model of learning progression in media literacy, from 5 to 16 years of age, the period of compulsory education in the UK. This chapter uses data from the first stage of our project, conducted between January and July 2009. It consists of an online survey of all students and staff involved in the project; and semi-structured interviews with a sample of 25 teachers associated either with the teaching of media literacy or with its curriculum management at both middle and senior management levels. At the time of writing, this phase of the project is not yet complete; the arguments presented here remain very much work in progress.

The project is based in two contrasting locations. The first is a relatively affluent small city, with expanding high-tech industries and two universities. Our research here is based in two 11–16 comprehensive secondary schools (schools A and B, which form part of a federation) and two of their partner primary schools. At A, the majority of students come from middle-class homes; while at B, there are greater numbers from working-class homes. The other loca-

tion is a working-class council (public housing) estate in a much more economically disadvantaged area of a suburban town. Our research here is based in a secondary comprehensive 11–16 school (C) and two of its partner primary schools. Almost all the students in this school come from working-class homes.

The first stage of the project identifies some 'baselines' in respect of media literacy in these two locations. Our questionnaire and interview data focus on how the students in the two sites engage with media; how their teachers engage with media in their own lives; how the teachers perceive the media cultures of their students; and how media are incorporated into lessons, both in the curriculum generally and in media education classes specifically.

Teachers' and Students' Use of Media

To what extent is there in fact a significant gap between teachers' and students' media cultures? One recent study found that the commercial nature of popular media raised considerable concerns for teachers, and that school was not seen as the place to spend time on media texts which occupy enough of children's home lives (Lambirth, 2003, p. 11).

In our initial fieldwork, by contrast, the small number of teachers who express similar anxieties are significantly outnumbered by those who value popular media in their own lives and are keen to engage with them in the classroom. While some are less enthusiastic about students' media preferences, many teachers also appear keen to enable them to use new technologies.

Nevertheless, as Lambirth (2003) points out, the inclusion of popular media places teachers in an 'ideologically tense position': it raises difficult issues about cultural value, about what is appropriate to address in school, and what will increase opportunities for children to learn. While this is partly a structural question about the nature of schools as institutions, teachers' responses to these questions are also greatly influenced by their own personal experiences of media and, more broadly, by their 'habitus' or cultural orientations and values (Marsh, 2006). Most of the media teachers in our sample also teach English, and have English degrees; and so these broader cultural dispositions often include a tension between the popular cultural affiliations typical of media teachers and the inclination towards heritage literature typical of English teachers (cf. Buckingham & Sefton-Green, 1994; Marshall, 2000).

We explored students' and teachers' experiences of media at home by means of two detailed online questionnaires. The student questionnaire was completed in school by 1,745 students (600 primary and 1,145 secondary). Our

analysis of this data is still ongoing, and here we present only some findings from the secondary questionnaire (for students aged between 11 and 16). We compare these findings with a survey of 259 school staff, including both support and teaching staff in the three secondary and two of the primary schools. Twenty-one of these reported having curriculum responsibility for media.

The overall picture that emerges from the student questionnaires largely confirms that of earlier UK surveys (e.g., Livingstone & Bober, 2005; Marsh et al., 2005; Ofcom, 2008). Broadly speaking, these young people enjoy high levels of access to a wide range of media and new technologies in their homes. In recognition of the way the school day shapes their access to media, we asked them to report on what they engaged with before and after school. Most noticeable is the amount of different media activity students report in any one evening. Secondary students report: listening to music (85%), watching television (84%), visiting websites (84%), playing computer, online or console games (79%), watching films (60%) and looking at photos (59%) in a single after-school period.

However, these students' lives are by no means wholly dominated by media. Only 47% of students agreed with the statement that 'the media I like tell people a lot about me'; and many were keen to represent themselves as having other interests, including sport, playing music, doing homework, socialising and being involved in family life. Twelve percent of the respondents agreed that 'media are not that important to me—I have other interests.' The use of media was not seen to preclude involvement in other interests, as this Year 7 student's comment demonstrates:

> I only have 1 hour on the computer or 1 hour on my ipod's (ipod touch) internet and sometimes I watch TV but only like 30 mins a day;then I do stuff outside of my home, playing in the park or playing with my lego and stuff like that. And sometimes I don't even watch TV or play any types of media games at my home.

Print media were less popular than moving image media, with fewer secondary students saying they read books (50%), magazines (44%), newspapers (30%) and comics (23%). Even so, they were far from insignificant; and students at the more working-class School C reported a higher level of engagement with magazines and newspapers (51% and 48%, respectively), naming among their preferred reading popular titles such as the *Sun* newspaper and *OK, Bliss, Closer* and *Heat* magazines. The findings from the staff questionnaire suggest that teachers are also intensive users of a full range of media in their personal lives. Almost 70% of staff reported frequent (almost continuous or daily) use of television, music and radio, whilst 65% reported frequent use of film and newspa-

pers. 68% of all staff (and 86% of media teachers) reported high frequency of use of music: none reported that they never listened to music.

Both teachers and students, then, are accessing and engaging extensively with a range of media in their home lives. The 'digital divide' between teachers and students is not particularly apparent here. Furthermore, generational differences did not seem to feature *within* our teacher sample: older staff were no less likely than younger staff to engage with newly emerging media forms such as social networking.

Even so, there were some differences, both between staff and students and between the two locations. Perhaps the clearest difference emerged in relation to games. Few staff reported playing computer games (on- or offline), and for those who did (9% and 15%, respectively) there were no significant differences in terms of gender, age, sector (primary or secondary) or the subject they taught. No staff named games in response to an invitation to list favourite media texts. Nevertheless, in a specific question on games, 63 respondents gave examples of recent games played, naming a wide variety, from the MMORPG *Everquest* to the World War 2-themed adventure games *Call of Duty* and *Medal of Honour*. Particularly popular were the Wii physical games, mentioned by 19. Around a quarter of our sample of staff, then, has some kind of engagement in gaming culture. Yet by contrast, 79% of students reported playing games, the fourth most popular option for media use after school. Game playing was more popular at the more working-class schools C (88%) and B (85%) than at School A (68%)—although the latter figure is still high.

In the case of television, there was a much greater overlap between teachers and students. Teachers reported watching a wide range of lifestyle, light entertainment, comedy, variety, drama and factual programming. Australian and British soaps, American serials and animation were all popular across the sample (though some preferred 'classic' TV drama). Many of the most popular programmes among teachers were also high on the list of the students' preferences: *The Simpsons*, the UK soap opera *EastEnders* and *The Apprentice*, the school-based drama *Waterloo Road* and the hospital series *Holby City*. There was also evidence of students and teachers watching a range of 'family' programmes such as *Britain's Got Talent* and the sci-fi drama *Doctor Who*. Although there were some distinct youth preferences here—for example, the teen soap *Hollyoaks*—much of the students' viewing seemed to consist of the same mainstream family programmes also preferred by most of the teachers.

In the case of online media, the differences were more to do with *purposes* of use, rather than *extent* of use. Almost 90% of all staff reported a high fre-

quency of internet use at home. Whilst the greater proportion of personal use could be described as 'functional,' such as shopping or banking, or work-related, a significant percentage (44%) reported using the internet for social networking. By contrast, students reported greater social, rather than functional, uses of online media. Eighty-six percent said they used Facebook, with 62% also claiming to use Bebo and 19% MySpace, while instant messaging (such as MSN) was widely used. However, no fewer than 47 other social networking sites were named, including Habbo, Piczo and Tagged. The internet appears to offer a distinct social space for communication and play, as one Year 7 student commented:

> I like to use it to keep in touch with old friends from my primary school that don't come here no more. And to go on games. When I'm bored I use YouTube to listen to music and me and my brother have fun playing online games together.

Further differences emerged in relation to media-*making* activities. Recent research has been inclined to celebrate the role of new technologies in giving young people access to new opportunities for media production (e.g., Jenkins, 2006). Such opportunities are certainly becoming more widely available, although our research here suggests that these activities may be rather more mundane than is sometimes suggested. In piloting our questionnaire, we found no students claiming to 'make films' at home; although when we revised this question for the full survey, no fewer than 77% reported using phones or cameras to 'film friends and family.' We found little evidence that these home movies were edited, even if they were more widely distributed.

A range of other media-making activities was reported, including creating images (70%), writing stories (62%), creating music mixes (47%), designing websites (46%), making comics (29%) and creating games (26%). By contrast, very few teachers reported making anything other than music (20%): 12% reported making books, 10% websites and 8% films. (It seems likely that the teachers who report 'making films' are referring to more advanced forms of production: had we asked the teachers the same question as the students, it may well be that many more would report casual use of camcorders in the domestic context.) Notably, media teachers appeared to be no more disposed than other teachers to engage in media-making outside school.

Very few teachers (3%) reported sharing their work online, by comparison with 27% of students. However, both students and staff who did create media in their own time reported sharing these with family and friends. Indeed, all media-related activity was reported as being highly sociable: for example, 90%

of respondents said that they talked about media with their friends. Nevertheless, only 3% of students reported sharing what they made with their teachers, which contrasts starkly with the figures for sharing with friends (85%) and family (53%).

This latter point would certainly confirm our broader finding that there is very little interaction of this kind in school. Indeed, it is hard under current circumstances to imagine where such interaction might occur. Overall, the students reported that they were not able to use the media they like in school or in lesson time—although School C permits more freedom for personal uses of media such as mobile phones and music players (over 75% say they are allowed them in school, if not in lessons, by contrast with 45% at School B and 27% at School A). More School C students also reported use of their preferred media in lessons, although the majority still reported not being able to do so. Books, newspapers and magazines were reported as the most tolerated media in schools; although even here, texts that students prefer rarely coincide with those they are reading in lessons. However, students do use school as a social space in which to share experiences of media: 71% of the whole sample said they talked about media they like in class, although we are unable to say at this stage whether this was related to the actual content of lessons.

To sum up at this point, our questionnaire data point to some significant differences between teachers and students in terms of their out-of-school uses of media. However, these are by no means as absolute as is often suggested. Unsurprisingly, teachers make more use of offline media than online (although students do the same); they have some different preferences in TV and film viewing; they read more (and they read different things); they use the internet more for professional and functional purposes; and they play games less than students do. However, TV, film and music are shared dominant interests in both groups, and many teachers use some of the media that are often seen as the exclusive terrain of the young (with Facebook being the most obvious common ground). More striking than the differences are the very significant overlaps and similarities between teachers' and students' uses of media. Although we are still in the process of gathering and analysing our data, our research thus far gives us good reason to question claims about the notion of a media 'generation gap' (cf. Murdock & Phelps, 1973).

This might suggest that there should be less of a gap than is sometimes supposed when teachers and students come into contact in the classroom. However, our survey also presents a map of widely varied choices across a wide range of different media. There is no homogeneous bloc or clear hierarchy of

taste evident in either group—although we have some indications of taste being stratified by social class, particularly in relation to games, books and newspapers. Both students' and teachers' cultural tastes are diverse, and this diversity extends into other spheres of social activity than the media.

Teachers' Perceptions of Students' Media Cultures

Further questions arise here about the nature—and perhaps the necessity or inevitability—of any gap between 'in school' and 'out of school' identities, for both teachers and students. There may be good reasons why both groups might not wish to bring aspects of their identity into school or have them reflected and scrutinised in the context of the classroom. Media educators have often expressed a certain unease about being seen to 'colonise' students' out-of-school media experiences, but teachers too might well wish to preserve a clear distinction between their 'personal' and 'professional' identities. The origins of such a desire need further exploration, although it might well take a particular form when it comes to the teaching of English and Media. Our own experience in teacher education suggests that the forms of cultural distinction both implicit and explicit in the training of English teachers, and in the formal curricula they are required to teach, might well encourage teachers to leave their own popular media cultures at the threshold of the school. Here, perhaps, we might be able to identify a rather different 'ideological tension'—between the pleasures, knowledges, and cultural dispositions of their personal uses of media and those of their professional lives.

Our survey data provide some fairly paradoxical evidence in this respect about how teachers perceive students' media cultures, and they raise further questions about the role of media education in bridging any apparent gap between them. In the case of the media teachers, there was considerable variation here. Some claimed to know their students' media cultures well; others were much less sure, with some even suggesting in interview that they felt quite remote from students' media cultures. The survey also showed that media teachers who claimed a good knowledge of students' media practices were more likely also to disagree strongly with the statement that children were 'more sophisticated than I am' in their understanding of media, though some took a different view. Opinion was similarly divided on whether children and young people understood the influence the media had on them: nine agreed, seven disagreed and two expressed no opinion.

While ideal images of media teachers portray them as popular culture enthusiasts closely in touch with their students' media cultures and committed to incorporating them into the classroom, the picture we have so far appears to be more mixed. Some teachers consider they know their students' media experiences well, others do not; some subscribe to the popular notion of the media savvy child, while others oppose it; some believe young people understand how the media influence them, others do not.

The notion of a gap between the teachers' and the students' media cultures appears in various forms in our interviews with media teachers. It is defined, firstly, as a matter of different experiences. At one extreme, there are media teachers who are quite clear that the students inhabit a different media culture from their own. This teacher, for example, makes a general—and generational—distinction between himself and the students:

> I found [teaching a course on computer games] quite challenging because it's something I don't do in my spare time....I mean one of the issues is that I'm drawing upon examples of my experience from the past as a young person of their age. That's a problem in some ways because I'm not engaging with their experiences.

This statement reflects a wider awareness on the part of the media teachers in our sample that their curriculum should pay close attention to students' media cultures: their schemes of classroom work typically begin with an exploration of the students' experiences of the media form, text or phenomenon in question. Teachers also attempt to enable students to study their own specific choices of text as part of a wider scheme of work on a given topic.

At the other extreme, another teacher lays claim to the cultural territory she sees her students as occupying, although this cultural proximity is marked as an object of surprise to the students:

> They went 'oh my god, the teacher's got Facebook!' It was like, grownups know about our media! They seem to have this idea that things like Bebo—Lily Allen was on Facebook—it just happens, yeah. But [I say] of course that's manipulated—[and they say] 'No!' So there's almost this naivety that their culture's *theirs*.

This teacher claims not just a familiarity with media that the students perceive to be their own but also a greater degree of knowledge and expertise, particularly about their commercial aspects—directly countering romantic notions of young people as spontaneously knowledgeable 'cyberkids.' However, the account given here also suggests an instability in the conjunction of teacher's and students' media cultures. On the one hand, this reflects a general uncer-

tainty about how to approach the more 'participatory' aspects of the internet. On the other hand, it may indicate the genuine difficulty of somehow effecting a synthesis of the students' and teachers' cultural worlds, as we will discuss below in relation to the idea of the 'third space.'

In other cases, specific distinctions are made between different kinds of media. One teacher ruefully observes a distance between his own media experience and interests, and those of the students, yet simultaneously recognised (as did several others) that the curriculum should not be dictated by his own interests:

> I'm not kind of Gadget-Man, I don't tend to have a lot of things, I don't tend to use a lot of things that perhaps young people are, so I feel a little bit out of touch in that respect....And I think it's important to look at those things, I don't think it's a case of plumping for traditional things just simply because of my deficiencies, I think it would be good to use those technologies.

The gap is defined here in terms of proficiency with technology, rather than of cultural tastes. This teacher also made an argument for the continued study of what he called 'more conventional forms of media,' on the grounds that it was important for students to know 'where things have come from.' Yet when it came to choosing his own preferred media for teaching, he opted for computer games, music and film and said he preferred to avoid newspapers ('I find it just a very dry topic')—suggesting that in spite of the distance he perceived between himself and the students, his own interests were remarkably similar to the patterns that emerged from the student survey.

These interviews generally confirm that even for specialist media teachers there is a gap here that can prove difficult to bridge. However, they also suggest that this gap is by no means as dramatic as is sometimes claimed. While some teachers perceive the students' media cultures as remote from their own, this is not the case for others; and the perceived differences are not always borne out by the data. Some teachers' media uses are closer to those of the students than they think, while some teachers' constructions of students as enthusiastic users of Web 2.0 are clearly inaccurate (two referred to the students' habitual use of Twitter, for example, which our survey showed was used by only 3% of students). Nevertheless, irrespective of their views of this gap, the media teachers generally believed that the students' media cultures *should* be reflected in the media classroom. Yet to what extent did they feel they were managing to achieve this in practice?

Media Education: Bridging the Gap?

The interview data so far suggest that media teachers perceive several significant gaps between the students' media experiences and the work they are able to do in the media classroom. Some of these are considered to be more or less necessary or inevitable, while some are clearly perceived as a result of the imposition of particular curricular or assessment structures. These gaps take several different forms.

Firstly, several teachers commented on a gap between the media *texts* that were popular with students and those that were actually explored in the media classroom. This was partly a matter of teachers' efforts to select texts that are accessible and familiar to the majority of students: mainstream forms such as comics or television drama. Rather differently, such apparently 'safe' choices could backfire when prescribed by public examination bodies, in ways that effectively constrain the choices available for individual schools. Thus, one teacher at the more working-class School C complained that the examination board's chosen genre for the year was situation comedy, a genre that he felt was much more appropriate for middle-class students. While the need to find a 'common culture' is understandable, it can marginalise more individual or specialised media enthusiasms. As contemporary media cultures continue to proliferate and students' media uses and tastes diversify, attempting to define and secure this shared 'common culture' becomes increasingly problematic.

This attempt, best represented perhaps in one school's programme of study based on two British weekly TV hospital dramas, can be seen in terms of Bourdieu's notion of cultural capital. This choice of material recuperates the vestiges of shared television culture, opting for a cultural resource likely to be familiar to both staff and students. At the same time, it legitimises this popular cultural knowledge as cultural capital recognised by the mechanisms of education, both local and national, through a series of transformations involving the application of abstract concepts and the use of practical production activities.

A very different version of this 'textual' gap was a distinction between popular media on the one hand and film (or moving image media) on the other— especially if, as has been the case in some recent work in the field, the latter is closely tied to 'art film,' or to literature. As one teacher put it:

> There's a danger that you kind of equate in their heads that media equals moving image or film…And if you keep just canonizing stuff…you're kind of preserving in aspic something that was twenty years old. In the case of film it's a hundred and odd year old media

form, isn't it? So to say 'oh we'll accept that now,' it very much is the English litera-
ture model of...'well it's been around for long enough now, we'll have that.' And it's
not really, it doesn't really engage with those other bits of media which are very new
and innovative and postmodern elements of media, and how students interact with
media texts.

At first sight, it seems that the issue here is the danger of abandoning the search
for a common culture evident in the hospital drama programme and adopting
instead exactly the kind of cultural distinction Bourdieu (1984) condemns so
vehemently in his critique of Kantian aesthetics. Yet for other teachers, it was
important that media education should not simply follow the latest (even the
most 'postmodern') aspects of their students' media experiences. As our survey
has shown, 'old' media such as film and television, and even print media,
remain a significant aspect of most children's cultural experience. Furthermore,
some teachers argued that it was part of their role to enable students to expe-
rience 'media that they would not otherwise have come across.' One teacher,
for example, spoke about the benefits of using Hitchcock's *Psycho* in a course
on horror and the French art film *La Haine*. For this teacher, it was precisely
the students' *lack* of 'pre-existing knowledge' that made it possible for them to
engage with the texts in a more active way. The question begged here, then,
is how to move beyond the binary structure of Bourdieu's model towards a more
pluralistic view of the media cultures students and teachers might explore, with-
out simply privileging elite cultural forms over popular ones (or indeed vice
versa).

A second gap was noted between the students' everyday media experiences
and the *critical skills* expected of media literacy. Different teachers prioritised dif-
ferent aspects of this critical approach. For some, it was very much a matter of
challenging students' assumptions about studying popular culture, arguing for
the need to 'identify how those industries work, how they operate, how they
play on the audience...,' as one teacher put it. This approach falls within the
'critical literacy' paradigm widely adopted within media education, although it
veers towards a kind of protectionism. However, this teacher was keen to
emphasise that this was not 'completely a negative thing,' and that it was not
always 'teacher-led' or 'didactic.' Meanwhile, another teacher commented that
this kind of analytical, 'deconstructive' approach could prove frustrating, even
when it was embedded in the context of practical media making. This was par-
ticularly the case where the examination rubric required students to demon-
strate specific forms of theoretical knowledge, for example about shot types,
audience demographics or *mise-en-scene*. In these examples, the process of con-

version from one kind of ('popular') cultural capital to another (that is perhaps more 'critical') entails an uneasy form of negotiation.

Several of the interviews suggested a third gap, between the students' experiences as media consumers (or users) and the *production* opportunities afforded in the media classroom. For all the schools, media production was a key dimension of media education; and yet with some media, it was still difficult to offer students opportunities that might come close to a 'realistic' production experience (although school creative work may possess its own kind of authenticity, as we shall discuss below). This was less the case with video than with other media. The teaching of moving image production was well established in all three schools, a picture typical of Media Studies teaching in the UK from 14 to 19 (Grahame & Simons, 2004) but extended here into the 11–14 age bracket. If the camcorder uses of the students are indeed typically low-level and casual (and this remains to be verified), then the school media curriculum is offering ample opportunities, again, to 'convert' one form of cultural capital into another—and not only for showing the results to a teacher or examiner, as was once the case, but also for online sharing and exhibition.

Nevertheless, this was more difficult with new media, as one teacher observed:

> ...there seems to be kind of a clear division, because with filmmaking, we can look at film, we can decode a film, we can take it apart and then it's very easy for a student to then really make their own film with a camcorder and basic editing software, you can do that. It's a lot more problematic say with a computer game.

The software package Mission Maker, a 'drag and drop' game-making resource, which was used by all three secondary schools, was seen to offer a solution to this—albeit only a partial one:

> Mission Maker is very good because it allows you to pull it together, but what you're not doing is you're not coding a game, which is obviously how games are put together.

This sense of limitation and uncertainty was also apparent in a fourth gap that emerged from the interviews: between the media curriculum and more participatory aspects of the internet. Several teachers encouraged students to use the internet as a research tool—for example, when researching the representation of social issues in the media or specific aspects of the media industries, such as the music business. However, addressing aspects such as social networking that were closer to students' everyday uses was seen to be more difficult. Several teachers expressed aspirations to engage more fully with online cultures and new media, both in the survey and in the interviews. Of the sample of 259, 131

responded to the question asking what media they would like to make with students if it were possible: of these, 47 said they would like to make animations, 44 said websites, 43 said films, and 31 said computer games. A number of the interviews also focused specifically on more participatory online applications of the Web 2.0 variety. One teacher commented:

> ...there's loads of things which we don't really touch on at all...machinima, and also kind of online communities, Second Life and things like that where...it's this kind of virtual social communities, and learning about how people communicate in those... I'm not sure I can conceptualise yet how one would be able to teach it and what the product would be...but that's an area that seems to be completely missing for us.

The problem here is seen as partly generational (as this teacher put it, 'you're much older than students are'), but it is also to do with the need to rethink established conceptual structures of the media curriculum, such as authorship and audience. Likewise, in discussing other aspects of Web 2.0 such as Wikipedia or social networking, several teachers recognised the general need to be developing skills of critical analysis but remained uncertain as to how this might be achieved.

Conclusion: A Third Space?

To what extent is there in fact a cultural or generational gap between students' and teachers' media experiences? Is it desirable, or necessary, or even feasible for that gap to be overcome? And if so, to what extent might media education provide the means with which to do so? Our aim in this chapter has been to open up some of these questions and to challenge some of the received assumptions about them rather than to offer a firm conclusion. Our research is at an early stage, and our findings here are still very provisional.

One possible conclusion here would be to say that the 'problem'—if it is indeed a problem—is not so much about *teachers* as it is about *schools*, or indeed about the wider culture and politics of education systems. The problem is not that teachers know nothing about their students' media experiences, or that they are unsympathetic to them, or uninterested in them. While there are some predictable differences between them, teachers and students share many of the same media experiences, and often the same tastes—even if neither group necessarily believes this to be the case. They may belong to different generations, and to different social groups, but they do not necessarily live in wholly different cultural worlds.

Nor is it the case that teachers do not *want* to include media in their

teaching. Many believe that learning needs at least to begin with the experi-
ences and orientations of students and that media and popular culture are an
important aspect of that. While the specialist media teachers in our study are
obviously enthusiastic about this, the large majority of the staff we have sur-
veyed were also keen to find ways of incorporating and engaging with media
in their teaching.

The reasons why they generally do not do so are perhaps partly to do with
teachers' individual dispositions, and the uncertainties or limitations in their
knowledge—in effect, their cultural capital. However, much of this is also to
do with the logistical, structural and institutional constraints of schooling.
Whatever they might individually wish, teachers' ability to address the diverse
and rapidly changing nature of their students' cultural lives is actively con-
strained in a context that is characterised by a nationally governed curriculum,
an emphasis on testing, and externally specified teaching frameworks.

In her research on the informal literacies of immigrant students in
California, Kris Gutierrez (2005) suggests that the classroom could provide a
'third space' where the cultures of teachers and students might overlap and come
together in constructive dialogue. The third space conceived of here is as
much a series of processes as a space, characterised by the transformation of cul-
tural resources (in the sense that Vygotsky implies) and by the joint construc-
tion of a new social reality. While this approach is optimistic, Gutierrez also
recognises the difficulties:

> Clearly, this process of transformation is anything but harmonious and it is these
> inherent continuities and discontinuities between individual and the environment and
> the larger system that, in part, I have been attempting to account for in theorizing the
> Third Space. (Gutierrez, 2005, pp. 13–14)

This argument could also be applied to media and popular culture, and these
'continuities and discontinuities' describe well the kinds of gap we have
observed. At the same time, the effort to produce 'authentic cultural practices'
in the classroom through play, through conceptual learning, through imagin-
ing how things might be different also tallies in certain ways with the efforts
visible in the schools in our project. These include the attempt of one teacher
to harness his students' use of social networking media to consider issues of cit-
izenship; the effort to find common cultural ground in popular TV drama; the
use of game-authoring software to address an important cultural form less well
known to the teachers; and the emphasis in schemes of work on accessing stu-
dents' prior cultural experience.

Yet, however we might conceive of the cultural 'third space' in this con-

text, we also need to consider the institutional context of schooling, with its attendant technologies of assessment, its constraints of time and space, and its externally prescribed curriculum. Our early data (interviews with teachers and managers, curriculum plans, policy documents) suggest a range of institutional constraints: the lack of national training programmes for media education; an emphasis on technology (rather than culture) in government policy, to which schools are expected to respond; changes in national procedures for constructing teachers' workloads, which, while directed benignly at preserving the 'work-life balance,' may also have the effect of constricting the time available for teachers to discuss these complex cultural factors.

Media education is constrained in similar ways, both by the institutional 'grammar' of schooling, and by specific curricular and assessment requirements; and as such, it cannot offer a simple answer to this problem. However, much as teachers may seek to use it as a 'third space' in which to embrace or at least engage with students' cultures, there are significant difficulties in doing so. As we have shown, current practice in media education continues to face difficult questions about the selection of media texts to be used, the kinds of critical concepts and terminology that students are expected to acquire, the relationships between media consumption and the experience of creative production; and the need to be responsive to the rapidly changing cultures of digital media.

Yet it would be misleading to suggest that structural constraints exist apart from the individual and collective cultures of students and teachers. The determining functions of cultural tastes and the social contexts in which they are formed, as well as the constraints that surround the development of teachers' professional identities, must be considered. One move that will be necessary as we continue our research is to shift our focus from the cultural contexts outside the classroom to the cultural work of the media classroom: the 'third space.'

The question of what kind of cultural activity actually arises in this space is a moot one. The British Cultural Studies tradition, in its championing of the vitality of spectacular youth cultures, has often tended to construct schools as culturally inauthentic, even oppressive places. Media teachers have responded by seeking to import their students' cultural experiences into the classroom. However, it could be argued that the kind of cultural production that arises here is not simply an extension of the students' everyday cultures, any more than it is merely an imposition of the culture of the school: it is, perhaps, a cultural encounter of a third kind. Thus, others have suggested that students' creative writing in school is a genre of its own (Moss, 1989); and we may extend

this argument to propose that students' drama, media or art productions are also something different from both the professional and the amateur spheres of production in the adult world. Such creative production draws upon and transforms external cultural resources, certainly, but it also possesses its own cultural authenticity.

Bhabha suggests that the 'third space' involves a kind of cultural translation, in which different cultures represent themselves to each other and that this act of representation displaces the histories of these cultures, making new kinds of negotiation and political structure possible (Rutherford, 1990). However, while it is useful to think of the culture of the classroom constructed from *representations* of the participants' cultures, we would argue that the cultural work of the classroom is necessarily connected to the cultural histories behind and beyond it, while the idea of 'representations' does not adequately convey the material, embodied work of the media classroom.

What our data are showing, then, can be seen as a series of representations or imaginings, realised in material media and embodied processes: the efforts of the teachers to imagine their students' media lives; the dramatic construction of imagined spaces of consumption and production in the classroom; the representation of media forms, images, narratives, concepts in worksheet, whiteboard and exercise book—and perhaps above all, in the material media productions of the students themselves.

We may find that this third space, rather than displaying any harmonious synthesis of cultures, is necessarily characterised by the hybridity and ambivalence that Bhabha (1994) identifies. It is a space that consequently 'challenges our sense of the historical identity of culture as a homogenizing, unifying force' (Rutherford, 1990, p. 208). However successful teachers might be in overcoming the structural constraints we have indicated, this hybridity is perhaps the essential condition of media cultures. It is a hybridity whose untidy flux has to be accommodated, however uncomfortably, by the mechanisms of the syllabus and the examination, and yet led by the responsive pedagogies media teachers are reaching for.

References

Bhabha, H. K. (1994). *The location of culture*. London: Routledge.

Bourdieu, P. (1984). *Distinction: A social critique of the judgement of taste*. London: Routledge.

Buckingham, D. (1998). *Teaching popular culture: Beyond radical pedagogy*. London: UCL.

Buckingham, D. (2003). *Media education: Literacy, learning and contemporary culture*. Cambridge, UK: Polity.

Buckingham, D. (2007). *Beyond technology: Children's learning in the age of digital culture.* Cambridge, UK: Polity.

Buckingham, D, & Sefton-Green, J. (1994). *Cultural studies goes to school.* London: Taylor & Francis.

Cuban, L. (1986). *Teachers and machines: The classroom use of technology since 1920.* New. York: Teachers College Press.

Ellis, V., Fox, C., & Street, B. (2007). *Rethinking English in schools: Towards a new and constructive stage.* London: Continuum.

Goodson, I., & Medway, P. (1989). *Bringing English to order: The history and politics of a school subject.* London: Routledge.

Grahame, J., & Simons, M. (2004). *Media studies in the UK.* London: Qualifications and Curriculum Authority.

Gutierrez, K. (2005). Intersubjectivity and grammar in the Third Space. Scribner Award Talk, Los Angeles: University of California, Los Angeles.

Heppell, S. (2000, December). Notschool.Net. *Literacy Today, 25.* Retrieved 28 October 2009, from http://www.literacytrust.org.uk/Pubs/heppell.html

Jenkins, H. (2006). *Convergence culture: Where old and new media collide.* New York: New York University Press.

Jones, K. (2003). *Education in Britain: 1944 to present.* Oxford: Blackwell.

Lambirth, A. (2003). "They get enough of that at home": Understanding aversion to popular culture in schools. *Reading, 37*(1), 9–13.

Livingstone, S. (2009). *Children and the internet.* Cambridge, UK: Polity.

Livingstone, S., & Bober, M. (2005). *UK children go online, final report.* London: London School of Economics.

Marsh, J. (2006). Popular culture in the literacy curriculum: A Bourdieuan analysis. *Reading Research Quarterly, 41*(2), 160–174.

Marsh J., Brooks, G., Hughes, J., Ritchie, L., Roberts, S., & Wright, K. (2005). *Digital beginnings. Young people's use of popular culture, media and new technologies.* Sheffield: University of Sheffield.

Marsh, J., & Millard, E. (2000). *Literacy and popular culture: Using children's culture in the classroom.* London: Paul Chapman.

Marshall, B. (2000). *English teachers: The unofficial guide: Researching the philosophies of English teachers.* London: Routledge.

Moss, G. (1989). *Un/Popular fictions.* London: Virago Press.

Murdock, G., & Phelps, G. (1973). *Mass media and the secondary school.* London: Macmillan.

Oblinger, D., & Oblinger, L. (2005). *Educating the net generation.* Washington, DC: Educause.

Ofcom. (2008). *Media literacy audit: Report on media literacy amongst children.* Retrieved October 28, 2009, from http://www.ofcom.org.uk/advice/media_literacy/medlitpub/medlitpubrss/children/

Prensky, M. (2001). Digital natives, digital immigrants.' *On the Horizon* 9(5), n.p.

Rutherford, J. (1990). The Third Space: Interview with Homi Bhabha. In J. Rutherford (Ed.), *Identity: Community, culture, difference* (pp. 207–221). London: Lawrence & Wishart.

AFTERWORD

Kevin M. Leander

The chapters in this book move in exciting directions for literacy pedagogy and unsettle many of our assumptions about teaching and learning with new literacies. Take, for example, a rough cut at a modal media literacy "lesson" of the sort that Michael Dezuanni (this volume) would place in the "dymystification" paradigm of Masterman (1990). Such a lesson would likely provide "students" "critical" tools for decoding media texts, such that they could "acquire agency" and knowledge for their forays into the social world of media beyond the "classroom." In the present pedagogical explorations, however—riffing on the authors' streams of connections—the notions of "students," "critical," "agency," and "classroom" are fundamentally challenged. The result is that digital media and popular culture are not merely being "connected" to classrooms, or not simply "integrated" (as a project of domestication), but are rather actively reshaping our assumed genres and roles concerning pedagogy and schooling.

Starting with the notion of "student" and the related, age-based association with "adolescent," the volume is full of multi-role and multi-generational accounts of interactions around learning. The authors trouble traditional teacher-student narratives and models. These developing modes of pedagogical practice involve not merely "student-centered instruction" or students taking on teacher roles but also uncertain learning relations—shifting and

dynamic networks of doing, making, playing, and learning where official teacher and student roles are less fitting, less at home. In exploring virtual worlds like Webkinz with middle schoolers, for example, Janie Cowan comments on the continually shifting roles among students and her own shifting roles as a game world learner and teacher-facilitator. Similarly, Amanda Gutierrez and Catherine Beavis consider how youth and their teachers drew strongly on their knowledge of the Australian Football League, on their own play of football, on sports statistics, and on other knowledge funds to participate in a fantasy football league "situated" in the classroom.

Andrew Burn, David Buckingham, Becky Parry, and Mandy Powell provide a needed critical reading of the supposed "gap" between secondary teachers and youth with respect to their media lives, drawing on survey and interview data from a larger study. While some key generational differences emerge (e.g., youth engage much more in social networking and gaming), a number of important similarities are also apparent, including the significance of music and music-related media across generations. Moreover, the internal variation within generational groups seems to be large with respect to media engagements, and with respect to the place that media have in relation to other forms of activity, greatly complicating "digital natives" vs. "digital immigrants" (Prensky, 2001) narratives. Similar generational upending runs across other accounts. Lalitha Vasudevan, Tiffany DeJaynes, and Stephanie Schmier, for example, describe how adults and youth engage in a "pedagogy of collegiality" together in Youth Radio, while two of the youth engaged in a mentoring program with Jairus Joaquin describe first learning about hip hop from their mothers. In reading across the studies, I get the sense that generational differences in media use and practice—to the extent that they exist—are less useful as a frame for planning than they are as an ongoing site of study and engagement. It may well be that our generational insider/outsider dichotomies are rapidly changing, that our ways of conceiving the "new" across generations may be growing old. On the other hand, for the purpose of transforming education, the differences in *fact* between teachers and youth with respect to digital media may be less important than differences in *perception*. Hence, Kelly Chandler-Olcott and Elizabeth Lewis, investigating these perceptions and conceptions of digital media identities in their chapter, propose an innovative pedagogical approach whereby such models could be made explicit and could be rewritten.

Returning to our modal media lesson for a moment, an emphasis on critical framing has been a staple of media education and adopted by new literacies education for some time now. Such a framing finds a natural fit with literature

pedagogy in secondary English classrooms, which, when it departs from personal meaning-making (e.g., Reader Response), moves into a general sense of "critical reading" or less often, into specific critical frames (e.g., Marxism, feminist theory). Across these chapters, however, I experience a lot of play. From the struggling and often sad lives of homeless youth described by Theresa Rogers and Kari-Lynn Winters, I see satire (academically responsible comedy) in their zines but also joking around, goofing off. Were I able to insert myself into many of the sites of engagement described by Theresa and the other authors, I imagine that I would laugh often—laugh myself to tears—and also cry as well. These playful engagements are emotionally saturated and affectively charged. They involve moving, interacting bodies, jokes, sweat, sexual innuendo and straight-up come-ons, imagined and real football kicks, identity desires and re-mixed photos of the "self" in performances of identity. What to make of it all, as a misfit for literacy education?

The authors in the volume juxtapose play on the one hand and "the critical" on the other in ways that seem particularly timely, if not uneasy, for literacy education. I believe they invite us to stop making school-like excuses for play ("Yes, I confess my students were at play, but look at all the learning going on!") and to wonder if school can be a site for play. They invite us to wonder if play is enough, if humor, in the end, is a major "accomplishment," loaded with all kinds of growth that we don't understand very well. In some of the work, there is a challenge put to the notion that critical mindsets need to be imparted to students by teachers. Yet, in other places, including Kelly Chandler-Olcott and Elizabeth Lewis' study, teachers firmly believe they would be eschewing their role without critically reframing students' naïve engagements. Still, as readers we have some evidence that playful engagements of all sorts lead youth to more natural critical acumen. Janie Cowan, for instance, illustrates how youth-at-play in Webkinz understand something of the consumerism of this world but also seem to critically assess the site navigation rules and their own stance as audience. The pedagogy described by Michael Dezuanni appears to be a type of graceful dance between playful and critical engagements, inviting youth into fully absorbed and playful production of online games and then drawing them into critical reflections through blogging and chat.

Can we have our playful poststructural cakes and critically eat them too? Guy Merchant imagines a union where the created "social object" (e.g., the social networking site, such as Facebook), becomes the critically engaged "learning object." He outlines a pedagogy in which social neworking sites are playgrounds for "active identity work" for youth but also serve as resources for

the critical appraisal of texts, commercial sponsorship, and other issues. Amanda Gutierrez and Catherine Beavis draw on Consalvo's (2007) notion of "gaming capital" as they reflect, from a Bourdieuian perspective, on how embodied dispositions/knowledge might move from one form of capital to another. Like many of the other authors, they raise questions for literacy educators about the "gaming" disposition, the playful identity, and the emotionally engaged body-in-motion. At the same time, Chandler-Olcott and Lewis identify how, for some teachers, a perception of "game" or "fun" in youth activity is equivalent to mindless entertainment and distraction and may lead to a failure to learn or even learning pathologies like narrow-mindedness. How do we understand this mediated body, this subject, this youth? And how are these engagements related to what we've taken to be the domain of literacy—the domain of texts? Returning to the movements of the playful and critical as described by Dezuanni, a partial response to these rhythms might be found in the circulation between playfully productive and critically interpretive moments in the classroom.

Certainly, part of the emphasis on play and affective engagement in the volume seems to be related to its rich exploration of youth media production, moving beyond media interpretation alone and its heritage of the critical formation of mind. Unsurprisingly, the broad range of media productions explored here—Youth Radio, virtual worlds, zines, blogs, MOO-based games, and social networking sites—involves an energized sense of agency that is not nearly so apparent in the vision of youth as apprentices of critical mindsets. David Kirkland's account of working with Black female youth is fundamentally a story of hope recovered through media production, in which authoring one's own story in a racially oppressive social context (including an oppressive media context and the "digital status quo") is fundamental to a form of "therapeutic pedagogy." Like many of the other pedagogies in the volume, however, Kirkland's also flows between creative production and critical analysis, breaking off in rhizomes or flowing eddies that move in multiple, unpredictable directions of imagination, creation, and critique.

Finally, the authors in this volume, in "connecting" classrooms to digital media and popular culture, are opening up and challenging classroom boundaries—are unmooring classrooms. Spatially and temporally, the historical modal media lesson as a preparation for an "out there" is no longer sensible as here/there and then/now/later come into contact through the media engagements described here. Perhaps it should come as no surprise that a pivotal generational difference between youth and teaching adults involves social

networking and constant communication practices. This finding is supported both through data on practices (Burn, Buckingham, Parry, and Powell) and data on teacher perceptions of youth (Chandler-Olcott and Lewis). Social networking practices open up and complicate social spatial locations much more than some online practices. As teachers are more prone toward "functional" uses of media (e.g., reading product reviews online) over communicational ones (Burn and co-authors), imagining the teaching and learning world as closer to that of a social network poses a more fundamental challenge to school space-time. Rogers and Winters have this wonderful example of how homeless youth producing an online zine are committed to expressing and transforming their world that exists in a "14 block radius" of Vancouver, all while using global media to engage in these modes of creation and re-reading the world. Joaquin's analysis of a hip hop piece by Jay-Z as a resource for critical media engagement depends on the capacity of widely distributed flows of media to reframe the experience of hip hop as shared across boundaries of the virtual and physical, of the community and nation. On the production side, Gutierrez and Beavis' account of fantasy football in the classroom is suggestive of a re-scaling of educational activity at multiple levels; students compete in the league with one another (inside a classroom), and simultaneously with other classrooms in the school, with teacher teams, and with 200,000 other teams in Victoria's larger fantasy league.

This volume is indeed an exciting invitation to the experience of pedagogy playing out on multiple spatio-temporal scales through a range of extended illustrations, imagined geographies, and analyses. The authors vividly reminded us that media convergence (Jenkins, 2006) is not a process abstracted from social and material spaces but is also a form of social-spatial convergence. How do we locate the classroom at the nexus of new online social spaces and the changing social spaces of popular culture? Burn and co-authors consider third space theory (e.g., Gutierrez, 2005), which certainly seems a productive point of departure for considering the interface of institutional and counter-institutional discourses and identities, for considering the classroom as a contact zone of official and unofficial scripts. However, moving toward a "pluralistic view of media cultures" will also engage the movement toward a pluralistic experience and (re)construction of social spaces—spaces that are conceptual, institutional, social, and material. What models will serve us well for reconceiving such connections across social spaces, spanning localities and globalities? Such new geographies of learning are situated in classrooms while not contained by them, activated through physical bodies while not bounded in them, and

responsive to institutional discourses while not described by them. The vibrant pedagogies described in this volume invite us to better understand our present locations in these geographies and invite us to re-imagine new traversals across them.

References

Consalvo, M. (2007). *Cheating: Gaining advantage in videogames*. Cambridge: MIT Press.
Gutierrez, K. (2005). Intersubjectivity and grammar in the Third Space. Scribner Talk, Los Angeles: University of California Press, Los Angeles.
Jenkins, H. (2006). *Convergence culture: Where old and new media collide*. New York: New York University Press.
Masterman, L. (1990). *Teaching the media*. London ; New York: Routledge.
Prensky, M. (2001). Digital natives, digital immigrants. *On the Horizon* 9(5), n.p.

CONTRIBUTORS

DONNA E. ALVERMANN is University of Georgia Appointed Distinguished Research Professor of Language and Literacy Education. Formerly a classroom teacher in Texas and New York, her research focuses on young people's digital literacies and popular culture. Her co-authored and edited books include *Adolescents and Literacies in a Digital World* (Peter Lang), *Reconceptualizing the Literacies in Adolescents' Lives* (Lawrence Erlbaum), and *Bring It to Class: Unpacking Pop Culture in Literacy Learning* (Teachers College Press).

CATHERINE BEAVIS is Professor of Education at Griffith University, Australia. She researches in the area of digital culture, young people, and new media, with a particular focus on the changing nature of text and literacy and the implications of young people's experience of the online world for English and literacy education and curriculum. Her most recent book is *Doing Literacy Online: Teaching, Learning and Playing in an Electronic World* (Hampton), edited with Ilana Snyder.

DAVID BUCKINGHAM directs the Centre for the Study of Children, Youth and Media at the Institute of Education, London University. His research focuses on children and young people's interactions with electronic media and on media education. Among his most recent books are *Beyond Technology: Children's Learning in the Age of Digital Culture* (Polity), *Youth, Identity and Digital Media* (MIT Press), *Video Cultures: Media Technology and Amateur Creativity*, and *Childhood and Consumer Culture* (both Palgrave).

ANDREW BURN is Professor of Media Education at the Institute of Education, University of London, and Associate Director of the Centre for the Study of Children, Youth and Media. He has researched and published on many aspects of the media, including young people's production of computer games, digital video and animation in schools, and media literacy. His most recent book is *Making New Media: Creative Production and Digital Literacies* (Peter Lang).

KELLY CHANDLER-OLCOTT is the chair of Syracuse University's Reading and Language Arts Center, where she directs the English Education program. A former secondary English teacher in her native state of Maine, she teaches courses in literacy across the curriculum and English methods. Her research interests include technology-mediated literacies and inclusive approaches to literacy instruction. She has published in *Reading Research Quarterly*, *Journal of Literacy Research*, and *Journal of Adolescent & Adult Literacy*, among others.

JANIE COWAN is a doctoral student in the Department of Language and Literacy Education at the University of Georgia as well as a school Library Media Specialist. Her research interests include adolescent digital literacies, cultural issues in education, and multicultural children's literature. She has published in *Teacher Librarian*, *Journal of Language and Literacy Education*, and *Education Review*.

TIFFANY DEJAYNES is a doctoral candidate at Teachers College, Columbia University in Communication, Computing, and Technology in Education as well as a high school English Language Arts teacher. She is interested in how adolescents and educators engage with media and new technologies—both in school and out of school. Her current research looks at the evolving landscape of literacy and composing practices in classrooms.

MICHAEL DEZUANNI lectures in Film and Media curriculum in the Faculty of Education, Queensland University of Technology (QUT). He recently completed a doctorate focusing on boys learning about video games in a media education context. He investigated how established approaches to media education theory and practice may be reconceptualized in digital media contexts.

AMANDA GUTIERREZ is a lecturer in Education at the Melbourne campus of the Australian Catholic University. While working on the book chapter she was a Research Assistant and casual lecturer in the Faculty of Arts and Education at Deakin University in Melbourne. She is also in the final stages of completing a Ph.D. through the University of Melbourne. Her dissertation is titled "Filling the Critical Literacy Vessel: Constructions of Critical Literacy in Australia."

JAIRUS JOAQUIN is a doctoral student in the Department of Language and

Literacy Education at the University of Georgia. He has worked as a speech-language pathologist in public schools and as a literacy consultant for an after-school program. His research interests include adolescent literacy, theories of Black masculinity and literacy, and critical, post-structural, and cultural studies.

DAVID E. KIRKLAND is an assistant professor of English Education at New York University. His research focuses on urban youth and popular culture in the areas of language and literacy. Dr. Kirkland has received many awards for his groundbreaking research, including an AERA Outstanding Dissertation Award. He is author of several top-tier journal articles and an upcoming book, *A Search Past Silence*, which explores literacy in the lives of urban adolescent Black males.

KEVIN M. LEANDER is an associate professor of Language, Literacy, and Culture in the Department of Teaching and Learning at Peabody College, Vanderbilt University. Co-editor of *Spatializing Literacy Research and Practice* (Peter Lang), his research focuses on understanding literacy as a spatial-social practice, on multimodality, and on digital literacies. He is currently involved in research (with Rogers Hall) on spatial analysis and modeling and is studying immigration and digital literacies with colleagues at Utrecht University.

ELIZABETH LEWIS is an assistant professor of education at Dickinson College in Carlisle, Pennsylvania. She was a secondary English educator for ten years before taking her current position of teaching at the higher education level. Elizabeth teaches courses in curriculum design, instruction, and student assessment across content areas in addition to English methods. Her research interests include adolescent literacy, technology-mediated literacy practices, as well as English Language Learner (ELL) literacy development and instruction.

GUY MERCHANT is Professor of Literacy in Education in the Faculty of Development and Society at Sheffield Hallam University. He has published widely on the topic of digital literacy. His work includes the study of teenagers' language in internet chatrooms, primary schoolchildren's use of email in developing narrative writing, and virtual worlds as environments for literacy development. He is author (with Julia Davies) of *Web 2.0 for Schools: Learning and Social Participation* (Peter Lang).

BECKY PARRY is a researcher on the Developing Media Literacy project at the IOE. Previously, a teacher of English and Media and then Education Manager at Showroom cinema where she established a film festival for children www.showcomotion.org.uk, Becky also set up Cube, www.cubeweb.org.uk, a

media production project for young people. She completed an M.A. in Educational Research prior to commencing an ESRC-funded Ph.D. at Sheffield University, researching children's engagements with film in relation to literacy.

MANDY POWELL has taught Film and Media Studies at a number of Higher Education institutions in Scotland. She has also taught on the Initial Teacher Education programme at the Stirling Institute of Education. Currently Mandy is working in the Centre for the Study of Children, Youth and Media at the Institute of Education, University of London, where she is a Research Officer on the three-year ESRC-funded project seeking to develop a model for media literacy.

THERESA ROGERS is a professor of Language and Literacy Education at the University of British Columbia, Canada. Her interests include new literacy practices among adolescents in schools and communities, and critical theoretical perspectives on adolescent literature. Her co-authored chapter is part of her recent research in the YouthCLAIM project, a government-funded project that explores arts and media as critical social practices among youth in communities and schools. For more information, see http://theresarogers.ca.

STEPHANIE SCHMIER is a doctoral candidate at Teachers College, Columbia University in the Department of Curriculum and Teaching and a National Academy of Education Adolescent Literacy Predoctoral Fellow. Her research explores how youth take up digital technologies, ways in which adolescents' digital literacy practices travel across physical and virtual spaces, and the meaning that youth make of their experiences with digital media across multiple contexts in their lives.

LALITHA VASUDEVAN is an assistant professor of Technology and Education at Teachers College, Columbia University. She is interested in how adolescents craft stories, represent themselves, and produce knowledge through the engagement of literacies and multiple modalities. Her research has been published in *E-Learning, English Education,* the *Journal of Adolescent & Adult Literacy,* and *Review of Research in Education.* She is co-editor of the volume titled *Media, Learning, and Sites of Possibility* (Peter Lang).

KARI-LYNN WINTERS is an assistant professor in the Department of Teacher Education in the Faculty of Education at Brock University, Ontario. Her research interests include exploring multimodal literacies across a range of diverse contexts, drama in education, children's literature, and new models of authorship. For more information, see http://kariwinters.com/academic.

AUTHOR INDEX

A

AAUW Educational Foundation, 167, 180
Acclaim Entertainment. 157, 160
Albers, P. 166, 180
Allen, J. 179, 181
Altheide, D. 118, 123
Althusser, L. 128, 142
Alvermann, D. E. 6, 8, 21, 23, 29, 31, 48,
 91, 103, 105–106, 110–111, 121, 123,
 145, 159–160, 175, 180–181
Anderson, J. 106
Apperley, T. 150, 152, 160–161
Apple, M. W. 30, 48
Arafeh, S. 177, 181

B

Bailey, N. M. 164, 180
Bakhtin, M. M. 82–83, 88, 98, 105
Baldwin, J. 19–20, 75
Barker, O. 163, 180
Barthes, R. 128, 142
Bauman, R. 98, 105
Beach, R. 122–123
Bearne, E. 145, 160

Beer, D. 59, 67
Bekerman, Z. 102, 105
Beringer, R. E. 118, 123
Besselaar, P. 68
Bhabha, H. K. 185, 200–201
bigtweet.com 64, 67
Birkerts, S. 169, 180
Bittanti, M. 24
Black, R. W. 93, 105, 163, 180
Bober, M. 52, 68, 187, 201
Boler, M. 92, 103, 105
Bouchard, D. E. 105
Bourdieu 140, 142, 149–150, 160, 185,
 194–195, 200–201, 206
boyd, d. 22–23, 54, 57, 66–67, 138, 142
Brandt, D. 54, 67, 97, 105
Briggs, C. 98, 105
Brisk, M. 82, 88
Brooks, G. 201
Bruce, B. C. 122–123
Bryant, L. 63, 67
Buckingham, D. 4, 23–24, 61–62,67, 93, 98,
 103–105, 125, 127, 142, 183–184, 186.
 200–201, 204, 207
Burbules, N. 102, 105

Burgess, J. 127, 142
Burgos, A. 82, 88
Burke, A. 8, 23
Burn, A. 4, 127, 142, 204, 207
Burnett, C. 58, 67
Butler, J. 128–129, 131, 134, 138–140, 142

C

Cammack, D. W. 166, 181
Carby, H. C. 76, 88
Carrington, V. 50, 66–67, 149–150, 153, 155, 160
Chandler-Olcott, K. 3, 6, 23, 178, 180, 204–207
Chavez, V. 8, 22, 24
Ciechanowski, K. 24
Clinton, K. 97, 105
Coiro, J. 102, 105, 107, 166, 179, 181
Cole, D. 106
Collins, P. H. 75–76, 82, 88
Compton, D. L. 181
Consalvo, M. 150–152, 158, 160, 206, 208
Corbin, J. 77, 89
Cowan, J. 2, 32, 41, 48, 204–205
Coyle, M. 118, 123
Cuban, L. 184, 201

D

Datpiff. 113, 123
Davies, B. 101, 105, 128, 142
Davies, J. 52, 56, 58, 63, 66–67
Dawe, B. 148, 160
DeCerteau, M. 91, 105
DeJaynes, T. 2, 204
Deleuze, G. 101, 105
DeVriese, K. 118, 123
Dewey, J. 122–123
Diaz, J. 14, 23
DJdownloadz.com. 113, 123
Dodge, C. 93, 105
Doriana, B. M. 76, 88
Dowdall, 58–59, 67
Duncan-Andrade 112–113, 124

Dyson, A. H. 83, 88

E

Ellis, V. 184, 201
Ellison, N. 54, 57, 67
Engestrom, J. 55, 67

F

Fabos, B. 163, 181
Facer, K. 52, 68
Fanfooty blog. 151, 160–161
Fecho, R. 179, 181
Finders, M. 168, 170, 176, 181
Fisher, M. T. 8, 23, 83, 88
Fitzpatrick, B. 66–67
Flood, J. 179, 181
Foster, M. 76, 83, 88
Foucault, M. 101, 105, 129, 131–132, 134, 142–143
Fox, A. 118, 124
Fox, C. 184, 201
Fox-Genovese, E. 76, 79, 88
Freebody, P. 145, 159, 181
Freire, P. 3, 86, 88, 98, l04–105, 118, 123
Frostwire. 114, 116, 123

G

Gamboa, M. 93, 105, 163, 181
Gee, J. P. 6, 11, 23, 29, 48, 52, 55, 67, 92, 103, 105, 110, 123, 145, 160, 164–165, 176, 181
Genette, G. 151, 160
Gibson, M. A. 89
Goffman, E. 53, 59, 67
Goodman, S. 8, 23
Goodson, I. 184, 201
Graham, L. 57, 68
Grahame, J. 196, 201
Grant, L. 68
Grunwald Associates. 33, 48
Gutierrez, K. 185, 198, 201, 207–208
Guy-Sheftall, B. 76, 88
Guzzetti, B. 93, 105, 163, 181

H

Hagood, M. C. 6, 12, 23–24, 29, 48, 121, 123, 175, 180
Hall, S. 126, 143
Halverson, E. 150, 153–154, 161
Halverson, R. 150, 153–154, 161
Hamerla, S. 82, 88
Hammett, R. F. 8, 23
Harris, C. 117, 124
Harste, J. 166, 180
Hartman, S. V. 76, 79, 88
Heath, S. B. 111, 123, 165, 181
Helsper, E. 52, 68
Hendrick, B. 31, 48
Heppell, S. 183, 201
HeraldSun TAC. 149, 161
Hermer, J. 91, 105
Hernandez, D. B. 115, 124
Higginbotham, E. B. 83, 89
Hill, M. L. 8, 23
Hinchman, K. 6, 23
Hoggart, R. 126, 143
Honan, E. 29, 48
hooks, b. 76, 83, 89
Horst, H. 24
Hubbard, R. 179, 181
Hughes, J. 201
Hull, G. 6–8, 23–24, 91, 106, 111, 123

I

Ishida, T. 68
Ito, M. 6, 21–22, 24
iTunes. 114, 124

J

Jackson, A. 112, 124
Jackson, K. K. 124
James, J. 76, 81, 89
James, M. A. 6, 23, 76, 81, 89
Jenkins, H. 28, 31, 48, 93, 102–103, 106, 116, 124, 127–128, 139, 143, 151, 161, 189, 201, 207–208
Jensen, J. 179, 181

Jewitt, C. 7, 24, 166, 183
Jones, K. 184, 201

K

Kajder, S. 178, 181
Katz, M. 8, 23
Kellner, D. 103, 106
Kelly, K. 31, 48
Kendrick, M. 106
Keyes, C. L. 111, 124
Kim, Y. 181
Kinzer, C. K. 166, 181
Kirkland, D. E. 2, 27, 48, 76, 80, 83, 89, 112–113, 121, 124, 206
Kitwana, B. 111, 124
Knobel, M. 6, 24, 30, 35, 48–49, 52, 54, 56, 66, 68, 92–93, 105–107, 161, 166, 179, 181
Kramer, K. 26
Kress, G. R. 7, 24, 145, 161, 166, 181
Kvale, S. 114, 124

L

Lambirth, A. 186, 201
LaMonde, A. 106
Land, R. 145, 159, 161, 181
Lankshear, C. 6, 24, 30, 35, 48–49, 52, 54, 56, 66, 68, 92–93, 105–107, 161, 166, 179, 181
Lapp, D. 179, 181
Leander, K. M. 4, 92, 95, 97, 106
Leavis, F. R. 126, 143
Lee, J. 31, 48
Lefebvre, H. 92, 106
Lemke, J. 98, 106, 159, 161
Lenhart, A. 31, 48, 52, 59, 68, 80–81, 89, 177, 181
Lesko, N. 170, 181
Leu, D. 105, 107, 145, 161, 166, 179, 181
Lewis, C. 166, 176, 181
Lewis, E. 3, 178, 180, 204–207
Lilley, C. 147, 161
Lingard, B. 160–161
Liu, H. 60, 68

Livingtone, S. 52, 68, 183, 187, 201
Lopez, J. 117, 124
Luke, A. 29, 107, 145, 149–150, 153, 155, 159–161,
Luke, C. 29, 48

M

Macgill, A. R. 31, 48, 68, 177, 181
Madden, M. 31, 48, 68, 80–81, 89
Magee, J. 42, 48
Mahar, D. 6, 23, 178, 180
Mahiri, J. 112, 124
Mandler, J. 82, 89
Manovich, L. 98, 106
Marsh, J. 145, 161, 184, 186–187, 201
Marshall, B. 186, 201
Marshall, W. 115, 124
Masterman, L. 126, 128, 130, 132, 143, 203, 208
Matute-Bianchi, M. E. 82, 89
McCarthey, S. J. 91, 106
McDowell, D. E. 76, 89
McKim, K. 92, 95, 97, 106
Medway, P. 184, 201
Merchant, G. 2, 51–54, 56, 58 63, 66–68, 205
Millard, E. 184, 201
Mills, E. 97, 106
MIT Convergence Culture Consortium. 151, 161
Moje, E. B. 19, 24, 91, 106
Moll, L. C. 19, 24
Monahan, J. 68
Montgomery, P. 148, 161
Moon, J. S. 21, 23, 121, 123, 175, 180
Moore, D. W. 6, 23
Morrell, E. 21, 24, 112–113, 124
Mosher, J. 91, 105
Moss, G. 199, 201
Murdock, G. 184, 190, 201

N

National School Boards Association. 48, 65, 68

Nelson, M. E. 7, 24
New London Group 11, 24, 124, 111

O

Oblinger, D. 184, 201
Oblinger, L. 184, 201
O'Brien, D. 82, 89
OfCom. 59, 68, 143, 187, 201
Ogbu, J. U. 89
Owen, M. 56, 65, 68

P

Pahl, K. 8, 24, 67
Parmar, P. 112, 124
Parry, B. 4, 204, 207
Passeron, J. C. 140, 142
Perry, M. 106
Phelps, G. 184, 190, 201
Phelps, S. 6, 23
Powell, M. 4, 204, 207
Power, B. 179, 181
Prensky, M. 29, 48, 173, 181, 184, 201, 204, 208
Pullen, D. 106

R

Ranker, J. 6, 24
Rawolle, S. 160–161
Reay, D. 150, 161
Richmond, R. 163, 181
Risko, V. 181
Ritchie, L. 201
Rivera, R. Z. 115, 124
Roberts, S. 201
Robinson, C. 118, 124
Robinson, M. 67, 145, 161
Rogers, T. 3, 93, 97, 106–107, 205, 207
Rose, T. 112, 124
Rottmund, K. 93, 107
Rowsell, J. 8, 24, 67
Ruddell, R. B. 181
Rutherford, J. 200–201

S

Sanchez, J. 44, 48
Sayers, S. 68
Scharber, C. 82, 89
Schmier, S. 2, 204
Schneider, C. 118, 123
Schofield, A. 92–93, 106–107
Schultz, K. 8, 24, 91, 106, 111, 124
Sefton-Green, J. 93, 98, 103, 105, 107, 186, 201
Selwyn, N. 52, 68
Shange, N. 71, 73–74, 77, 79, 85, 89
Share, J. 103, 106
Sharpley-Whiting, 76, 81, 89
Showalter, E. 89
Silberman-Keller, 102, 105
Simons, M. 196, 201
Skinner, E. 6, 24
Smith, A. 31, 48, 68, 177, 181
Smith, B. 161
Smitherman, G. 73, 89
Smythe, S. 106
Soep, E. 8, 22, 24
Soja, E. 92, 107
Spires, H. 31, 48
Squire, J. 179, 181
Stake, R. 166, 181
Staples, J. M. 21, 24
Stein, P. 98, 107
Steinkuehler, C. 93, 105
Stolle, E. 164, 181
Stone, J. 30, 33, 49
Stovall, D. 112, 124
Strauss, A. L. 77, 89
Street, B. 30, 49, 107, 110, 124, 184, 201
Sutherland, L. M. 81–82, 89
Szwed, J. F. 111, 124

T

Tanabe, M. 70
Tapscott, D. 52, 68

Tedeschi, B. 35, 49
Terdiman, R. 101, 107
Thomas, A. 43, 49, 164, 182
Thompson, D. 126, 143
Torck, D. 93, 107
Turkle, S. 128, 143
Turner, G. 49
Turner, K. 31, 48
Turner, M. 36, 49
Twhistory.com. 64, 68
Twitter.com. 8, 64, 67–68

U

University Laboratory High School (IL). 64, 68
Unrau, N. 181

V

Vasudevan, L. 2, 7, 16, 23–25, 204
Vavra, S. 124

W

Waff, D. 6, 23
Walsh, C. S. 150, 152, 160–161
Ware, P. D. 6, 25
Warschauer, M. 128, 143
Watkins, S. C. 112, 124
Wellman, B. 53, 68
Weinstein, S. 112, 124
Wesch, M. 6, 25
West, K. C. 83, 89
Whannel, P. 126, 143
Willet, R. 59, 61, 69, 145, 161
Willett, R. 24
Williams, R. 30, 49, 126, 143
Winters, K. 3, 97, 106
Wissman, K. 8, 25
Wright, K. 201

Z

Zimmerman, J. 163, 182

SUBJECT INDEX

A

access 38–39
affinity groups 63, 92–93
agency 28–31, 40, 43, 82, 85, 150, 203, 206
alternative pedagogies 17, 104–105, 134,
authority 159
avatars 2, 7, 30–31, 35, 37, 39–40, 42–43

B

Bebo 51, 54, 59, 189, 192
Bhabha (see third space)
Black female narratives 80–85
Black feminism
 male perspective 73–75
 theoretical framework 75–76
blog/blogging 3, 13–16, 41, 131–133, 141
Bourdieuian perspective 150–151, 185,
 194–195, 206
 capital (see cultural, embodied, symbolic
 capitals)
 field 150–153, 156
 habitus 149–150, 152–156, 160,
 184–186
British Cultural Studies 199

C

chat (see online chat)
Chobots 2, 28, 32–33, 37, 41–43
choreopoem 73
Club Penguin 2, 28, 32–33, 36, 38, 41, 43
composing (see writing)
computer games (see also video games)146,
 187–188, 196–197
collective cultures 199
counter discourses 100–102, 104
counter pedagogies (see alternative pedago-
 gies)
critical
 awareness 123
 framing 204
 literacy 61, 118, 121,129, 157, 163, 198,
 205–206
 media literacy pedagogy 61, 112
 readers 117–118
 theory 29–30
cultural
 authenticity 196, 200
 capital 3, 43, 65,140, 146, 150–153,
 155–57, 159, 194, 196, 198

distinction 195
encounter (see third space) 199
histories 200
models/modeling 3, 122, 164–165,
 167–171, 176, 178–180
tastes 59–60, 115, 185, 191, 193–194,
 197, 199
values 112, 185–186
Cultural Studies (see also British Cultural
 Studies) 29, 126,
curriculum units
 learner-centered, 122
 SuperCoach Fantasy AFL game 3,
 147–149
 Video Games Immersion Unit 3,
 129–141

D

decoding 126–128,
demystification approach 128
Detroit 71
digital
 divide 29, 188
 generation gap (trope)183–185
 natives and immigrants 29, 104, 173,
 183–184, 204
 landscapes 6–7, 21
 literacies 1, 6–7, 21–22, 28, 51, 58, 80,
 110, 113, 137, 142, 146, 159, 176
 media literacy, 2–4, 127
 rewritings 80–85
 texts 21, 73–77
Discourse (Gee) 164–165
DIY 92, 103

E

embodied capital 153, 160, 206
ethnography 76

F

Facebook 13, 15, 36–37, 51, 54, 57, 59, 65,
 78, 163, 173, 189–190, 192, 205

Fantasy Sport games 3, 148, 156
femininity 71, 74, 80, 86, 138
film 135–137, 194
Foucault's 'technologies of the self' 131, 134
Freire 3, 86, 104, 118
funds of knowledge 19, 21, 204

G

game play 3, 30, 35–36, 40–41, 125, 132,
 134, 137, 148, 152, 154–159, 188–190,
 198, 204–206
games (see curriculum units)
gaming capital 151, 159
Garage Band, 11
general equivalency diploma (GED) 17–18
generational 'gaps' 4, 185, 194
generational upending 204

H

habitus (see Bourdieuian perspective)
hip hop
 history 111–112
 opportunities for teaching 118–122
 phenomenon 111–112
 Roc Boys (And the Winner Is) 118–119,
 122
 sociocultural perspective 110–111
 texts 3, 112–114
homelessness 91, 94–95, 99, 103
hybridity 4, 6, 43, 200

I

ICTs (Information Communication
 Technologies) 52, 171–172, 174, 183, 185
iDentities 73–74, 77, 80, 82, 85
identity 53, 59–60, 62, 94–95, 102–104, 112,
 127, 130–131, 141, 146–147, 155, 159,
 205–206
identity positions 95, 103–104
ideology 30, 43, 128
 'ideological tense position' 186
immigrant students 198

J

Jay-Z, 115, 118–120, 122–123, 207

L

learning 2–3, 8, 21–22, 56, 59–66, 87, 98, 101–104, 112, 118, 122, 129, 130–131, 140–141, 146, 170, 172, 198, 203–207
library media specialist (see school media specialist)
literacy practices (see also zines) 2–3, 7–8, 52–54, 58–59, 66, 87, 91–93, 103–105, 110–111, 146, 149, 158–159, 163, 167, 179, 184,
literary criticism 76

M

machinima 199
media (see also popular culture)
 consumers 28, 43, 116, 126–127, 141, 183, 196
 convergence 147, 151, 158, 207
 cultures 127, 130, 184. 191–195, 198–199, 202, 207
 education 126–127, 128, 183–184, 186, 195–197, 204
 flows 207
 literacy 125, 130, 140, 142, 185–186
 offline 57, 97, 146, 159, 190
 production 92, 127–128, 134,196, 200, 206
 teachers' and students' uses 186–191
 texts 6, 21, 110–111, 115, 121, 146, 159, 199
Media Studies 9, 58, 61–62, 196
metaphysical dilemma 71, 73–75, 79, 82, 84–85
 transcendence 80, 82, 84–85
multi-generational 203
multimodality 2, 7, 166
multimodal pedagogies 5–25,
multimodal play 7–9, 21–22
multiple literacies 28–29
MySpace 5, 10, 17–19, 51, 54, 59, 74, 76,

78–79, 83, 114–116, 163, 168, 173, 189

N

new literacies 2, 7. 10, 54, 56, 63, 102–103, 145, 166–167, 174, 176, 178–179
New Literacy Studies 30–31, 110, 164, 184
New London Group 111
new media journalists 9–12
new technologies 31, 52, 54, 103, 110, 170, 184
New York City 72
Ntozake Shange 71–73

O

online literacy(ies)
 and offline (not polar opposites) 159
 Black feminist perspective 71–88
 chat/chatting 3, 36–37, 39, 41, 53, 57, 126, 137–142, 173, 207, 211
 communities 77, 81, 92, 102, 141, 147
 identity performance 59–61
 pseudonyms 133–136
 sexual politics 77–80
 surveys 52, 59, 65, 177, 185–197, 204
 theoretical considerations 127–129
organic pheminism, 73, 77

P

paratexts 151–152, 155–158
participatory culture 31, 102–103, 116, 127–128, 151, 193, 197,
pedagogy of collegiality 8, 204
performative variation 134, 140
performativity (Butler) 131, 137–138
permissions 32, 37
Pew Internet & American Life Project 81, 177
popular culture (see also media) 1, 6, 112, 141, 184, 191–192
poststructural theory 3, 128, 205
primary theory(ies) (see also cultural models)165, 176 -177

R

reggaeton 114–115
remix 128, 130, 137
representations 20–21, 119, 138, 200
responsive pedagogies 19, 21, 200
rhizomes 206

S

satire 99–100
school library media specialist 2–3, 28, 180
Second Life 197
social
 class 184–186
 literacy 115–116, 149–158
 software 55–56, 198
 spaces 207
social networking 2–3
 arena for New Literacies 56–59
 friendships 51, 57, 59, 81,
social networking sites (SNS) 16–21, 53–56
 educational uses 63–66
 unpacking the text 61–63
socially situated cultural practice 145–146
spatio-temporal scales 207
street youth 3, 91–102
structural constraints 198–200
student
 academic preparedness 170
 perspectives 31, 34, 43, 138, 140–141
subjectivity 118, 143
symbolic capital 146, 150, 152–153, 155–157

T

tactical uses of public spaces (DeCerteau) 91
teacher
 constructions of adolescents' online lit-
 eracies 167–176
 perceptions of students' media cultures
 3–4, 167–168, 191–193
teacher-student relationship 183
tech-savvy (savviness) 168
television 157, 183
textual play 98–99

therapeutic pedagogy 86–88
third space (see also hybridity) 4, 185, 193,
 197–200, 207
Twitter 8, 54, 64, 193

U

unmooring classrooms 206
unsanctioned web spaces 32–33
urban education 9, 111, 118

V

video games 3, 6, 125–126, 133, 146, 160
 gendered 138, 140
Video Games Immersion Unit Project (see
 curriculum units)
virtual worlds 30, 35, 45, 54, 147, 204, 206,
Vygotsky 200

W

Web 2.0 6, 52, 56, 61, 66, 79, 103, 193, 197
Webkinz World 2, 34–36,
 agency 40–41
 epistemology 42–43
 parent involvement 36–37
 site construction and ideology 43–44
 social and economic ethos 38–39
 traditional literacies and possibilities
 44–47
Wii 188
Writing 2, 11–12, 14–15, 20, 44, 54, 56, 58,
 73–75, 80–87, 94, 101, 112, 131, 139,
 177, 189, 199

Y

YouTube 5, 13, 16, 19, 21–22, 77, 79, 87,
 110, 114, 116, 118, 147, 189
Youth Radio 8, 204, 206

Z

zines and street zines 92–93
 alternative learning spaces 102–103

alternative pedagogies 9, 17, 104
Another Slice 93–95
literacy practices 91, 97–102
shifting spaces 95–97

new
literacies
¶

AND DIGITAL EPISTEMOLOGIES

Colin Lankshear, Michele Knobel,
& Michael Peters
*General Editor*s

New literacies and new knowledges are being invented "in
the streets" as people from all walks of life wrestle with
new technologies, shifting values, changing institutions,
and new structures of personality and temperament emerging
in a global informational age. These new literacies and
ways of knowing remain absent from classrooms. Many educa-
tion administrators, teachers, teacher educators, and aca-
demics seem largely unaware of them. Others actively
oppose them. Yet, they increasingly shape the engagements
and worlds of young people in societies like our own. The
New Literacies and Digital Epistemologies series will ex-
plore this terrain with a view to informing educational
theory and practice in constructively critical ways.

For further information about the series and submitting
manuscripts, please contact:

Michele Knobel & Colin Lankshear
Montclair State University
Dept. of Education and Human Services
3173 University Hall
Montclair, NJ 07043
michele@coatepec.net

To order other books in this series, please contact our
Customer Service Department at:

(800) 770-LANG (within the U.S.)
(212) 647-7706 (outside the U.S.)
(212) 647-7707 FAX

Or browse online by series at:

www.peterlang.com